Surrealism
SURREALIST VISUALITY

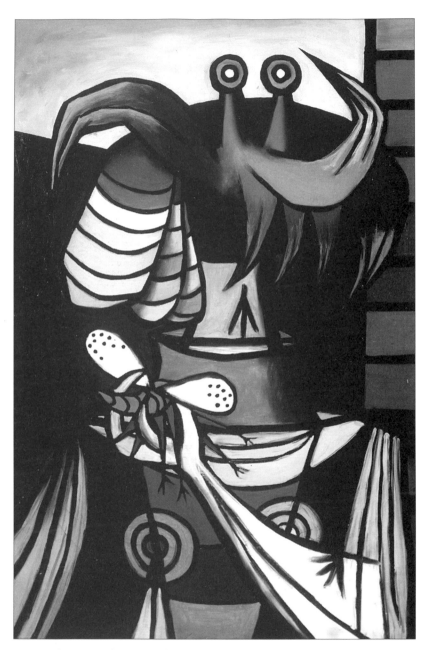

Desmond Morris, *The Entomologist*, 1951

Surrealism

SURREALIST VISUALITY

Edited by Silvano Levy

NEW YORK UNIVERSITY PRESS
Washington Square, New York

Selection and arrangement of material, and Introduction
© Silvano Levy 1996, 1997

First published in the U.S.A. in 1997 by
NEW YORK UNIVERSITY PRESS
Washington Square
New York, N.Y. 10003

Library of Congress Cataloging-in-Publication Data

Surrealism : surrealist visuality / edited by Silvano Levy.
 p. cm.
 Originally published: Keele, Staffordshire : Keele University
Press, 1996.
 Includes bibliographical references and index.
 ISBN 0-8147-5128-8 (clothbound). — ISBN 0-8147-5127-X (paperback)
 1. Surrealism. 2. Arts, Modern—20th century. I. Levy, Silvano.
NX456.5.S875 1997
700'.09'041—dc20 96-36461
 CIP

Printed in Great Britain

Contents

List of Illustrations

Introduction

Silvano Levy

The term 'visuality' is defined by the *Oxford English Dictionary* as 'mental visibility; a mental picture or vision'. It was precisely this concept which André Breton identified with the plastic manifestations of Surrealism. [1] He insisted that, rather than represent phenomena taken from 'the external world', painting should rightly devote itself to 'internal representation'. By a 'poetic' act, Breton maintained, the external object, as such, would be 'excluded', thus permitting the plastic form to exist in terms of its relationship with the interior world of consciousness. He reminds us that for Dalí the object not only 'lends itself to a minimal amount of mechanical functioning' but also that it is 'based on phantasms and representations brought about by the materialization of unconscious acts'. Breton regarded this '*necessity to express internal perception visually*' as being realizable through a wide spectrum of practical means, 'a world of possibilities which stretches from pure and simple abandonment to the picture-making urge to the *trompe-l'œil* fixation on dream images'.

The aim of this volume is to explore the nature of the imagery associated with Surrealism, from its earliest manifestations in the form of collages and those automatic drawings of the mid-1920s through which André Masson sought to offer a paradigm for Surrealist art, through to the mature paintings of the 1930s and 1940s which consolidate Surrealist visuality within a coherent aesthetic, which, nevertheless, allowed great scope to individual style.

For centuries it has been external objectivity rather than internal perception which has dominated representation. Ever since the Renaissance, traditional academic art has been restricted by and bound to a tradition which has given primacy to an exoteric visual model. Alberti's perspective construction, after all, had at its core the concept of a 'window' through which an 'outside' reality could be viewed and recorded. Such rules have left their toll on both artist and spectator and visuality has become almost inextricable from fidelity to an objective reality. None would be more conscious of this constriction than academically trained artists, amongst whom René Magritte can be counted. The teaching which he received at

the Académie Royale des Beaux-Arts in Brussels led the young painter to
produce a series of stilted military portraits and hackneyed landscapes.
Equally unremarkable were his early experiments with post-Cubism and
Orphism, themselves fundamentally formalistic movements. It quickly
became clear to the young Belgian painter that, in order to escape his blink-
ered vision, he had to bring into question the very rules which had given
rise to it. Not long after the conclusion of his course he embarked on no
less than a systematic subversion of the academic pictorial construction.
He attacked and defied the axioms and principles which he had spent years
mastering and thereby demonstrated that the world of objects could be
perceived through means other than those which are imposed externally.

This vision is borne out in Surrealist film, which conveys 'the image of
something that is not really there'.[2] Artaud held the view that cine-
matographic figuration should be divorced from any kind of referential
representation. For him, the cinema had the task of conveying the origin
of thought. Not that this implies the enactment and recreation of dreams.
Rather, it refers to a formulation of thought so elemental that it falls outside
the scope of articulated verbal language. Words and linguistic constructs,
Artaud believed, are intrinsically inhibitory to thought. He regarded the
rules and logic demanded by grammar and language as repressive. The
cinematic image was held to link disparate fragments of thought. Through
film, Artaud tried to override the intermediary and logical mechanism of
meditated representation and reference.

In his formative years as a Surrealist artist, which coincided with the
last decade or so of the silent films, Magritte was also enthusiastic about
cinema. He shared the Surrealists' approach, seeing cinema at once as a
novel and popular medium not yet encumbered with academic and aes-
thetic paraphernalia, as uniquely competent to undermine common sense
and retinal notions of reality and, by the same token, possessing the power
to endow with conviction and substance the wildest flights of the imag-
ination. We can trace many of Magritte's most famous images of the
period – not least the 'Fantômas' series – directly back to shots from
films which he had seen as an adolescent. More importantly, many of his
broader pictorial strategies for displacement and enigma-making, such
as framing, editing and special effects of *mise-en-scène*, relate to film form.
Magritte's vision involves the same 'ways of seeing' that find expression
in films such as Dalí's and Buñuel's *Un Chien andalou* and *L'Âge d'or*.

In the same vein, Max Ernst insists that the significance of the techniques
adopted by Surrealism is that they 'have allowed certain artists to fix on
paper or canvas the stupefying photograph of their thought and their
desires'.[3] For him, activities such as frottage are to be equated with auto-
matic writing and, therefore, with a form of expression which provides
access to the unmediated mental representation about which Breton wrote

and within which he perceived a means of substituting external reality with psychic reality. Even when Ernst is clearly drawing on external, historical sources, he does so in order to use them to express essentially subjective concerns.

The rejection of external reference is evident in the Surrealists' conception of the self-portrait. Max Ernst's identification with the fictitious bird personage 'Loplop', for instance, demonstrates a substitution of the recognizable persona with a metaphorical allusion to an inner and, perhaps, hidden identity. Many Surrealist portraits replace, deform or ridicule the social, public face of the subject. In other words, the mimetic recording of objectivity is subverted in favour of a less overt, corporeal signification. The reference is more often to a state of the mind rather than to a physical state.

Breton's focus on the object demonstrated just such a shift away from concrete signification. In spite of their manifest link with a tangible reality, elected objects became not so much a reference to the palpable as vehicles of the supremely incorporeal, that is to say desire. Rather than offering the possibility of a direct interpretative reading, Breton's manipulations of objects in his *poèmes-objets* offer only *loci* of bewilderment. We are not presented with stable explication but with polyvalent signification. If anything, the privileged object takes on the role of fetish: it becomes a direct link with the creator's psyche. But, of course, the significance for Breton of such inner searchings lay in their capacity to have repercussions within external reality, that is to say to be socially subversive. Accordingly, Conroy Maddox squarely places Surrealist activity within the realm of social intervention. He regards the various techniques employed by Surrealism not only as pictorial and poetic methods of investigation, but also as being politically operative. The relationship which Maddox perceives between reality and the Surrealist enterprise is that of antagonism. Surrealism, he maintains, both dissociates itself from the values of capitalist culture and struggles against it.

The political significance of a work like Picasso's *Guernica*, for example, is manifest. It is both a commentary on an act of political aggression and (as history confirms) it has functioned as a catalyst to politicized reaction. Picasso himself affirmed that the work is a deliberate attempt to foment a committed social stance. The study of texts, including visual representations, historically leads to an understanding of the dialectical and contradictory conditions in which they and their meanings were produced: with reference to Picasso's *Guernica*, this involves the exploration of the visual image in the light of a causal nexus characterized by Surrealist politics, the Spanish civil war, the Popular Front, the relationship between 'Picasso' as symbolic figure within contemporary rhetoric and Picasso's own lived experience.

Breton insisted that 'there is no reality in painting'. His conception of Surrealist Visuality was that of an affront on the world arising from conventional wisdom and habit. 'Surreality', he maintained, 'and not reality will rightfully reassert itself.'[4] The chapters which follow enquire into the ways in which this ideal has been sought.

Notes

1. 'Situation surréaliste de l'objet' (1935), André Breton, *Position politique du Surréalisme* (Paris: 1971), pp. 87–120.
2. Linda Williams, *Figures of Desire. A Theory and Analysis of Surrealist Film* (University of California Press, Berkeley, Los Angeles, Oxford: 1992), pp. 18–19.
3. Max Ernst, 'Comment on force l'inspiration', *Le Surréalisme au service de la révolution*, No. 6 (May 1933), p. 43.
4. André Breton, 'Le Surréalisme et la peinture', *La Révolution surréaliste*, Nos. 9–10 (1 October 1927), p. 40.

Only Chaos within One Gives Birth to a Dancing Star

Conroy Maddox

The stress in Surrealism is always upon life and thought, not on literature or technique. To a Surrealist everything is dictated by the place which art has in life. Art would lose its function if it were separated from the problems of everyday living. Many years ago I wrote a letter to the Pope, suggesting that he should alter the last line in the Lord's Prayer and that it should read 'Give us this day our daily Surrealism'. I was quite hurt when I received no reply, this is a movement that has survived for seventy years despite the gravediggers who persisted in trying to bury it.

What is exalted in the imagination by Surrealism is its marvellous liberating power. Surrealism explores the use of elements foreign to painting – collage, fumage, automatism, decalcomania and frottage. They are all methods of investigation and give back to art its true meaning. We are, after all, surrounded by invisible forces that cry out to be explored politically, pictorially and poetically.

It is worth mentioning that the most revealing approach to Surrealism, which is like saying reality, may not always be a frontal approach. One can come to it from an angle and a special viewpoint and discover aspects of the real that are frequently concealed, hidden by the banal view of the familiar. Even the simplest things unveil exciting questions and shed a strange radiance. An example would be some of the objects that find their way into railway lost-property departments. Amongst this intimate hoard listed by London regional transport have been a box of glass eyes, a mouldering stuffed eagle gorging on its prey, a fibreglass leg, an assortment of knives and false teeth, crutches (one lost every month – could it be that Sister Wendy Beckett wanders through the tube trains offering instant cures?). Also lost were a pith helmet with a solar-powered forehead fan, a bottle of sperm from a prize bull, a display case of a condom salesman, a briefcase with a blow-up doll inside tucked between a sandwich and a thermos flask. Do these instances not reveal chinks in that armour we wear against what the world calls a sense of reality? Surrealism, as it were, is happening all around us. Everything one sees in the world, which is unexpected, unlikely or improbable, is symptomatic of a principle inherent in Surrealism.

On a more personal note, let me say, as an artist, that I hope never to discover myself. I still salute those charming creatures, some audaciously nude or dressed in the latest fashions, that stare blankly at one from shop windows. I have, in fact, lived with two for many years. I look at the ruins in Greece and think how strange these appear, in view of the fact that other countries have rebuilt their cities. I try to listen to music, but suddenly remember that an okapi died from stress after listening to a taped recording of Wagner. I pass a nun in the street in Valencia and wonder whether she is one of the two nuns who beat Raphael Marques unconscious, when he broke into their convent. But it is not enough to notice the absurdities which surround us. It is still necessary to oppose norms and convention. I go to sleep each night hoping to recapture a dream I had of being an anti-missionary, following Billy Graham around and winning people back from God. Such thoughts are the perfect mirror of subjectivity, of taking the mind on a sleepwalking adventure. Back in my youth I set out to write a novel, although such a literary form has always been condemned by Surrealism. Mine was going to be different: I would write using only clichés. It began: 'He snatched his eyes from his plate and glued them on her face...' That was all. It was going to be the shortest novel in the world.

An American University for women issued a questionnaire to 300 of its students, asking what stimulated them most sexually. While only 25 said books, and 21 said paintings, no fewer than 254 gave the re-assuring answer 'men'. The findings are clearly obvious in the extreme and, as such, are about as stimulating as watching the wool programme in an automatic washing machine. Surrealism, on the contrary, has never ceased to avail itself of occurrences which diverge from the expected and the rational – chance encounters and black humour. Surrealism seeks the confusing, the unstable, the transitory and, even, the suspect.

Whilst not being divorced from reality, Surrealism essentially stands in opposition to it. The movement has and still refuses to come to terms with a society in which flagrant contradictions exist between the life of dreams and the waking life, between love and hate, between reason and unreason, between sanity and madness, between the real and the unreal. The significance, for instance, of dreams for the Surrealist is that they make us discontent with life. Surrealism has always sought to resolve contradictions. It has attempted to reconcile distant realities in order to offer an escape from the impoverished pressures that seek to compartmentalize our lives. Beauty, truth and God are, to the Surrealist, merely abstractions, hanging on the walls of yesterday by the glue of nostalgia. The magic power of the imagination would be put to very poor use indeed if it merely served to preserve and reinforce discredited ideals. Make no mistake, Surrealism represents the most revolutionary experience in poetry

and art. It opposes those myths upon which capitalist culture depends, it breaks down all those Christian values which have been erected around a wooden cross.

Genuine Surrealists devote themselves to a spirit of research and discovery. However, the manner in which they have done so has not been an uncontentious issue. Initially Surrealist painting was not endorsed by the group around Breton. The obstacles that confronted them were crystallized in experiments that Breton and Soupault made in 1921 with *Les Champs magnétiques,* in which they explored the imaginative liberty in automatic writing. Five years later the *Manifesto of Surrealism* sowed the seeds of the movement, confining it to verbal language. Surrealist painting was only referred to as a footnote, although Max Ernst had held his first Paris exhibition in 1920. 'Poetry', said Breton, was 'the perfect compensation for the misery we endure'. E. L. T. Mesens, the Belgian Surrealist, went even further when he proclaimed that poetic expression would conquer all the domains of human activity.

Nevertheless, to channel all creative practice into automatic writing, I feel, was rather like denying that spirit of enquiry that Surrealism claimed to support. I would maintain that the spontaneity of the paintings produced by the Dadaists could not have passed unnoticed by the group around Breton and the emerging Surrealist movement in 1924. Max Ernst had his first exhibition in Paris in 1920, which clearly supported evidence of a role for Surrealist painting. Nevertheless, painting was rejected as too conscious an act, a decision made without any serious reflection. It is not inconceivable to recognize this resistance when one considers that the group, at that time, comprised Breton, Aragon, Eluard, Soupault, Naville and others. All, one notes, were poets.

To be fair to Breton, he soon recognized the danger of his early definition of Surrealism as 'pure psychic automatism without any conscious control' when applied to poetic creation, since this mode of expression frequently leads to repetition and monotony. While proposing utmost fidelity to automatism, Breton recognized that, in order to complete the work, an element of conscious control might become necessary to realize the discovery initiated by the technique. Yet reservations still existed, as we can see when we consider that Breton's writings on painting were published in 1928 under the tentative title 'Le Surréalisme et la peinture' (Surrealism and Painting).

Nevertheless, as more painters were drawn into the Surrealist universe, one witnessed a sharp change of direction in which painting made its entry into the field of Surrealism, offering an illuminating spark other than that of verbal language. While accepting pure automatism as an essential method of discovery in Surrealism, which would have destroyed the liberty which they sought, the Surrealists recognized the necessity of some

conscious intervention, since, once a new reality is perceived in the work, there is no necessity to continue working in a purely automatic way. Once an image is revealed, it is possible to arrest the work and to allow it to develop in a more conscious manner.

It is important to remember that the Surrealists have always questioned reality, not by resolutely rejecting it so much as directing attention away from the manifest content to its latent content.

It is well known to the general public that Surrealist painting has proved more comprehensible than any of the literary works, although the written word and the visual complement each other on all levels. When you think of it, it is unawareness, not knowledge, that lies at the source of a Surrealist painting. It is discovery, not proof, that really justifies its existence.

I would argue that Surrealism has raised life and reality to a higher meaning and subjected it to a re-evaluation. It has shown that one's sensibility to the real is always influenced by desire. By refusing to be reality's dupe, it takes us beyond the limits of the day-to-day. If chance, arbitrary events and the marvellous are valued by Surrealism, it is because they are seen to enrich our perception of reality. Everything hinges on the Surrealists' way of looking. What is depicted in Surrealist paintings must never be regarded as an end in itself. Rather, it is a means, a pathway, as it were, which leads beyond our mundane perceptions and aspirations. 'True life', said Rimbaud, 'is absent.' The time has come to appropriate it.

René Magritte: Representational Iconoclasm

II

Silvano Levy

The early work of René Magritte, I shall argue, is iconoclastic. During the 1920s Magritte's work functions as a refutation and negation of the pictorial tradition which has become the cornerstone of Western art. Commentators have rightly highlighted the artist's unorthodox portrayal of plastic form and have shown that its conception indeed rests on the 'internal vision' preferred by Breton rather than on objective principles.[1] But little critical attention has been given to the activity which preceded this reorientation and contestation of figuration. The aim of this discussion is to identify and examine the rationale behind the subversion of pictorial convention, which characterized the artist's initial essays.

David Sylvester makes the point that Magritte had taken his studies at the Académie Royale des Beaux-Arts in Brussels extremely seriously. By his own account, the painter considered the academic study of the disciplines of anatomy and of perspective as being 'as indispensable to an artist as grammar to a writer'.[2] The briefest of surveys of Magritte's production would indeed confirm that the painter was well versed in and overtly practised the techniques of academic painting. Sylvester points out, for example, that the complicated perspective of *La Géante* (1931) is likely to have been based on diagrams seen in the textbook on perspective used at the Academy, *Traité pratique de perspective* by A. Cassagne (Paris, 1873). Yet, whilst acknowledging and having recourse to the conventions of representation, the painter undeniably subverts their application. Constantly, the rules which govern traditional painting can be seen to be flouted in an overt manner by his work. This general inobservance of the principles of figuration, which can be identified with Magritte's production as a whole, emerges as particularly acute throughout a period of feverish experimentation lasting from about 1924 to 1930. During that time Magritte appears to have engaged in no less than a calculated defiance of the conventions of painting. It would seem that he undertook methodically to single out the individual precepts which make up academic painting and then to disrupt and subvert their utilization. Magritte had said that a

15

painting was 'un object construit'.[3] It is clear that he also considered it
capable of being deconstructed. He 'dismantled' form and space and, I shall
argue, conducted a radical and systematic critique of academic pictorial
construction.

The origin of the formal principles which had formed the basis of the
painter's training at the Academy and which were the focus of his
concerted attack can be traced back to the writings of the Renaissance
theoretician, Leon Battista Alberti (1404–72), who was the first to system-
atize the stages of construction of a painting or a sculpture. In 1435 or
1436 Alberti had written that:

> youths who first come to painting (should) do as those who are taught
> to write. We teach the latter by first separating all the forms of the
> letters which the ancients called elements. Then we teach the syllables,
> next we teach how to put together all the words. Our pupils ought to
> follow this rule in painting. First of all they should learn to draw the
> outlines of the planes well. Here they would be exercised in the ele-
> ments of painting. They should learn how to join the planes together.
> Then they should learn each distinct form of each member.[4]

It is through an essentially linguistic taxonomy that Alberti identifies
discrete elements within the pictorial construct. He begins by equating
the verbal primaries, 'letters', to his concept of pictorial primaries, 'the
outlines of planes'. Then he advances that in a subsequent stage of pictorial
construction these 'elements' join together, just as 'letters' are grouped
into 'syllables', to form planes. The linguistic analogy at this point arguably
extends to the phonological level, since the notion of linguistic constraints
acting upon and determining permitted sequences of sounds is itself
echoed in Alberti's insistence that there must be a sense of appropriate-
ness in the ways in which planes can be combined.[5] These combinations
are, in turn, said to result in the depiction of the 'member', that is, the
smallest part of the image which has an independent semantic value and
which could, tenably, be termed a 'pictorial morpheme'.

The analogy between the elements of language and the basic principles
of graphic construction is, in fact, quite consistent and Alberti implies
that all the 'stages of painting', which he goes on to detail, can be equated
with the progressive lexical and syntactical linguistic strata. For instance,
the elementary skill which he requires of painters, that 'they should learn
each distinct form of each member' (p. 92), clearly involves a selection
from the various graphical possibilities and a capacity to give the unitary
shape the identity of an isolated symbol. Each shape is regarded as a com-
ponent of the various classes of concurrent alternatives and it is from

these that an appropriate 'kind' of form is deemed to be selectable. The painter, Alberti insists, should discriminate between 'the rough wool cloak of a soldier' and 'the clothes of a woman' (p. 74). Should he fail to make such distinctions, and, for example, depict 'a figure whose face is flesh and full' as having 'muscular arms and fleshless hands' (p. 74), he is regarded as having shown an inability accurately to select from categories which themselves are correctly combined.

What Alberti does is to make the fundamentally linguistic distinction between selection and combination, which becomes particularly apparent in his definition of the 'three parts' (p. 67) of pictorial construction. Here, he expressly distinguishes between the interrelation of objects and their faithful representation or identification. The text details a first stage of painting – termed 'circumscription' – which involves 'the drawing of the outline' (p. 68), and so, the definition, in two-dimensional terms, of the space occupied on the panel. The outline thus acts as a boundary between the internal or 'semantic' description of the object and its external situation or 'syntactic' relations with other objects. Indeed, our primary means of recognizing an object 'involves separating [it] from its background'.[6] Second, Alberti describes graphic concatenation – 'composition' – as 'that rule in painting by which the parts fit together in the painted work' (p. 70). This 'grammar' of the picture predetermines a clear hierarchy of relations. As already mentioned, 'planes are parts of the members' and, in addition, 'these members are parts of the bodies' (p. 70). Moreover, the overall regulatory force which orders the arrangement and relations of each object in the composition is 'l'istoria'. This 'greatest work of the painter' is defined by Jean Clair as 'la composition des corps, leurs relations, leurs intervalles, tels que les déterminent d'une part leur grandeur propre, d'autre part leur fonction'.[7] Composition, in Albertian terms, comprises the rules of contiguity, both within objects, thus determining how planes and members are joined, and between them. In this respect, Alberti's perspective construction is clearly central to the determination of spatial sequence. Finally, Alberti treats the plastic representation of the object, which he calls 'reception of light' (p. 68). By means of this 'stage' the object is given 'light and shade' as well as colour and texture. The reception of light entails the final technical procedures which turn the various parts of the painting into well-nuanced, or semantically precise, objects.

It is against this background of precise and extremely systematized rules that Magritte formulated his affront on formal art. Because of the discrete (compartmentalized) and stratified (hierarchical) nature of the procedures involved in academic painting, which the linguistic comparison has highlighted, it was possible for the painter to direct his dissension in a focused manner. Not only was he able to subvert individual aspects of the stages of painting but he was also to do so in a selective manner. By

being directed at specific prescriptions, the instances of iconoclasm were
all the more poignant.

Spatial Imprecision

The convention of painting from which Magritte most blatantly diverges,
and with which this discussion will concern itself, is that of 'composition',
that is, the 'grammar' of painting. This facet of the painter's contestation
is clearly evidenced in *Cinéma bleu* (1925). The notable feature of this work
is its disruption of the relations between the objects it depicts. The pictorial
device of perspective, which normally has the function of unifying the
elements of a composition, emerges here as absent or intermittent.

 The reason why the painting gives an initial impression of random order
and lack of co-ordination is that there is imprecision in the chief device by
which pictorial context is defined – the illusion of depth and space. The
intelligibility of pictorial space, 'composition', is disrupted in such a way
that the objects in *Cinéma bleu* appear impossible to locate accurately in
space. In fact, it is the particular technique used by Alberti to define space,
and therefore composition, 'dividing the pavement' (p. 58) which is dir-
ectly contradicted in *Cinéma bleu*. The most problematical aspect of the
painting is the floor area. Although the painting may seem to depict a
straightforward theatrical set, there are certain representational incon-
sistencies which undermine the illusion of a flat, horizontal 'pavement'.
For example, in spite of the presence of a high light source originating
from the right, confirmed by the skittle and the columns, no shadows are
cast and, as a result, the single figure in the painting, that of a slender
woman in a model-like pose, does not appear to be standing on the ground
but rather to be hovering in the air. Assuming that the 'floor' exists at
all, the inconsistency of its relations with the elements of the painting in
general makes it an equivocal space with only contingent possibilities
of interpretation. Indeed, this floor can be read, at various points in the
painting, as any gradation between a horizontal plane perpendicular to
the picture surface and a vertical plane parallel to it, a feature which will
now be briefly considered. As already implied, the general setting (the
flanking red curtains, the rudimentary classical scenery, the grimacing,
poised figure turning away from a toppled object) conveys the impres-
sion of a theatrical situation, and this urges us to understand the lower
grey area as a flat stage floor.[8] At the same time, the concept of horizon-
tality is contradicted: the lower folds of the curtain on the right, which
apparently rests on the floor, are neither vertical nor horizontal but slant
down towards the spectator to form a vague slope, the idea of a gradient
being emphasized by the presence of the rolling skittle which, in reality,

2.1 René Magritte, *Cinéma bleu*, 1925 (© ADAGP, Paris and DACS, London 1996)

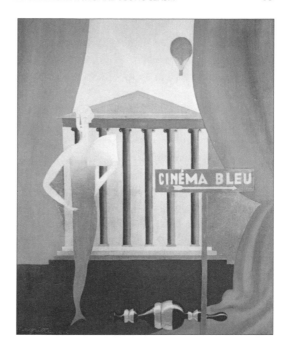

has to be balanced by the momentum of rotation. Thus, the ground area is distorted in such a way that it appears sloped. This reinterpretation of the pavement is itself put into question when we notice that the 'stage floor' appears to be a downward continuation of the bottom riser of the classical façade, and, far from being construed as a horizontal plane, the so-called 'floor' therefore assumes the uprightness of a vertical surface.

These various readings of the perspective do not, however, abut against one another to produce positive boundaries at which opposing interpretations clash and conflict. The effect is more that of an informal structure which admits ambivalence. Space in *Cinéma bleu* is inconsistent, and, as a result, perspective loses its unifying force. Whereas the exaggeration of perspective in, for example, de Chirico's *Mystery and Melancholy of a Street* (1914) brings pictorial elements into a tense, brooding proximity, *Cinéma bleu* alienates objects by reconciling incompatible viewpoints. Obviously, Magritte here is ignoring Alberti's insistence on compositional cohesion and instead adopts a somewhat arbitrary pictorial arrangement. It would even be possible, as I have proposed elsewhere, to consider the structure of *Cinéma bleu* as being more akin to that of many shop-window displays, with their vague, illusory settings and their deliberately unexpected arrangements of objects, than to formal composition.[9] With this parallel in mind, together with the theatrical undertones of the painting,

Cinéma bleu could very well be construed to allude to a 1920s fashion design, with which Magritte, who had prepared advertisements and catalogue covers for the 'Norine' fashion house, was familiar. It may not be incidental that the slim, fluid figure in *Cinéma bleu* closely resembles Norine (Honorine Deschrijuer) herself with her slight build and bobbed hair style. Certainly the rolling skittle is clearly related to the stylized tailor's mannequin which appeared in one of Magritte's numerous advertisements designed for Norine. What is significant about *Cinéma bleu*'s similarity with commercial advertisements or fashion displays is that it reinforces the view that the painting rests on principles which are independent of formal composition. The analogy serves to highlight the compositional instability and vacillatory relationships in the work.

An example of this pictorial inconsistency would be, say, the foreground skittle. On the one hand, its highly polished surface, its highlights and shading make it a solidly modelled object in the round, but, on the other hand, it casts shadows neither on the floor nor on the curtain, and so its position in relation to these two elements remains unclear. It is not possible to deduce whether the skittle is on the floor or on the curtain or indeed whether it is on both or neither. Certainly, it is situated behind the post of the 'Cinéma bleu' sign, but we have no idea about how far behind. According to José Vovelle, perspective here has been abandoned to such an extent that the links between objects, or rather their relative positions, are only definable as 'la simple succession de plans' and not as sequences in space.[10] In fact, Magritte goes further and does not permit even this tenuous method of situating objects. Evidently, if each object is gauged by the one which precedes it, then the intelligibility of the structure of the whole painting relies on the situation of the foremost element.[11] Since this foreground object, the sign-post, is rooted below the lower edge of the painting, there is no fixed point of reference at all. So the positional 'composition' is disrupted.[12] The 'Cinéma bleu' sign, in itself, stresses the overall disruption of the concept of a unified, self-regulated composition. The effect of the arrow, for example, is to turn an otherwise affirmative label into a pointer to a context beyond the picture boundary. The arrow indicates that the words 'Cinéma bleu' have nothing to do with what is represented in the painting. The arrow is, in fact, a digressive device which is in keeping with a bias in *Cinéma bleu* towards compositional disassembly: in opposition to the arrow pointing to a centre of interest on the right, the woman glances to the left and, similarly, the implied rising motion of the balloon opposes the tumbling down of the skittle. The painting evinces a lack of compositional control: objects are grouped without achieving the concatenating correlation prescribed by Alberti. *Cinéma bleu* is a defiance of the 'grammar' of pictorial space. It takes a step away from compositional clarity and towards spatial imprecision.

Spatial Paradox

While in *Cinéma bleu* the plastic representation of objects is sometimes inconsistent, it is uniform and explicit in *La Fenêtre* (1924 or 1925). There are two geometric shapes in the painting, a pyramid and a rectangular block, which are unambiguous and solid. In contrast to the representational techniques in *Cinéma bleu*, physical shape is immediately conveyed here. Indeed, objects in this painting are generally clear and simplified. The flanking curtain, for instance, has only two folds. It would seem, moreover, that the spatial setting is as well defined as the objects. For example, in conformity with the rules of perspective, the pyramid sharply recedes into space, as does the top of the rectangular block, which slopes towards the vanishing point. Furthermore, in the landscape outside the window, the path, bordered by diminishing posts, leads towards, and so establishes, a horizon. In general, a clear distinction is made between the distant outdoor scene and what is inside. It could even be said that the landscape shows signs of aerial perspective or that, as Alberti put it, 'as the distance becomes greater, so the plane seen appears more hazy' (p. 48). In contrast to the clear-cut faces of the pyramid in the foreground, the hill in the background has a lack of surface variation. Similarly, the well-modelled hand differs from the flat figure in the distance. However, although the various objects are themselves accurately and appropriately portrayed, each having an explicit representational meaning, they occupy only the semblance of a well-defined space. The inconsistency in the reception of light between the pyramid, illuminated from the right, and the rectangle, illuminated from the left, is indicative of a fundamental disruption of the spatial composition. Indeed, between the horizontal plane which supports the pyramid and the supposed vertical edge of the window there is an insubstantial form which simultaneously lies on both these surfaces and consequently puts into doubt their mutual perpendicularity. Hence, there emerges an uncertainty about what is close and what is far away. For example, the hand, obviously inside the room, 'semble vouloir saisir un oiseau qui vole' and is about to grasp a bird which perspective should have put out of its reach.[13] This confusion of relative distances is characteristic of Magritte's questioning of the way in which perception makes sense of the visible world:

> malgré les combinaisons compliquées de détails et de nuances d'un paysage réel, je pouvais le voir comme s'il n'était qu'un rideau placé devant mes yeux. Je devins peu certain de la profondeur des campagnes, très peu persuadé de l'éloignement du bleu léger de l'horizon … J'étais dans le même état d'innocence que l'enfant qui croit pouvoir saisir de son berceau l'oiseau qui vole dans le ciel.[14]

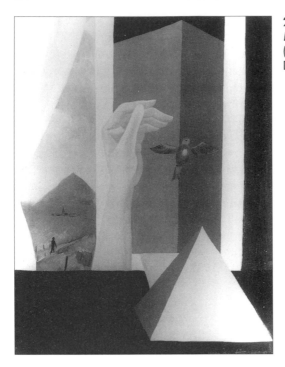

2.2 René Magritte,
La Fenêtre, 1925
(© ADAGP, Paris and
DACS, London 1996)

This particular device also appears in *Une Panique au Moyen Age* (1927), where the foreground figure is vertically connected to a smaller, more distant figure partially outside a window. As in William Hogarth's (1697–1764) *Whoever Makes a Design without the Knowledge of Perspective*, which deliberately confuses planar proximity with distance constructed by perspective, *La Fenêtre* and *Une Panique au Moyen Age* create a compositional confusion between two otherwise distinct spatial settings, inside and outside. This phenomenon is further demonstrated in *A la suite de l'eau, les nuages* (1926), in which the distant clouds *outside* are shown to continue into the foreground *inside* space through a window. Even in the limited space visible outside the window of *La Fenêtre*, there are two possible interpretations of depth: the landscape visible from the left pane shows a sharp spatial recession giving the illusion of a penetration of the picture plane, whilst the shape on the right protrudes towards the spectator almost as if the perspective pyramid had been reversed and the intersection of the orthogonals were at the foreground instead of away from it.

The suggestion of a reversed perspective construction recurs, somewhat more plausibly, in other paintings of this period. For instance, the table in *La Fatigue de vivre* is gently angled to indicate an obverse vanishing

point. But it is particularly in *L' Oasis* (1925–7) that 'Chinese perspective' is quite evident. [15] In opposition to Alberti's concept of the painting as 'an open window through which I see what I want to paint' (p. 56) and a 'cross-section of a visual pyramid' (p. 52), and, as such, an illusory space in which scale decreases as the distance from the viewer increases, the table in *L' Oasis* sharply diminishes towards the foreground and thus disrupts the conventional systematization of space. Instead of controlling the representational context, perspective here confuses the expected sequences in depth and relations of scale. For instance, whereas clouds are generally the most distant and largest elements in a landscape, in *L' Oasis* the size of the clouds is reduced and some of them appear in front of the three trees in the foreground. The painting as a whole shows a progressive contraction in scale and a corresponding reduction in the distances between objects as the foreground is approached. The impression of infinite space and size in the distance contrasts with the proximity of various foreground elements, since, not only are the clouds brought down to meet the trees, but the blue sky is not fully extended upwards. As though the Albertian perspective construction had been totally inverted, the view-point seems to be from the opposite end of the perspective pyramid. The impression is that of seeing the whole scene 'from behind', all the expected sequences in space and scale being reversed. Moreover, at the point of the perspective pyramid, where the theoretical orthogonals would approach their point of intersection, the represented space diminishes and positional relations become indistinguishable. Accordingly, at this hypothetical 'focus' of *L' Oasis*, the table and the trees merge together, as objects are seen to do on the horizon of a 'conventional' painting, where the reducing transversals are finally superimposed.

Another implication of this subversion of Alberti's pictorial control is the disaffirmation of the very basis on which perspective is constructed, the assumed position of the observer himself. An important concept for Alberti is that 'both the beholder and the things he sees will appear to be on the same plane' (p. 56), in other words that the spectator should be assumed to be directly in front of the painting. What Magritte's disruption of pictorial space does is to put into question this traditionally fixed relationship between the observer and the painting. It is true that already in the sixteenth century Erhard Schön (*c.* 1500–1550) had drastically modified the frontality of the spectator's view-point, but Magritte goes further by actually reversing this view-point and perhaps dispensing with it altogether.

To return to the former consideration of the pictorial pavement, we have so far noted that, whereas for Alberti the intelligibility of the ground area is a prerequisite for the 'composition' ('first I begin with the foundation', p. 70), the floor spaces in *La Fenêtre* and *L' Oasis* as well as in *Cinéma*

bleu are incoherent and thus brings about a degree of ambiguity in the space depicted. Basically, the confused state of the pavement in these paintings arises from the inadequacy and absence of perspective cues. But, in a small number of paintings of 1926 which contain crossed lines on the ground, perspective can be seen to become positively contradictory. Far from alluding to the 'converging tramlines' of perspective, these intersecting lines establish an irresolvable polyvalency of the ground. Although the lines in the lower half of *Georgette* (1926) appear to designate a surface of shallow pyramids, it is impossible to interpret the pavement as a consistent alternation of peaks and hollows. Due to a lack of shading, each 'pyramid' has two alternative readings and the way in which we perceive the polygons is thus subject to continual reappraisal. The inadequacy of the data produces the 'illusions generated by ambiguity' about which R. L. Gregory writes.[16] The uppermost part of each pyramid can also be interpreted as the base of another. Furthermore, if we consider the various undulations as a continuum, the overall sequence becomes problematical. Whether a polygon is seen as concave or convex, the consequent deductions on the adjoining forms will either contradict the approximate horizontality of the pavement or produce an impossible sequence.[17]

In addition to the imbroglio of the pavement, the pictorial space in *Georgette* is further confused by the unclear sequential relations of the objects depicted. As in the case of *Cinéma bleu,* it is not possible to establish '[une] simple succession de plans',[18] but in *Georgette* this results from conflicting rather than inconclusive compositional ties. The skittle, for example, could be positioned behind a framed picture of Georgette, which depicts the portion of the skittle which it hides, a situation similar to that in *La Condition humaine* (1933–4). Consequently, the continuous blue background and the shadow cast on the skittle would indicate that we are looking at an empty frame through which the skittle and Georgette are visible. However in this instance Georgette's shoulders would not overlap the edge of the red surface and so, as with the polygons, either interpretation is eventually perceived as untenable. The observer is confounded by the mistaken assumption that the pictorial cues indicate alternative readings: if one option is not admissible the other one(s) will be considered to be correct. As Judith Greene observes in a general sense: 'In a binary situation to affirm one possibility is the same as denying the other possibility. Similarly, a negative statement that one event is not the case amounts to an assertion that the other event is the case'.[19] In *Georgette* neither alternative is plastically valid. The negation of one possibility is accompanied not by the affirmation of the other but by a further negation. The arrangement of objects differs from the ambiguous illusion in that the suggested interpretations are equally unlikely rather than being equally probable.

Spatial Fragmentation

Magritte's defiance of Albertian pictorial syntactics has thus far been seen either to have denied the painted object a precise locational resolution or to have placed it in a paradoxical situation. In the paintings of the 1920s there is a third type of decontextualization in which the lack of definition in the relationships between objects arises from another state, that of isolation. Composition is not determined by an incomplete or polyvalent grammar but by what could effectively be termed pictorial 'agrammaticality'. In certain works there emerges a discontinuity between meaningful units which is comparable to the aphasic condition. As in this linguistic defect, there are interruptions of contextual continuum: the potential interrelation of semantic units would be evidenced but frustrated. In opposition to Alberti's caveat that the parts of the painting should 'fit together' (p. 70), pictorial elements are kept apart.

A suggestion of how this pictorial segmentation was to be effected first appeared in the suitably entitled *Le Prisonnier* (1926), which depicts potential, but empty, receptacles. The painting simply demonstrates prototypes for two kinds of 'incarcerations' that are to appear in future paintings. The upright, flat, irregular planes in the middle distance are similar to those that, in other works, are to be moulded around objects in order to embed them in fixed, insulated situations, and the wooden box in the foreground brings to mind the encasements of individual objects, which Magritte was yet to make. Unlike subsequent boxes, however, the one in *Le Prisonnier* has transparent and possibly glass sides which give it the appearance of a display case. Nevertheless, this box is in keeping with the more solid subsequent boxes and, in fact, it symbolizes their function, since the objects which are to be depicted in them will be arranged precisely as though they were on display, that is, as inventories of isolated objects rather than as interrelated items.

Both of Magritte's methods of implementing pictorial isolation are present in *Le Dormeur téméraire*, in which a sleeper is confined in a wooden box and six objects are set into a slab made of concrete or lead. As opposed to the suggested movement of the swirling clouds in the background, whose location is rendered indeterminate by the absence of a horizon, each of these objects is frozen in a fixed position. They rest in tightly fitting recesses, outside of which they have no significance or influence. The mirror does not reflect its surroundings and the candle casts no light.[20] No compositional concatenation bridges the spaces between the objects to give them relational ties and, instead, each niche is a self-sufficient, insulated space. The static, quasi-ornamental arrangement of the objects denies them all semblance of potential activity. The rigidity of the candle's niche, for instance, seems to remove the possibility that the wax may be

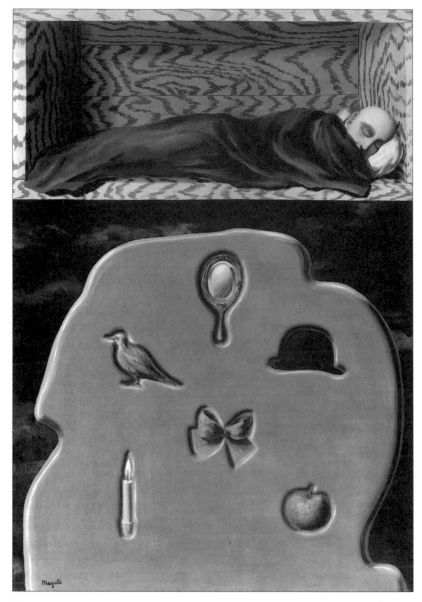

2.3 René Magritte, *Le Dormeur téméraire*, 1928 (© ADAGP, Paris and DACS, London 1996)

consumed. The objects are permanently inert and out of context. Just like the objects below him, from which he is compositionally distinct, the recumbent figure is firmly encased. The box in which he lies is just long

enough to accommodate him, and his body is almost totally enveloped in a blanket. This immobile pose is further emphasized by the fact that the sleeper's face sinks deeply into the pillow, echoing the way in which the objects are pressed into their niches. Furthermore, each element in *Le Dormeur téméraire* is not only confined laterally and in depth but it is also intercepted frontally by the picture plane. Both the edge of the box and the bottom of the slab touch the picture edge and thus 'press' the objects against the foreground plane which acts as a transparent surface which hermetically seals each encasement. As opposed to Alberti's requirement that 'both the beholder and the painted things he sees will appear to be on the same plane' (p. 56), Magritte paints the sleeper's box in such perspective that the view-point is above the top edge of the canvas and therefore removes any direct correlation between the observer's space and the painted space. In spite of the drape which overlaps the edge of the box, the real space in front of the painting is not a continuation of the painted space and, consequently, there is no suggestion of a vacant space in front of the objects. Equally, the painting itself is not like 'an open window' (p. 56) giving onto an illusory, extended space.[21] Beyond the 'cross-section of [the] visual pyramid' (p. 52), which separates the observer's space from the painted space, *Le Dormeur téméraire* evidences only spatial occlusion. As opposed to the dissipation of a common setting in *Cinéma bleu* brought about by an inconsistency of spatial relations, *Le Dormeur téméraire* presents an inventory of elements in a clear, voluminous setting which itself inhibits compositional ties. Although the implied dynamic divergence of objects in *Cinéma bleu* contrasts with the rigid inertia of *Le Dormeur téméraire*, in both paintings individual objects are effectively alienated from one another. Whether objects have an indeterminate area between them or whether they are deprived of peripheral space, the overall effect in these early paintings is that of spatial fragmentation.

Conclusion

Magritte's disruption of academic composition can be seen to occur on three levels. Pictorial space is first rendered ambiguous, then paradoxical and, finally, it is fragmented. In all of these cases the result, and probably the intention, is a mitigation and even counteraction of the dominance of formal artistic practice over figuration. By painting in direct defiance of received convention, Magritte, effectively, dismisses the supposed supremacy of Albertian precepts in the pictorial depiction visible phenomena. Plastic form is codified not so much in accordance with objective rules as in response to a subjective conceptualization, that is *visuality* rather than vision.

Notes

1. For instance, Suzi Gablik, *Magritte* (London: 1970), Paul Nougé, *Histoire de ne pas rire* (Brussels: 1956), Patrick Waldberg, *René Magritte* (Brussels: 1965).
2. David Sylvester, *Magritte* (London: 1992), p. 32.
3. René Magritte, *Écrits complets* (Paris: 1979), p. 19.
4. Leon Battista Alberti, *On Painting*, trans. by John R. Spencer (London: 1956), p. 92. Further references to this book appear in brackets in the main text.
5. Combinations in general are determined by the rules of 'composition', but Alberti specifically mentions that planes are to be joined together in fitting ways: 'in this composition of planes', he writes, 'grace and beauty of things should be intensely sought for' (p. 72).
6. R. L. Gregory, 'The Confounded Eye', in R. L. Gregory and E. H. Gombrich, eds, *Illusion in Art and Nature*, (London: 1973), p. 89. In paintings such as *La Grande Famille* (1963) and *Le Séducteur* (1950), Magritte violates this boundary by replacing the internal description with the situational setting: the rules for constructing the grammatical context are used to formulate the internal structure of the morpheme.
7. Jean Clair in catalogue of exhibition *Rétrospective Magritte* (Brussels: 1978), p. 39.
8. In the year of the painting, 1925, Magritte had in fact designed the stage set for a performance by the Groupe Libre, Brussels, according to André Blavier in Magritte, *Écrits complets*, p. 672.
9. Silvano Levy, 'René Magritte and Window Display', *Artscribe*, 28 (March 1981), pp. 24–8.
10. José Vovelle, *Le Surréalisme en Belgique* (Brussels: 1972), p. 67.
11. Alberti insists that, in a correct perspective construction, the transversal closest to the foreground should be carefully calculated. It is on the basis of this foreground construction line that the subsequent recession markings are located. Hence, the 'correctness' of the entire picture space depends on the precise definition of a 'foreground element'.
12. Alberti stresses that the painter must know well 'how each thing ought to be done and where located', and that, in this respect, there must be 'the greatest certainty' (p. 96).
13. René Magritte, cited in Vovelle, *Le Surréalisme en Belgique*, p. 67.
14. Magritte, *Écrits complets*, p. 106. Translation: despite the complicated combinations of details and nuances in a real landscape, I could see it as though it were a mere curtain placed in front of my eyes. I became uncertain of the depth of natural scenes and hardly convinced of the distance of the light blue of the horizon ... I found myself in the same state of innocence as an infant who thinks himself able to reach out from his cot and catch a bird flying in the sky.
15. A. M. Hammacher, *René Magritte* (London: 1974), p. 78.
16. Gregory, 'The Confounded Eye', p. 83.
17. The same is true of M. C. Escher's *Waterfall* (1961) where, although each part of the work is comprehensible, the overall sequence is an impossible

arrangement. This is because, in spite of the correctness of each part of the composition, the manner in which these parts are linked is inconsistent with the modelling. See Anon., *The Graphic Works of M. C. Escher* (London: 1961), p. 16.

18. Vovelle, *Le Surréalisme en Belgique*, p. 67.

19. Judith Greene, *Psycholinguistics, Chomsky and Psychology* (Harmondsworth: 1972), pp. 123–4.

20. Albertian 'circumscription', emphasized by the encompassing recesses, is no longer the point of transition between the object and its context. The reception of light literally does not occur from the rest of the composition. Circumscription here acts as circumvallation.

21. Ideally, for Alberti the observer should feel involved in the painting: 'In an istoria, I like to see someone who admonishes and points out to us what is happening there; or beckons with his hand to see, or menaces with an angry face and with flashing eyes, so that no one should come near; or shows some danger or marvellous thing there' (p. 78).

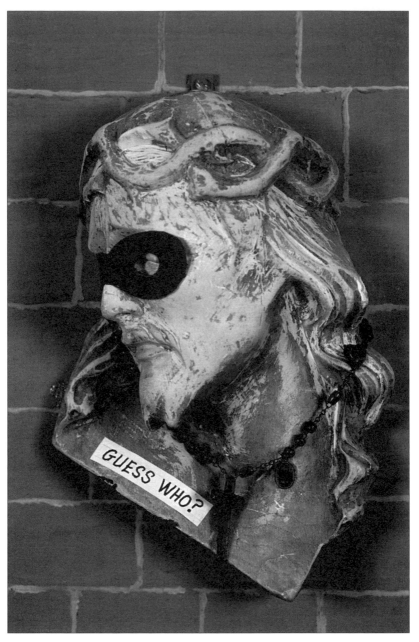

Conroy Maddox, *Guess Who?*, c.1960

The Surrealist (Self-)Portrait: Convulsive Identities

Elza Adamowicz

'According to the description on his identity card, Max Ernst is only forty-five years old at the time of writing this text. He has an oval face, blue eyes and greying hair. He is just above average height.'[1] In this description of his physical appearance, which opens the text *Instantaneous Identity*, Max Ernst refers to himself in the third person. The self is presented as double, not only in an implicit reference to the mirror-image reflecting the subject as both observer and observed, but also, as the text proceeds to explain, in the apparently contradictory traits of Ernst's character. Ladies find Ernst's pleasant manners and gentle expression ('full of charm, "reality" and seduction, a perfect physique and pleasant manners') difficult to reconcile with violent thoughts and a stubborn character. They conclude that he is full of contradictions, '*both transparent and enigmatic*, rather like the pampas'.

'What they find particularly unpleasant and unbearable is that they can't figure out his IDENTITY in the flagrant (apparent) contradictions, between his spontaneous behaviour and the behaviour dictated by conscious thought.'[2] An example of this apparent contradiction is to be found in Ernst's attitude to 'nature': 'He is both cerebral and vegetable', identifying, on the one hand, with 'the god Pan and Papuan man' in a fusion with nature, and, on the other hand, with Prometheus, sworn enemy of nature. Ernst thus constructs his identity as the site of an unresolved tension, which he compares explicitly to the collage principle: 'similar to what happens when two very distant realities are placed together on a plane which does not suit them ... in the form of an exchange of energy provoked by that very bringing together'. And he ends his text with the programmatic: 'Transposing André Breton's thought, I conclude that IDENTITY WILL BE CONVULSIVE OR WILL NOT BE' (Ernst's capitalization). Not only is Ernst openly transposing Breton's closing words in *Nadja* (1928): 'Beauty will be CONVULSIVE [Breton's capitalization] or will not be';[3] there is also a second, unacknowledged appropriation of Breton, who had ended an article on Max Ernst's first Paris exhibition written in 1921 with the words: 'Who knows if, in this way, we are not on the point of breaking away from the principle of identity'.[4]

Max Ernst's invitation to his 1935 Paris exhibition, *Exposition Max Ernst – dernières œuvres,* is a photomontage based on a formal photograph of the artist taken by Man Ray.[5] Like the verbal self-portrait presented in *Instantaneous Identity,* this self-portrait is a double image, in a playful allusion to the alienation and fictional status of the mirror phase as described by Lacan. The photomontage enacts a radical questioning of the principle of identity through the formal subversion of the traditional studio photograph. The glass-plate negative of Man Ray's photograph has been smashed and the glass splinters stuck together with tape. This tape was then written on with india ink and the result exposed, so that the light-coloured tape has come out black and the writing white.[6] As a result, the face of the artist appears as if in a fractured mirror, and a text, giving the details of the exhibition and titles of some of the works exhibited, fills the cracks. Max Ernst is visibly parodying the traditional function of photography as a mimetic recording of reality, by shattering representation and forming a new reality with its splintered pieces; and, by focusing on the medium itself, he is challenging the claim that photography is an *instantané* or index of presence. In short, by exploding the mimetic claims of photography, fragmenting the face, and displacing the visual by the verbal, Ernst foregrounds the (self-)portrait as an artefact, presenting identity as a construct – split, fragmented, held together by writing – bringing together irreconcilable fragments in the manner of collage.

Like Max Ernst, the Surrealists explore through their texts and pictorial works the destabilization and splitting of identity, portrayed as a *locus* of contradiction, fragmentation and decentring. My discussion here will focus essentially on Surrealist photomontage portraits and self-portraits, with special reference to Ernst and Breton – although I shall also refer to other visual and verbal modes of production where the principle of deliberate assemblage is visibly inscribed.

The Dadaists had already parodied the genre of the portrait. Picabia's *Portrait of Cézanne, Portrait of Rembrandt, Portrait of Renoir; Still Lives* (1920) consists of a toy monkey stuck onto cardboard; Soupault's *Portrait d'un imbécile,* exhibited at the Salon Dada in 1921, is an eighteenth-century mirror; while Aragon's contribution to the same Salon was a *Portrait de Jacques Vaché,* made up of cut-out papers and dried leaves. In *Bloomfield-Dada-Chaplinist* (1921), Blumfield pastes a photograph of his head onto the postcard of a naked female body, in a parodic use of the popular fairground photograph. The term 'photomontage' itself was allegedly invented by the Berlin Dadaists, several of whom claimed paternity for the term. For Raoul Hausmann: 'This term translated our aversion at playing the artist, and, thinking of ourselves as engineers … we meant to construct, to assemble [*montieren*] our works.'[7] Many of these works are, in fact, photocollages, since the photographic fragments are pasted on the page or canvas rather

than processed.[8] The term 'photomontage' will be used here both for photomontage proper and for photocollage. It will be shown that photomontage is a privileged mode of portrayal of Surrealist identity, since, to use Ernst's words apropos of his identity, the medium is *both transparent and enigmatic* (Ernst's italics). It is a transparent medium, because of the apparent immediacy of the photographic mode; but it is also an enigmatic medium, since montage, by transforming reality, appears as a visibly coded discourse.

The Surrealists use the model of the formal studio or identity photograph in order to undo its role as a means for fixing identities by reproducing an external likeness. 'The principle of montage', writes Adorno, 'was supposed to shock people into realizing just how dubious any organic unity was.'[9] Hence, by manipulating photographic fragments on a single surface, the Surrealists question the principle of the unitary self – instantaneous identity – and expose identity as a construct, a site where conflicts, displacements and decentring of identity are staged. Moreover, we will see that, far from excluding or even transcending the external object, visuality as discussed by Breton, which aims to explore 'pure mental representation', often stages that object as external, both through the Surrealists' choice of visual phenomena taken from 'the external world', notably visual fragments as contingent and apparently meaningless as photographs, and through strategies of *détournement* of these fragments.

Identity staged as a dramatic conflict, notably as the reworking – or rather the conscious replay – of the Oedipal situation, is present in a large number of Max Ernst's works. In an early *Self-portrait* (1920), for example, a formal photograph of Ernst is combined with a second, smaller figure made up of the photograph of the bust of a woman onto which is pasted a head from an anatomical engraving.[10] The photograph is inscribed with Ernst's Dadaist name 'dadamax', while the *écorché* of the engraving is identified as 'caesar buonarroti'. The alternative title of this work, *The Punching Ball or The Immortality of Buonarroti*, probably a *fatagaga*[11] title or inscription given to it by Arp, indicates that this work is both a political parody and a re-enactment of the classic Oedipal scenario. The reduced father-figure is both lawgiver (Caesar) and artistic model (Michelangelo). The figure has been flayed (disfigured), feminized (given a female bust), cut up (castrated), ridiculed (in the grotesque montage of anatomical head and female bust), reduced to the subordinate role of the donor in a parody of early religious paintings, and objectified as an item of sports equipment. A political reading foregrounds the caricature of Kaiser Wilhelm, whose discredited rule was the object of many parodies in postwar Germany. (In 1920 John Heartfield enacted a similar dramatization in a self-portrait in which he represents himself with a pair of scissors, in the process of cutting up the effigy of the Berlin Chief of Police.) In Ernst's photomontage, in opposition

to the photographic mimeticism, and hence enhanced ontological reality of the son, who occupies the focal point of the composition, the father is displayed on the periphery, as an ungainly artefact, a two-dimensional puppet similar to a fairground effigy – its lower edge overlaps the bottom of the frame – propped up and prevented from toppling over the edge by the son. It is less a human figure than an object, a *cadavre* rather than a *cadavre exquis*. In a parody of the academic self-portrait, the palette and brush of the ideal or real father (Ernst's own father was an amateur painter) are replaced by the collage materials of the son's artistic activity. Ironically, these were learned from Ernst senior himself, for Max's first lesson in collage is said to have been watching his father paste the head of family members and friends on bodies of saints and angels in copies of old masters – or heads of Nietzsche, Calvin and Luther on the shoulders of the damned!

The visibility of the collage process in *The Punching Ball* is further underscored by the use of various media: photograph, engraving and text. We have already seen that the figures are identified by fictitious names. Moreover, to the right of the two figures a measuring line has been drawn, regularly notched and inscribed with the number 5000, held by a disembodied hand. These inscriptions break the mimetic continuum of the photograph by pointing to the image as an artefact, thus further destabilizing the role of the photograph as an index of reality. The immediacy of standard photography, based on its seamlessness (the photograph of Ernst), is coupled with the mediated discourse of photomontage, based on a visible juxtaposition of parts, involving fragmentation and hence the presence of seams or spacing, which articulate the sign. [12] 'For there to be a sign', writes Roland Barthes in *Camera Obscura*, 'there must be a mark; deprived of a principle of marking, photographs are signs which don't *take*' (Barthes's italics). [13] In photomontage the mark is foregrounded, thus articulating a double system of representation, where the immediacy of the photographic element is coupled with the mediacy of the sign – '*both transparent and enigmatic*'.

The ambivalence of Surrealist portraits, as both presence and sign, can be seen in Max Ernst's first collective portrait of the Paris group in 1922, *Au Rendez-vous des amis*. [14] Although an oil painting, it is based on the collage principle, visibly assembled from separate fragments which are not perfectly adjusted: there are discrepancies in scale and lighting, and the stiffness of the poses reminds us of the many fairground photographs of the Surrealist group taken around that time, such as those taken at the Montmartre fair where the group poses self-consciously in a cut-out plane or a car. Ernst used individual photographs as a model for each of these portraits; for example, the portrait of Desnos is based on a Montmartre group photograph. As in *The Punching Ball*, the viewer is made aware that s/he is looking at an artefact: numbers identify the members of the group

as in scientific diagrams. Into this painting, Ernst integrated images based on engravings from the science journal *La Nature*: the circular forms in the background above the figures, for example, are derived from an engraving of the haloes observed around the sun, turned on its side; the still-life arrangement in the lower left is based on another engraving from *La Nature*, a 'Bird's eye view of an underground fortress', while the knife and apple are taken from an illustration of a trick cutting of an apple, itself an allusion to the collage process. [15] Although each of the members is realistically depicted and immediately recognizable, their gestures – modelled on the gestures of sign language (Ernst's father was a teacher of deaf-mutes [16]), but also on the jerky movements and stiff poses of the insane (the visual model here being Kraepelin's group photographs of catatonic patients [17]) – defy interpretation. Thus, by processes of reification – language reified as gestures emptied of their significance in this painting; the figure of the father fossilized as a fairground dummy in *The Punching Ball* – the work challenges the doxa, the authority of the father or of coded language. At the same time it points to a new language in the enigmatic gestures and still uncoded signs of the future Surrealist group. [18] The dual status of the portrait as presence and sign is also explicated in Max Ernst's second portrait of the Surrealist group, *Au Rendez-vous des amis 1931* or *Loplop présente les membres du groupe surréaliste*. [19] It forms part of a series of some 70 collages produced in 1931–2, where the composite figure Loplop – as Max Ernst's *alter ego* – displays images on an easel or canvas. Loplop had made its first appearance in *La Femme 100 têtes* (1929), and Ernst identifies him as a 'personal phantom of exemplary faithfulness attached to my person'. [20] Ernst refers to the series as *papiers collés* rather than collages: the pasting process is visible and the components are made up of different media, in contrast with the collages produced at the end of the 1920s – notably *La Femme 100 têtes* – designed for reproduction, which were based on wood-engravings and where Ernst carefully masked the seams. In *Au Rendez-vous des amis 1931*, Loplop appears as a variant of the *cadavre exquis*: the collaged head of Loplop is visible in profile above the frame, while the photographic and engraved elements constituting the 'body' are made up of the portraits of the Surrealist group, and two schematic 'feet' appear below the frame. Ernst added a caption to the work identifying the individuals portrayed:

DESCRIPTION OF IMAGE OPPOSITE: From top to bottom, following the serpentine line of heads: whistling through his fingers, Yves Tanguy – on his hand, wearing a cap, Aragon – in the bend of his elbow, Giacometti – in front of a woman's portrait, Max Ernst – standing in front of him, Dali – to his right, Tzara and Péret – in front of the man in chains, his hands in his pockets, Buñuel – lighting a cigarette, Eluard – above him,

Thirion, and to his right, raising his hand, Char – behind the hand clos-
ing over Unik, Alexandre – lower down, Man Ray – then, immersed up
to his shoulders, Breton. On the wall there is a portrait of Crevel and
at the top right, turning his back, Georges Sadoul.

In his 'Description' Max Ernst directs the viewer's gaze in a serpentine
line from top to bottom, a visual structuring device repeated as a *mise-en-
abîme* in the cut-out image of the snake to the left of Eluard. Herta Wescher
interprets this work as an apocalyptic scene: 'Tanguy, Aragon and Alberto
Giacometti are being carried down from heaven by bodiless hands and
arms, while the heads of Breton and Man Ray slither up amidst worms
and serpents out of the water of a gloomy cave.'[21] For Werner Spies, the
snake is both a structuring device and the totemic figure of the Surrealist
group; he associates this work with the motif of the Last Judgement,
identifying the Surrealists with fallen angels.[22] Such readings indicate that
this work is not only a historical record of the contributors to the fourth
issue of *Le Surréalisme au service de la révolution*, but, more importantly,
a dramatic *tableau*. The artefactual character of the work is underscored
in the *ostensio* motif: the hand which points and demonstrates (as in the
illustrations in popular science journals such as *La Nature*) is also the hand
which cuts and pastes. Loplop the artist is visibly displaying, and his easel
or frame functions as a performative, a sign addressed directly to the
viewer. The play on different media – photographic print, contact print,
negative, engraving – serves to undermine the role of the image as simply
representational, and the simple, indeed simplistic, labelling offered by
Ernst clearly does not adequately account for the various components of
the montage. We recognize Gala behind Ernst – significantly, none of
the female figures is identified by Ernst in his description – but who is the
female figure behind Breton, or the woman behind Char who is repro-
duced in a negative print? Who is the tall man in chains and a helmet
towering over Buñuel? Ernst is also silent about the other photographed
or engraved scenes and objects juxtaposed with the portraits: the reptiles,
knives, an eyeball, a crowd scene, several hands, entomological plates.
Several of these signs can be deciphered by reference to the Surrealist
context. For example, the figure of Buñuel is pasted over a display of knives,
while a gigantic eye appears on the same level on the right of the photo-
montage, in an obvious reference to the opening sequence of Dalí and
Buñuel's *Un Chien andalou*. Georges Sadoul, an active Communist like
Aragon, is standing on the photograph of a crowd of workers, whose
heads are echoed in the engraving to the left where rows of dolls' heads
are lined up, taken from the illustration of a dolls factory in *La Nature*.[23]
The analogy between disembodied heads in the image of the masses and
the image of mass-production techniques can be read as a satirical com-

ment on workers' alienation. Yet many of the signs appear to invite a decoding, while resisting interpretation: why the entomological plates, the schematic engravings of reptiles? why all these hands, clenched, open or holding objects or heads? The hands in the upper left do direct our gaze towards the main part of the photomontage, but the hand above Tzara's head holding an insect-like form is enigmatic, as is the hand at the end of a reptile body holding a long stick-like object, and the hand hovering over the crowd of workers.[24] Severed from the body, they hover between the status of object and sign, indeed they appear to function as signals rather than signs, both promising yet withholding meaning. And this very resistance to meaning is linked to their strong presence *as* objects, a quality which Breton emphasizes in his introduction to Ernst's *La Femme 100 têtes*: 'one can, naturally, go so far as to estrange a hand by isolating it from an arm, foregrounding the hand as a hand'.[25] The viewer is faced with the existence of photographs as an index of reality, a reading suggested by Max Ernst's caption identifying the various members of the Surrealist group, and as potential signs, which function as destabilizing factors, not only by challenging the mimetic role of photography, but also by drawing the viewer's attention to details in a decentring process. Identity is not a simple labelling, it is a questioning, a riddle or rebus, where subject becomes object, and the photographic portrait, using photomontage techniques, framed by the easel, and foregrounded by the 'Loplop présente' motif, hovers between presence and sign.

The role of the photographic portrait as a nomadic sign, whose meanings are determined by its various contexts, can be seen in the recycling, and often satirical *détournement*, of such images. For example, the photograph of Breton in the photomontage of the Surrealist group assembled around Magritte's painting of a naked female figure, inscribed with the words 'Je ne vois pas la … cachée dans la forêt' (published in 1929 in *La Révolution surréaliste*), was used in the 1930 pamphlet *Un Cadavre* (itself an appropriation of the Surrealists' 1924 *cadavre* on Anatole France) signed by Georges Ribemont-Dessaignes and Georges Bataille, amongst others. A crown of thorns and drops of blood have been added to the original photograph, producing a satirical comment targetting the leader of Surrealism. In Valentine Hugo's group portrait of the Surrealists, *Surréalisme* (1934), the head of Breton – the same head that seems to emerge from the waters of the unconscious in Ernst's *Loplop présente le groupe surréaliste* – is repeated three times, once enlarged in the centre, surrounded by the portraits of the Surrealists, with two smaller versions, floating on cut-out paper shapes on a dark ground. Hugo appears to elevate Breton's image among the saints, surrounding it with halo-like paper cut-outs as in popular iconography, indicating here a clearly laudatory intention, in contrast to the 1930 *cadavre*.

This photograph of Breton had first appeared in *Nadja*. 'Who am I? ... Is it not all a matter of whom I "haunt"?' (p. 647), asks Breton in the opening lines of this text, which is a montage of disparate discourses (diary, dream accounts, polemics, photographic illustrations) in which he records the signs (persons, places, events and dreams) that compose his identity. Breton thus presents the haunting self as a nomadic identity determined by the hidden palimpsest of the city, its libidinal forces, its enigmatic signs and chance encounters. A few pages before the end of *Nadja*, he includes a studio portrait of himself (p. 745). Yet, far from fulfilling the traditional function of the photographic portrait as an index of reality and a key to identity, and thus providing an answer to the opening question, this photograph is as enigmatic as the earlier shots of empty Paris streets and squares, or Nadja's own drawings. Just as the photographs of Paris do not uncover the hidden topography of the city, so the formal photograph of Breton, mask-like, appears to deny access to his identity. Subjectivity is encoded in the signs of the city, whether in shop signs such as 'Bois et charbons' or the pointing hand, constantly displacing and destabilizing the writer's identity, reformulating it through the encounter between an inner desire and an outer reality. The photographic portrait, read in the context of *Nadja* as a montage text, hovers in an indeterminate space, between iconic likeness and enigmatic sign, recalling an early self-portrait by de Chirico (1911) painted in the traditional style of the Renaissance nobleman portrayed in profile, and inscribed on the frame with the words (in Latin): 'What shall I love if not the enigma?' As Michel Beaujour concludes: 'there are signs, then, in the "dumb" photographs [in *Nadja*], which may be read if they are taken in conjunction with the text. And yet they can never be fully "interpreted".'[26]

The question 'who am I?' displaces the focus from fixed identity to fluctuating signs, from metaphorical identification to metonymical displacement. This kind of decentring of identity is sometimes evoked through the metonymical series or list, such as that presented by the Loplop collages. In his *Design for an Exhibition Poster* (1921), which can be considered formally as a proto-Loplop montage, Ernst has combined a photograph of himself with 'samples' of some of his works, to create a mask-like shape.[27] He includes a text (in German) which reads: 'Exhibition of Painting. Drawing. Fatagaga. Plastoplastik. Watercolour. Max Ernst is a liar, legacy-hunter, scandalmonger, horsedealer, slanderer, and boxer.' An equally arbitrary listing of attributes is also included in Marcel Mariën's *Self-portrait*, where a photograph of Mariën is combined with the photograph of a parrot and a *curriculum vitae* consisting of a long list of adjectives:

Distinguished – seedy – young – sinister – dressed – crippled – proletarian – cheerful – slovenly – solitary – moustached – brutal –

happy – dirty – slow – lazy – lecturer ... – smoker – believer – marxist – fertilized egg. [28]

This is clearly a parody of a police identikit portrait, evoking identity through an open-ended inventory which articulates contradictory qualities – arbitrary fragments listed in a constantly decentring process. Another playful example of the portrait as an open-ended amalgamation of features is seen in the portrait game played by the Birmingham Surrealist group – Conroy Maddox, John and Robert Melville. The following 'portrait' of Maddox is an example of this collective text:

> I hope Conroy goes home too
> They say he's made of ectoplasm
> He's nice really
> He's a surrealist incarnate
> Surrealist, my arse!
> That's why he has a moustache
> But it's all mixed
> With his cardboard wrist
> His whimsical smile. [29]

These catalogues of autonomous details are similar to a constantly proliferating *cadavre exquis*, or to the part-bodies which people Surrealism. Far from forming a unitary identity or a complete portrait, they are autonomous fragments, a collation of units rather than a finished configuration.

A similar mode of decentring can be seen in Joseph Cornell's object-boxes. In two of his works he combines Man Ray's solarized portrait of Breton with objects – a postage stamp, an owl, or a cut-out photograph of a diamond-shaped rock-crystal. According to Martine Antle, these objects, evoking travel and the exploration of the unconscious, 'serve to decentralize the space that Breton's figure occupies'; the box becomes a theatrical set where the portrait of Breton appears to be reduced to a prop. [30] The combination of signs and indexes in the theatrical setting of the box, similar in function to Loplop's easel, destabilizes the ontological reality of the photograph by displacing the subject from its position as the focus of the composition.

Breton's own photomontage *L'Écriture automatique* (1938) can also be read as a cross between portrait and theatrical *tableau*. [31] Similar in construction to the stylized tableaux of nineteenth-century melodrama, where the protagonists are portrayed striking exaggerated poses, theatricality is encoded in the highly artificial poses (Breton in the guise of a scientist alongside his microscope) and expressions (the fixed smile of the woman). In melodrama, these momentarily frozen scenes are intended to give a

clear visual summary of the narrative situation, the objective being to make signs transparent and hence immediately legible.[32] In this photomontage, however, there are no obvious links between the figure of Breton, the female figure behind bars and the microscope on the table. Rosalind Krauss reads this work in the manner of a rebus, both as a *mise-en-scène* of the automatic process where the microscope as a lensed instrument is used as a metaphor for automatic writing – 'the photography of the mind' (Breton, 1921) – and as a *mise-en-abîme* of writing, where photographic fragments become signs, transforming reality into representation.[33] Yet it seems to me that we are looking at objects which resist this reductive reading: Breton's head, disproportionately large in relation to his body, is the head of the scientist-poet actor of a dramatic tableau; but it is also a 'dumb' index of reality, both presence and sign. Like John Berger, I would argue that 'the peculiar advantage of photomontage lies in the fact that everything which has been cut out keeps its familiar photographic appearance. We are still looking first at *things* and only afterwards at symbols.'[34]

A similar staging of the self is explored in Man Ray's *Self-portrait*, which appeared as the frontispiece to the Surrealist journal *Minotaure*, 3–4 (December 1933), a rare example of the use of photomontage by Man Ray. It consists of a plaster bust, surrounded by several of the artist's works: a hand holding a lightbulb, a round prismatic form from which a hand emerges, the photograph of a woman's eyes with artificial tears, entitled *Tears*, and a child's bilboquet. The self, displayed/displaced as a plaster bust, is presented on a plinth among other objects, arranged like stage props. The formal echoes – the round head repeated in the ball, lightbulb, tears, bilboquet and eyes – detract from the role of the head as a posing subject and underscore it as an object among others. The eye of the viewer is distracted from the bust, although it is placed at the centre of the composition, onto the objects arranged around it. Self-identity appears displaced in the objects around it or in the artist's works, as in the Loplop series. And whereas *L'Écriture automatique* enacts the passage from portrait to theatrical tableau, Man Ray's *Self-portrait* is situated between portrait and still life: the portrait becomes a table or stage, where the head, objectified or petrified as a plaster bust, merges with the objects around it, and, through this levelling process, it relinquishes its status as the compositional focus.

Enter the self as other, located between the stage and the table top, mediated through the enigmatic objects of a still-life. In de Chirico's *Self-portrait* (1913) – reputedly the first portrait in Western art not to be a representation of the sitter – disparate elements are arranged on a stage-like construction suspended in space: two plaster feet, an egg, a roll of paper, a proscenium wall where the sign X is inscribed, signalling the absent body, the invisible corpse. Many of Dalí's portraits, such as his *Paranoiac*

Metamorphosis of Gala's Face (1932), are pure artifice, the Arcimboldo principle exploited to excess in arbitrary constructs. [35] In the Surrealist quest for a multiple identity or the 'soluble I', the individual often merges with the anonymous, where the self as the locus of a coherent identity is displaced or dissolved in the other.

In their exploration of self-identity, the Surrealists experience the double limits of the self, as the multiple other dissolved in anonymity and as the reified self in the mask. This anonymity is enacted in the ambiguities of Max Ernst's *Loplop Presents the Postman Cheval*. [36] An anthropomorphic shape is suggested in the head, the bow-tie, the blue rectangular torso, and the feet. The schematic form is both a figure and an amalgam of diverse media and objects – grattage, cut-out engraving (the coral shape), line-drawing, photograph, postcards. Facteur Cheval is present only by synecdoche in the envelope held by the Loplop figure. The peep-show motif is humorously encoded in the dirty postcard peeping out of the torn see-through envelope, and in the young girl visible through the peep-hole of the torso, none of which appears to refer to the Facteur Cheval at all.

Such photomontage portraits, by foregrounding the manipulation of images, overtly acknowledge and exploit the portrait genre as a fictional construct. 'Thanks to the painter the face remains unseen', writes Max Ernst (*Écritures,* p. 367). Far from being the central posing subject, the self is constantly displaced in strategies of decentring, doubling or erasing. The Surrealist portrait thus often becomes the site of an uncanny identification of the self with the other. In such deliberately artificial *mises-en-scène*, the photographed face itself becomes a mask, as in the photograph of Breton in *Nadja*, or in Duchamp's transvestite pose as *Rrose Sélavy*. In Man Ray's *Portrait of André Breton* (1930), Breton, wearing aviator's goggles, has his face framed by a white paper rectangle, which gives it a mask-like quality, as does Man Ray's later photomontage of Breton, where the face is pasted onto the Statue of Liberty, in yet another parodic use of the popular fairground photograph. [37] Bataille contrasts the harmony of 'the open face', which communicates the stability of the established order, with the mask, which conveys the absence of certainty and the threat of sudden changes. [38] In these photomontages the familiar face, projected into an alien context, is destabilized as a recognizable entity, endangering the order of a stable identity.

It would seem that the search for the self – 'who am I?' – is thus constantly displaced as a search for the other – 'whom do I haunt?' – and this no doubt explains why Surrealist writers and artists often elect hybrid creatures as their *alter ego*: if Loplop Bird Superior has been seen by some critics as the artist's miniature super-ego, [39] cataloguing and framing the artist's samples, some bestial others mark the surfacing of the id – Breton's soluble fish or Dali's soft grasshopper, Picasso the minotaur – as the outer

limits of an *informe* identity. Through these staged hybrid identities, the self is displayed as a convulsive being, in figures articulating both self and other, the self within the other or the other within the self, a process best exemplified by the hermit crab in *Les Champs magnétiques*, which occupies empty shells, thus prompting the question of its identity: 'In this simulated hybrid', writes Philippe Audoin, 'who is the *I*, who is *the other*?'[40]

Identity is the stranger within, undoing the automaton portrait, the social face. In Latin, *persona* – both person and mask – is linked to the verb *personare*: '*Là est* persona *où Ça sonne à travers; et devient ainsi Moi*' (Bril's italics), writes Jacques Bril.[41] Hence, no doubt, the question that Breton asks at the end of the second part of *Nadja*, reformulating his opening question: 'Who goes there? Is it me alone? Is it just me?' (p. 743). Thus, from the haunting self, seeking a point of convergence, that of objective chance, between the signs of the city and personal desire, the focus is displaced in the constant decentring or mediation of identity, via the shattered surfaces of photomontage, the shifting representations of Loplop, the synecdoches of the identikit portrait, the mythical identifications with the god Pan, Papuan man or Prometheus, or the arbitrary combinations of the mask.

Finally, the Surrealist (self-)portrait is an equivocal space, situated between the melodramatic stage where Oedipal conflicts are self-consciously enacted, and the still-life table where the face becomes an object among others. In their portraits the Surrealists often preferred to manipulate the socially coded face by strategies of disjunction and displacement rather than create the irretrievably other. Max Ernst may well have identified with Pan and Papuan in a Dionysian participation with the other; yet it is significant that he also identifies with Prometheus who, through conscious strategies, appropriates the fire of the gods, in an act of defiance of the other. The convulsive identity that he constructs from these conflictual selves does not transcend the cracks in the mirror, the oppositions are not resolved in a dialectical flourish, as Breton would have it. Surrealist identity is apprehended and articulated *as* conflict. It remains both contingent *and* opaque, '*both transparent and enigmatic*'.

Notes

1. Max Ernst, 'Identité instantanée', in 'Au-delà de la peinture', *Cahiers d'art*, 14 (1936); also in *Écritures* (Paris: 1970), p. 267.
2. *Ibid.*
3. André Breton, *Œuvres complètes* I (Paris: 1988), p. 753.
4. *Ibid.*, p. 256.

5. *Cahiers d'art* 13 (May 1935). Reproduced in Werner Spies, *Max Ernst. Collages. The Invention of the Surrealist Universe* (London: 1991), fig. 533.

6. Jürgen Pech, 'Mimesis und Modifikation. Fotografische Portraits und ihre Verwendung im Werk von Max Ernst', in *Max Ernst. Das Rendez-vous der Freunde* (Cologne: 1991), p. 267.

7. Raoul Hausmann, quoted by Dawn Ades, *Photomontage* (London: 1986), p. 12.

8. 'The most significant contribution of the Berlin [Dada] group was the elaboration of the so-called photomontage, actually a photo-collage, since the image was not montaged in the dark room.' Walter Rubin, *Dada, Surrealism and their Heritage* (New York: 1968), p. 42.

9. Theodor Adorno, *Aesthetic Theory*, tr. C. Lenhart (New York and London: 1984), p. 223.

10. Reproduced in Spies, *Max Ernst. Collages*, fig. 152.

11. 'FAbrication de TAbleaux GArantis GAzométriques', collective collages made in Cologne in 1919–20 by Ernst, Hans Arp and Johannes Baargeld.

12. Rosalind E. Krauss, 'Photographic conditions of surrealism', in *The Originality of the Avant-Garde and Other Modernist Myths* (Cambridge Mass. and London: 1986), p. 106.

13. Roland Barthes, *La Chambre claire. Note sur la photographie* (Paris: 1980), p. 18; translated as *Camera Obscura*, tr. Richard Howard (London: 1993), p. 6.

14. Reproduced in Spies, *Max Ernst. Collages*, fig. 220.

15. See analysis of *Au Rendez-vous des amis* by Charlotte Stokes, 'The scientific methods of Max Ernst: his use of scientific subjects from *La Nature*', *Art Bulletin* 62, 3 (September 1980), pp. 453–65.

16. See Werner Spies, *Die Rückkehr der schönen Gärtnerin. Max Ernst 1950–1970* (Cologne: 1971), p. 136.

17. See Elizabeth M. Legge, *Max Ernst. The Psychoanalytical Sources* (Ann Arbor and London: 1989), p. 150.

18. According to M. E. Warlick, Ernst has portrayed the group as pursuers of hermetic knowledge, under the sign of Mercury, protector of the arts: Crevel represents music, Dostoievsky literature, de Chirico sculpture, the trick-cut apple geometry, and the solar halo astronomy. M. E. Warlick, 'Max Ernst's alchemical novel: *Une Semaine de bonté*', *Art Journal* 46 (Spring 1987), pp. 61–73.

19. Reproduced in *Le Surréalisme au service de la révolution* 4 (December 1931), 37.

20. Ernst, *Écritures*, p. 247.

21. Herta Wescher, *Collage*, tr. Robert E. Wolf (Abrams, New York: 1968), p. 204.

22. Spies, *Max Ernst. Collages*, p. 242.

23. *La Nature* 771 (10 March 1988), p. 232.

24. A similar juxtaposition of portraits and apparently unrelated objects, including an entomological plate, is present in Breton's photomontage for the cover of *De l'humour noir* (Paris: 1937).

25. *Œuvres complètes* II (Paris: 1992), p. 305. Breton had already been struck by the presence of photographed images in the early photocollages of Ernst's who used 'elements endowed in their own right with a relatively

independent existence – in the same sense that photography can evoke a unique image of a lamp, a bird or an arm'. *Surrealism and Painting*, tr. Simon Watson Taylor (London: 1972), p. 26.

26. Michel Beaujour, 'Qu'est-ce que *Nadja?*', *La Nouvelle Revue française* XV, 172 (April 1967), p. 791.

27. Spies, *Max Ernst. Collages*, fig. 46.

28. Marcel Mariën, *Auto-portrait*, *Opus International* 123–4 (April–May 1991), p. 216.

29. Michel Rémy, *Le Mouvement surréaliste en Angleterre. Essai de synthèse en vue d'une définition du geste surréaliste en Angleterre*, 2 vols., Doctorat d'État (Université de Paris VIII, 1984), vol 2, p. 1478.

30. Martine Antle, 'Portrait and Anti-Portrait: From the Figural to the Spectral', in Anna Balakian and R. Kuentz, eds, *André Breton Today* (New York: 1989), pp. 46–58.

31. Reproduced in Ades, *Photomontage*, p. 114.

32. Breton's photomontage of Paul Eluard, *Nourrice des étoiles* (1935) is another example of the portrait as a theatrical *mise-en-scène*, based on a rebus; here the pun on the milky way ('La voie lactée'), is humorously encoded in the row of milkbottles above Eluard's head and in his jacket, made from a cut-out from an astronomical chart.

33. Krauss, 'Photographic conditions of Surrealism', pp. 102–3.

34. John Berger, *Selected Essays and Articles: The Look of Things* (London: 1972), p. 185; quoted by Ades, *Photomontage*, p. 48.

35. The portraits of Arcimboldo (1527–93) are made up of composite images related, for example, to a trade or a season. Similar composite images were reproduced in *La Nature* in Gaillot's lithographic series *Arts et métiers*, where the head is made up of objects relating to a particular trade; see Werner Spies, *Loplop. The Artist's Other Self* (London: 1983), p. 111.

36. Spies, *Max Ernst. Collages*, fig. 75.

37. Cover design for *Young Trees Secured Against Hares – Jeunes cerisiers garantis contre les lièvres*, tr. Edouard Roditi (New York: 1946).

38. Georges Bataille, 'Le Masque', *Œuvres complètes* II (Paris: 1970), p. 403.

39. Spies, *Loplop*, p. 80.

40. Philippe Audoin, Preface to André Breton, *Les Champs magnétiques*, (Paris: 1971), p. 18; italics in original. Audoin is referring to the text 'Le Pagure dit'.

41. Jacques Bril, *Le Masque ou le père ambigu* (Paris: 1983), p. 183.

Max Ernst and Surrealism

Malcolm Gee

The aim of this essay is to examine key features of Max Ernst's involvement with the Surrealist project. It will suggest that, while in many respects he was the 'complete Surrealist artist', there were some ways in which his particular concerns might be said to have taken him beyond this project.

In the *Dictionnaire abrégé du surréalisme* (1938) Eluard identified Ernst as a 'Surrealist painter, poet, and theorist from the origins of the movement to the present day'. This sums up Ernst's quite distinctive position as a painter associated with the Surrealist group. He had been present and active in the circle of Parisian Dadaists who created the movement, and in the mid 1930s he remained a member of this circle, even though he had not participated in all its manifestations. His art had been exhibited and discussed in the context of the movement's activities throughout its changing orientations, and it could be demonstrated that he had actively responded to the evolving creative doctrine of Surrealism in relation to the visual arts. In his case the delicate relationship between word and visual image was attenuated by the ability to mix the two modes, and a relative indifference to the claims of 'plasticity' (the principle appealed to by critics like Maurice Raynal, who condemned the Surrealist influence on art in the late 1920s). Moroever, he had, repeatedly, set out to clarify in writing in Surrealist publications the theoretical basis from which he worked and which he claimed to be in accordance with the principles of the movement. In 1927 he had released his first account of the childhhood memories which constituted the basis of his personal artistic 'myth': 'Visions de demi sommeil', published in the magazine *La Révolution surréaliste,* issue 9–10 (October 1927); in the final issue of *Le Surréalisme au service de la révolution* (May 1933) he published an extract from a so-called 'Traité de la peinture surréaliste' – 'Comment on force l'inspiration'; shortly after this he provided a full survey of his work and ideas in a special issue of *Cahiers d'art,* entitled 'Au-delà de la peinture'. As Werner Spies has argued, it is evident that the latter publications were in part motivated by Ernst's wish to establish his own claim to a Surrealist identity and the anteriority of this position, in the face of Dalí's initially successful campaign

to postulate himself as the Surrealist artist *par excellence*.[1] He had, of course, also made two specific homages to the Surrealist circle: in 1922, with the painting *Au Rendez-vous des amis,* and in 1931 in the collage *Au Rendez-vous des amis 1931* (or *Loplop presents the Surrealist group).* It could be said that, the first case, he was laying out a pantheon of the new order, and, in the second, he was reiterating his participation in a group that was undergoing a difficult period of transition.

In 'Comment on force l'inspiration' (published in the sixth issue of *Le Surréalisme au service de la révolution*), Ernst sets out to explain that visual art, and his above all, does conform to the key demands of the Surrealist project, as laid out in the first manifesto. He explicitly dismisses Naville's argument that a visual equivalent of automatic writing is impossible and argues, citing Breton and Lautréamont, that 'techniques, some of which, in particular collage, were employed before the coming of Surrealism, but systematised and modified by it, have allowed certain artists to fix on paper or canvas the stupefying photograph of their thought and their desires'. While acknowledging Dalí's contribution, (implicitly) by mentioning the significance of the Surrealist object, and by referring to his theory of the paranoiac image, he suggests that his practice of collage had led to an earlier form of the 'multiple image'. By 'passively transcribing that which sees itself in us', banal found images were transformed into 'a drama revealing our most secret desires'. And he introduces his final section on frottage by placing it directly under the aegis of Breton and the 'details concerning the mechanism of inspiration found in the Manifesto of Surrealism'. These arguments are repeated and developed in 'Au-delà de la peinture', where they are integrated into an autobiographical catalogue which further reinforces Ernst's claim to be the first and the most consistent practitioner of a Surrealist art form. Here, he explicitly equates frottage with automatic writing:

> in the same way that the role of the poet, since the famous lettre d'un voyant, consists in writing under the dictation of that which thinks itself (articulates itself) in him, the role of the painter is to trace and project that which sees itself in him ... In devoting myself more and more to this activity, which later was named 'paranoia-critical' and in adapting the methods of frottage to painting ... I managed to be present like a spectator at the birth of all my works, from the 10th of August 1925 onwards.

He even sets out, in a footnote, a typology of Surrealist art of which one aspect – which we would term dream painting – was established by himself between 1921 and 1924, prior to the invention of frottage. (Interestingly, he makes no mention of André Masson here.) And he ends the text by

adapting Breton's famous phrase from *Nadja* to a description of himself: 'identity will be convulsive or will not be' – Max Ernst, in his own person, then, is the embodiment of the marvellous, irrational, Surrealist collage principle.[2]

It is also clearly the case, as he himself suggests, that the current thinking in the group was a key influence on what he actually did at a number of crucial moments. On returning from the Far East, in the autumn of 1924, to find the Surrealist movement constituted, he apparently embarked on a number of experiments which were attempts to accentuate the 'automatic' character of his work. In October he brought in to the 'Bureau de recherche surréaliste' a drawing made on a long scroll 'made according to the Surrealist method'.[3] In due course he developed the frottage practice as a personal version of automatic drawing. This and its painting equivalent dominated his work in the mid-1920s. When in 1929 he reverted to collage in the form of the 'novel' – *La Femme 100 têtes* – he was in part responding to the challenge to his position constituted by the Dalí phenomenon and to the renewed radical posture of Breton and his colleagues. Compared to his paintings of the late 1920s, Ernst's novels are more subversive, both in relation to the concept of *metier* and in terms of their subject matter. For the first time, virtually, his work could be said to be explicitly social, and, so, political. Finally, when in the late 1930s he experimented with decalcomania, this too was partly in response to Breton who was then attempting to revive the concept and practice of automatism and who had enthused over this technique, in particular in 1936 and 1939 in the journal *Minotaure*, having pointed out that the earlier automatic procedures of both Ernst and Dalí had been less than complete.[4]

Ernst therefore projected himself as a Surrealist artist and sought to make his work conform to the evolving definition of what Surrealist art might be. I should add that the work he produced substantiated his claims in many ways. It defied normal rational comprehension; it displayed images of a new and startling kind; it deployed a splendid insolence towards artistic orthodoxy; it focused on the metaphorical embodiment of desire; it defied both narrative 'closure' and aesthetic self-sufficiency. He had even, in the collage-novel, developed a mode of representation characterized by an interconnected sequence of multiple images which could be said to answer the issue of the flow of thought in 'automatism' – one of the problems raised by Max Morise in 1924 in relation to the question of a possible Surrealist art.[5] Indeed, as Breton's texts on his work implicitly acknowledge, Ernst had, from 1921 onwards, played a major part in showing him and his friends what Surrealism might mean as a visual practice.

However, arguably, there are a number of important features of Ernst's work that are not fully subsumed by this Surrealist identity. Two things are worth remarking about his self-presentation in *Cahiers d'Art* in this context.

First, there is a predominance in the illustrations of his early work from 1919–24. While, on the one hand, this served to emphasize his position as leader and indeed precursor of Surrealist art, it also underlined the specificity of his origins and preoccupations, stemming from the period of Cologne Dada and his interaction with Baargeld and Arp, both of whom are included among the 'friends' of his 1922 picture. Second, this account, like the earlier 'Visions' and the later 'Some data on the youth of M.E. as told to a young friend',[6] is largely informed by the rather extraordinary project of constructing a personal myth, in which the protagonist himself becomes an artist, like Leonardo da Vinci as imagined by Freud, as the result of childhood trauma and a distinctive resolution of the Oedipal conflict. While in many respects this myth has an entirely Surrealist character, the insistence with which Ernst returned to it again and again, and the careful control he excercised in both its construction and its mobilization in his painting, were indicative of a very distinctive artistic egotism which set him apart.

As has been now thoroughly, but not exhaustively, documented – indeed it is probably impossible to do so – Ernst's work was partly constructed from carefully chosen sources, some of them visual and some literary and intellectual. The latter included Freud. It is clear that Ernst had an extensive and detailed knowledge of Freud's writings, including some case studies as well as *The Interpretation of Dreams*, and the *Introductory Lectures*. There is some disagreement as to the significance of this. Werner Spies, who was the first to explore this territory fully, has suggested that Ernst used Freud's work as a sort of modern *Metamorphoses*, a source of poetic myth to be drawn on at will, and is resistant to the idea that he was interested in the 'latent content' of the dream images he produced. For him, the urge to interpret Ernst's work through the identification of either intellectual or visual sources is an – albeit understandable – error.[7] This is a fundamental and complex issue, which this essay will not seek to resolve. What is important in the present context is to note the self-consciousness and deliberation that Ernst brought to both making and presenting his work. In a fascinating study, David Hopkins has shown the communality and interaction between Ernst and Duchamp, notably in their use of alchemical and Rosicrucian imagery as a subversive structuring device for making art.[8] The element of detachment and control which Ernst excercised in his œuvre is not, I would suggest, fully compatible with the Surrealist project – it certainly poses problems in relation to the concept of 'pure psychic automatism'.

In 1922 Ernst represented himself as a member of the Surrealist circle of 'friends', and in 1931 his *alter ego* Loplop 'presented' the Surrealist group. This artistic assertion of his affiliation to Surrealism, which was reinforced by contributions to Surrealist reviews and participation in group

exhibitions, does not mean that he was always entirely at ease with this connection to a self-proclaimed group. For him, indeed, Surrealism perhaps meant above all friendship with Eluard, rather than a principled community. He vividly recalled, after his death, Breton's opposite position, involving the sacrifice of friendship to the cause.[9] Ernst was not temperamentally suited to disciplined group activity, and, beyond that, although he worked at overcoming it, he had the difficulty of being a painter. This meant, on the one hand, that at times, for instance in the latter part of the 1920s, he was involved in the 'banal' business of producing for a living, having one-man exhibitions and responding to a wider public than a tiny network of initiates, and, on the other, that he necessarily engaged with specifically artistic concerns. While this was always with a suitable irreverence for aesthetic or moral norms, it was another matter which set him somewhat apart. An aspect of this phenomenon was his very particular attitude towards the history of art.

Many of Ernst's works seem to present an ironic, often comic, reworking of the art and iconography of the art of the past. There is, however, frequently an element of respect in his treatments – his fascination with Leonardo was partly an assertion of affinity with a driven, but cerebral, painter and theorist, comparable in this respect to himself. And his appropriation of imagery from Hans Baldung Grien is, surely, a homage to a master who had grasped, consciously or intuitively, the artist's power to project onto the natural world the instinctual drives that are central to human experience. It is interesting, in this context, if somewhat perilous, to consider Ernst's declared 'favourite artists from the past',[10] in the light of his close acquaintance with the discipline of art history – he had practiced it as a student in Bonn between 1910 and 1914, he had married an art historian, and had another in the family, his sister Loni.[11] Of the artists he cited in the American periodical *View* in 1942, four (Seurat, Van Gogh, Rousseau and de Chirico) are recent. The sixteen others all lived between 1397 and 1569. In terms of geographical origin they are divided between Italy and Northern Europe (Germany and the Netherlands) in a proportion of nine to seven. While many of Ernst's choices would concur with those of a French Surrealist interested in the visual arts – Bosch and Brueghel, obviously, Uccello and Piero di Cosimo, probably – it is also the case that his selection could be seen as fairly typical of a young German art historian of the time, reflecting the long-held Northern fascination with the harmonious clarity of Italian Renaissance painting, on the one hand, and a growing interest in the distinctive values of early German art on the other.

Paul Clemen, the professor of art history at Bonn when Ernst and Luise Strauss were students, was a specialist in German art (particularly of the architecture and sculpture of the Rhineland) and he offered courses in it as well as typical survey courses on Italian art: Ernst followed some of

both. [12] Early twentieth century German studies of Northern Renaissance art emphasized two aspects: the persistence of pre-Renaissance thinking and style, given a very positive gloss, as, for example, in Hanna Closs's *Magie und Naturgefühl in der Malerei von Grünewald, Baldung Grien, Lukas Cranach und Altdorfer* (Bonn, 1936), and the emergence it revealed of a national cultural identity. 'The world historical meaning of German thought and art', wrote F. Burger in 1913, 'lies perhaps less in the distinctive way in which it adapted the culture of the Italian Renaissance than in the further development and completion in it of the great ideas of the Middle Ages, through an ever more strongly growing national spirit.' [13] This was a very ideologically loaded reading at the time, of course, and one with an even more dangerous resonance in the 1930s. In a speech in 1936, entitled 'Italian Art and us', Paul Clemen acknowledged that the German love of Italian Renaissance art could be seen as an undermining danger to German art. However, he concluded that Italian art fulfilled an inner need for German intellectuals, and that immersion in it in fact allowed one to see one's own art better. [14]

The suggestion here is that this pattern of historical reflection constituted a distinctively German conceptual matrix, on which Ernst drew as one of the multifarious methods that he developed to select and structure his source material; that he, in a sense, appropriated the material which related to it to provide his own personal, subversive, gloss on it. While it is possible to see his treatment of Italian sources as a satirical rejection of the Italian Renaissance in favour of the more Romantic art of the North, it is more accurate to say that the 'Ernstian' reading of the North–South polarity, like that of the art historical establishment, saw virtues in both. Clearly, Ernst admired Bosch and Baldung Grien for their visionary qualities and the sense that their work conveyed of the power of irrational, even occult, forces: Cranach for his eroticism; and Altdorfer for his representation of the mesmerizing qualities of the natural world. On the other hand, his work often incorporates features reminiscent of that clarity and desire to control the visual perception of the world that was commonly considered a property of Italian art. He sometimes employed the perspective systems of Uccello and Piero della Francesca for burlesque effect, as, for example, in the lost painting *The Immaculate Conception* (c. 1922), but even here there is, arguably, a homage to the hallucinating possibilities of this technique. Elsewhere, notably in the murals for the Eluard home at Eaubonne of 1923, the traduction of the 'limpid' qualities of quattrocento painting is more direct. The clarity of Piero's painting, in particular, is astonishing: the effort and system employed to construct a satisfactory representation actually generates an eerie character to his images. Ernst, I would suggest, found this interesting, and sometimes sought to emulate this effect.

4.1 Piero della Francesca, *The Raising of Judas*, 1452–9, from mural cycle *The Legend of the Holy Cross* in the Church of St Francis Arezzo (Photo: Alinari-Giraudon)

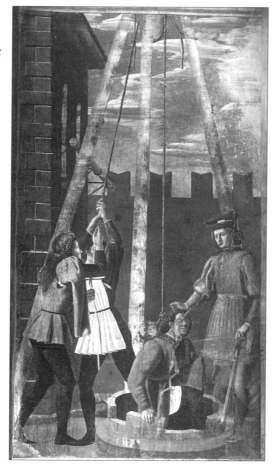

Ernst's 'favourite artists' indicate a slight disposition towards the fifteenth rather than the sixteenth century in Italian art, towards a period of discovery rather than consolidation, and of transition in knowledge of both art and philosophy. It includes two key figures from the School of Ferrara – Cossa and Tura – whose work, arguably, exemplifies these features. It is just possible that Ernst was aware of a particular analysis of the relationship between Renaissance art and the medieval tradition, which had helped to make the reputation of its author Aby Warburg, who had himself studied art history at Bonn in the 1880s. In a celebrated presentation to the International Congress of Art Historians held in Rome in 1912, Warburg had argued that, in the mural decorations at the Palazzo Schifanoja in Ferrara, Cossa and his colleagues and advisers had visually negotiated the relationship between classical culture and its translation,

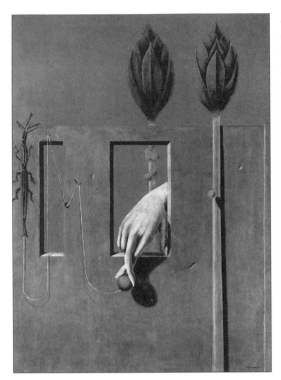

4.2 Max Ernst,
Au premier mot limpide,
mural from the Éluards'
bedroom at Eaubonne,
1923
(© SPADEM / ADAGP,
Paris and DACS, London
1996)

inherited by the medieval world, into an occult, magical world view. By juxtaposing the antique gods and the 'decans' which had incorporated them into an astrological system, the cycle of pictures exemplified the complex history of iconographic motifs, and also displayed the recovery of classical reason in the Renaissance period.[15] Here I may very well be succumbing to the classic error of over-interpretation, but I do not think it is merely fanciful to suggest that Warburg, the omnivorous iconographer, fascinated by astrology and magic, but committed to a classical-humanist ethical and philosophical position, represents a model of intellectual enterprise in relation to the visual arts which Ernst to some extent inverted. He, too, was a tireless consumer of visual signs, including those of the past, but he did not construct a model of interpretation for them in which Hellenic reason and order triumphed, because he could not identify them with the 'good'. Rather, in his system, rationality, the ability to reflect and analyse, became instruments for the discovery and revelation of the irrational, understood in entirely libertarian terms.

This brings us back to the theme of Ernst and Surrealism. The distinction suggested here between Ernst the 'ideal' Surrealist on one hand, and Ernst

the 'non-Surrealist' on the other, brings out some pertinent features of his work and approach, but it is, of course, somewhat artificial. Some artists took the 'problem' of automatism very seriously, but, in painting even more than in writing, it was, ultimately, intractable. And, while the Surrealist group accepted in principle the notion of disciplined, collective, purpose, each of them, also, like Ernst, negotiated a personal set of creative methods and concerns. And, certainly, Ernst's intellectual rigour, erudition and purposefulness were entirely compatible with a Surrealist persona, if Breton is an indication of such. The intensity, consistency, inventiveness and elegance with which Ernst developed his images, and the constant return in them and in this process itself to the theme of Eros, placed him, whatever his idiosyncracies, decisively on the side of the Surrealist 'fallen angels'.

Ernst's painting *La Toilette de la mariée*, from the end of the 1930s, exemplifies these qualities. It displays a bewildering range of visual and intellectual sources, combines the *explosante-fixe* of decalcomania with a dislocated 'Renaissance' space, and presents a hallucinating image of the eroticized female body. David Hopkins has unravelled the key elements that have gone into this 'collage': they include Cranach, Grien, Masonic ritual, Freud and Rosicrucianism.[16] One particular aspect of this extraordinary work relates to the theme developed here of Ernst's interest in the dismantling of Hellenic reason. Is not this sensual, staring woman, with a medallion of the Medusa's head on her breast, part Athene – virgin goddess of wisdom? Ernst may even have drawn directly on an image from the recent past as a source for the distinctive golden aegis – Gustav Klimt's *Pallas Athene* of 1898.[17] Klimt's *Athene*, in keeping with his shift from a

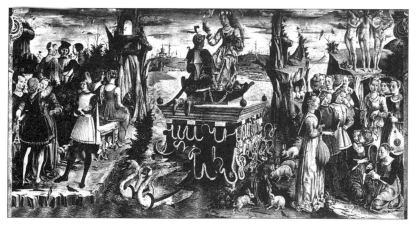

4.3 Francesco Cossa, *The Triumph of Venus*, 1467–70, from *April*, mural at Palazzo Schifanoja Ferrara (Photo: Alinari-Giraudon)

4.4 Max Ernst,
La Toilette de la mariée,
1940
(© SPADEM / ADAGP,
Paris and DACS, London
1996)

'liberal' outlook to a subjective anti-rational one, stares out at the viewer
with a red-haired nude in her palm. Ernst, fascinated by birds and their
potential as symbols, would also certainly have enjoyed Jacques Delamain's
remarks in his article 'Les Oiseaux de la nuit', published in 1935 in *Mino-
taure,* 7, which considered the mating habits of the chouette-chevêche.
Delamain commented that this particular bird was unusual in not displaying
the sexual discretion normal in 'birds of the night': 'The small owl of the
wise goddess, who one would have thought to be more restrained in its
passion, does not even wait for the winter sun to set to bear witness to
its ardour.' Freud and his followers, of course, read the Medusa's head as
an image of the castration threat. Rather suggestively, Freud's discussion
of this in the *New Introductory Lectures* (1933) occurs in the same passage
as a reference to the sexual significance of a robe or cloak, as demonstrated
in the 'extremely ancient bridal ceremony of the Bedouins'.[18] The virgin
goddess may, therefore, be represented here in a ritual of empowerment
through the release of repressed libidinal forces. At the very least, Ernst's
Bride is surely an embodiment of the subversive fusion in his work between
the classical 'Italian' artistic values of clarity and order, and the romantic
'German' ones of subjective vision and feeling.

Notes

1. W. Spies, *Max Ernst: Loplop The Artist's Other Self* (London: 1983), pp. 68–87.
2. Max Ernst, 'Au-delà de la peinture', *Cahiers d'Art*, special number (1936). The footnote is on p. 42.
3. Presumably 'L' Aimant est proche sans doute', and 'Leçon d'écriture automatique', Spies/Metken catalogue nos. 564 and 565. See Centre Georges Pompidou, *André Breton: La Beauté convulsive (Paris: 1991)*, p. 173. Cited in W. Camfield, ed., *Max Ernst: Dada and the Dawn of Surrealism* (Munich and Houston: 1993), p. 153.
4. A. Breton, 'D'une décalcomanie sans objet préconçu', *Minotaure* 8–9 (1936), and *idem*. 'Des tendances les plus récentes de la peinture surréaliste', *Minotaure* 12–13 (1939). Here he comments that 'collage, frottage, and the first products – the least specious and most valuable – of the so-called "paranoia-critical" activity, always maintained a certain equivocation between the involuntary and the voluntary, and to allow reason the upper hand'.
5. Max Morise, 'Les Yeux enchantés', *La Révolution surréaliste* 1 (1924). In 'Au-delà de la peinture' (pp. 33–4) Ernst referred explicitly to the generation of a sequence of images in the creation of collage and frottage 'se superposant les unes aux autres avec la persistance et la rapidité qui sont le propre des souvenirs amoureux et des visions de demi-sommeil'.
6. *View* (New York) 2, 1 (April 1942), pp. 28–30; *Beyond Painting* (New York: 1948), pp. 26–9.
7. Spies first explored Ernst's use of Freud in *Die Rückkehr der schönen Gartnerin* (Cologne: 1971) and developed it further in *Max Ernst: Collages*, (Cologne: 1974; London: 1991), and *Max Ernst: Loplop*. For his warnings on over-interpretation see 'An aesthetics of detachment' in Tate Gallery London, *Max Ernst*, (Munich: 1991), pp. 9–53, and 'An open-ended oeuvre' in Gamfield, *Max Ernst*. Extensive consideration of Ernst's use of Freud will be found in, *inter alia*, C. Stokes, 'La Femme 100 têtes by Max Ernst' (Ph.D. thesis, University of Virginia: 1977), E. Legge, *Max Ernst: The Pyschoanalytic Sources* (Michigan: 1989), M. Gee, 'Max Ernst, God, and the Revolution by Night', *Arts Magazine* 55, 7 (March 1981), pp. 85–91; *idem, Max Ernst: Pietà or the Revolution by Night* (London: 1986), and the work of D. Hopkins (see below).
8. D. Hopkins, 'Hermeticism, Catholicism and Gender as Structure. A comparative study of themes in the work of Marcel Duchamp and Max Ernst' (Ph.D. thesis, University of Essex: 1989 – a revised version of this study will be published by Oxford University Press in 1996); also, *idem*, 'Max Ernst's "La Toilette de la mariée"', *Burlington Magazine* 133 (April 1991), pp. 237–44, and 'Hermetic and Philosophical Themes in Max Ernst's "Vox Angelica" and Related Works', *Burlington Magazine* 134 (November 1992), pp. 716–23.
9. See 'Après la mort d'André Breton', *Les Lettres françaises* (6–12 December 1966), reprinted in *Max Ernst: Écritures* (Paris: 1970), p. 415.
10. 'Max Ernst's Favorite Poets and Painters of the Past' in *View* 2 (1 April 1942). It should, of course, be noted that the particular circumstances of the time may have encouraged him to include German artists. The full list of artists

was (as cited on the chart from top to bottom): Brueghel, Bellini, Bosch, Grünewald, Altdorfer, Francesca, Seurat, Uccello, Cranach, Baldung, Carpaccio, Vinci, Tura, Crivelli, de Chirico, Rousseau, Cossa, Cosimo, N. M. Deutsch, Van Gogh.

11. See *Max Ernst in Köln* (Cologne: 1980), pp. 49, 63–6.

12. E. Trier, 'Was Max Ernst studiert hat', in *Max Ernst in Köln*, pp. 63–6.

13. F. Burger, 'Uber Wert und Wesen der deutschen Kunst der Renaissance', in F. Burger, H. Schmitz, I. Beth, *Die deutsche Malerei vom ausgehenden Mittelalter bis zum Ende der Renaissance* (Berlin: 1918), bd. 1.

14. 'Die italienische Kunst und wir', published in P. Clemen, *Gesammelte Aufsätze* (Düsseldorf: 1948), pp. 16–23.

15. 'Italienische Kunst und internationale Astrologie im Palazzo Schifanoja zu Ferrara', published in *L'Italia e l'Arte Straniera. Atti del X Congresso Internazionale di Storia dell'Arte*, (Rome: 1922), and in A. Warburg, *Gesammelte Schriften*, bd. II (Berlin and Leipzig: 1932). See E. H. Gombrich, *Aby Warburg: An Intellectual Biography* (Oxford: 1986), chapter IX. Warburg was also fascinated by the North–South theme. In a paper of 1917 he analysed Dürer's 'Melencolia' in similar terms of liberation from the hold of astrological superstition, related to the Reform – see Gombrich, *Aby Warburg,* chapter X.

16. See Hopkins, 'Hermeticism, Catholicism and Gender', chapter 3 and 'Max Ernst's "La Toilette"'.

17. Historisches Museum, Vienna.

18. S. Freud, *New Introductory Lectures* (1933), Standard Edition (London: 1964), p. 24.

The Surrealist *Poème-Objet*

Phil Powrie

Breton had been interested in the object from the early 1920s,[1] but it was not until the mid-1930s that he devoted himself to a theoretical and practical exploration of it.[2] From 1934 onwards he published a series of theoretical texts focusing on the nature of the object, principally as a vehicle for the revelation of unconscious desire.[3]

It is no coincidence that these texts were written immediately after 'Le Message automatique' (1933), in which he proclaimed his disappointment with automatic writing, while at the same time introducing a discussion on the relative merits of verbal and visual automatism in automatic writing, privileging the former. Nor is it a coincidence that, of the fifteen *poèmes-objets* that Breton produced, the first was in 1933, the year of 'Le Message automatique', and that nine of them were produced in the period 1933–7.[4] It would seem that the focus on the object allowed Breton to shift his attention away from the disappointments of automatic writing, where written objects were the vehicle for desire, to the promise of *l'amour fou,* where privileged three-dimensional objects were the vehicle for desire.

Here, I would like to reconsider the standard question asked of these productions, i.e. how can we read *poèmes-objets*? An important part of the difficulty we may have in reading them lies in the problem that taxed Breton during this period – the peculiar tensions between the verbal and the visual. I shall, therefore, be taking to task the usual totalizing readings which attempt to unify the visual and verbal elements. Like other commentators, I shall consider various definitions of the *poème-objet*, but, unlike others, I shall avoid looking closely at those which have already been commented on by Breton, since such comments cloud the issue of interpretation. After a discussion of the taxonomy of the *poèmes-objets,* which shows how the visual elements in many of them serve a purely illustrative function, I shall offer various readings of a *poème-objet* where the object does not appear to be an illustration of the written text: formal, (auto)biographical, psychoanalytical (as applied to the author). As I hope to demonstrate, these readings are inadequate, since they are unable to

prove the premise which motivated them, i.e. that the visual and verbal elements can be unified. They are also inadequate because they do not interpellate the reader as interpreter. I am well aware that the confrontation of different 'readings' of a *poème-objet* undermines the act of interpretation. But this is not an act of critical abnegation, since I shall offer a final (but not definitive) reading, using the psychoanalytical tools developed in film theory to show how the *poème-objet* is a fetish which constructs a position of loss and consolation for the reader. I shall link this to the notion of surreality as an attempt to regain a non-differentiated state. I shall be claiming that the *poème-objet* cannot unify its various elements, and that it forces the rational mind to confront the loss of the surreal, which in this reading becomes the mnemonic trace of the pre-Oedipal phase. This in turn makes it a more perfect Surrealist image than the purely verbal image: a gesture towards a hypothesized totality prior to the circulation of signs.

Although it is not possible to consider all of Breton's *poèmes-objets* here, I would like to start by establishing a taxonomy, before selecting one of them which seems to me to be particularly fruitful for analysis. They fall into three broad types:

1. the complex *poème-objet,* which is accompanied by an interpretation by Breton;
2. texts where the objects in the *poème-objet* seem to function largely as an illustration of the written text;
3. enigmatic *poèmes-objets,* where the verbal and visual appear distant from each other. I feel that only two of the fifteen fall into this category – (iii) and (v) – and I have already commented on the first of these; [5] I shall dwell on the second later in this chapter.

The logic of this taxonomy lies in the guiding principle of this paper: how can we read these productions? Breton's commentaries, sometimes extremely detailed, pre-empt an open reading, by which I mean an interpretation which we, as readers, may feel is as valid as anybody else's. Breton's commentaries act as constraining frames. Clearly, too, if the *poème-objet*'s objects seem to be mainly illustrations of the written text, then a reading is more straightforward than if readers feel that the objects introduce a disruptive and problematic heterogeneity into the text.

It is questionable, of course, whether my second category – the object as illustration of the written text – is an appropriate one. Breton's definition of the *poème-objet* was: 'A composition which tends to combine the resources of poetry and the plastic arts and to speculate on their ability of reciprocal exaltation.'[6] The illustrative function that I am claiming hardly corresponds to the notion of exaltation. I shall therefore examine a *poème-objet* to show what I mean by the illustrative function.

A well-known *poème-objet* from 1937 – (viii) in my list – contains three objects (an ermine, three porcelain star or flower shapes, and three horn-shaped pieces of wood assembled onto a stem to look, possibly, like a brooch); these are interspersed in a short text, as follows (see figure 5.1):

<div align="center">

Madame vous m'êtes apparue pour la premi

[*ermine*]

Quelle tempête cette nuit

[*stars*]

nous nous promenions tous deux avenue des Acacias

J'aime vos yeux penchés

[*brooch*]

Madame you appeared before for the fir

What a storm there was that night

we walked together in Avenue des Acacias

I like your downcast eyes

</div>

The most obvious 'illustration' is the set of three star shapes, which readers would connect with the night. For readers familiar with Breton's work, the ermine also functions as an illustration in the form of a metaphor, since one of the 'Poisson soluble' texts which accompanied the first manifesto in 1924 begins: 'The woman with ermine breasts stood at the opening of the Passage Jouffroy.'[7] Even without this knowledge, it is arguable that readers would see the object as a synecdoche, the white fur of the ermine signifying the fur coat worn by the woman. The final object is less easy to decipher. If we accept that its form suggests a brooch, however, then the woman in question would naturally see it if her eyes were downcast, as the text has it. My conclusion, then, is that in this type of *poème-objet* readers are less likely to be able to 'speculate' on interferences between objects and written text precisely because the objects have a similar function to graphic illustrations.

This is why I find it difficult to agree with Drijkoningen, who, while focusing less on Breton's notion of 'exaltation réciproque', and more on the notion of combination of verbal and visual, still suggests equality between the verbal and visual elements: 'One reads these objects partly through words, just as one reads the words partly through objects … The words are to be seen as much as read, the objects are to be read as much as seen.'[8] Fijalkowski combines the totalization implied by Breton, while at the same time insisting on the combinatory aspect. He sees the *poème-objet* as 'a resolution of the problems implied by the difference between

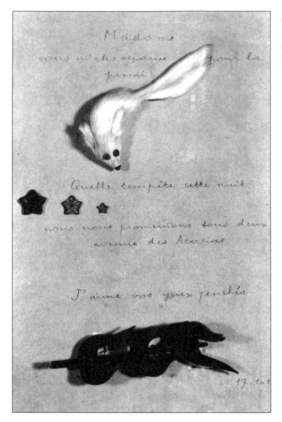

5.1 André Breton, *Poème-objet*, 1937 (© SPADEM / ADAGP, Paris and DACS, London 1996)

verbal and visual images by subjecting its elements to transformations allowing them to form a single unity',[9] which he relates analogically to Breton's definition of the 'point suprême' in the second manifesto, the resolution of all antinomies: 'Concrete objects disintegrated and lost their identities while "abstract" phrases solidified, fused to surfaces and interacted physically with the elements around them.'[10] Elsewhere, Fijalkowski makes the claim that the *poème-objet* 'objectified language and poeticized the visual'.[11] The Surrealist José Pierre's brief comments on the *poème-objet* on which I would eventually like to focus, and which consists of a short text and a penknife attached to the card below the text, take the same line: 'Breton here tries to tip the object – a humble penknife – into the poetic domain, to integrate it as the equivalent of a fragment of writing, of a few verses into the subjective domain of the poem while, reciprocally, the written poem tends to take on the objective quality of the penknife.'[12] The 'point suprême', however, was merely a hypothesis for Breton, and a careful return to his definition of the *poème-objet* would perhaps lay greater

emphasis on the tentative 'spéculer'. Breton's formula suggests that the verbal and visual elements may, but equally may not, generate more than the sum of their parts. The problem for readers of such objects is that the elements may well resist the kind of totalizing tendencies activated by such readings. Moreover, to say that the *poème-objet* objectifies the subjective and vice versa merely describes a possible function; it does not allow us to read the detail of the text.

The most suggestive analysis has been by Octavio Paz in the introduction to the collection of Breton's *poèmes-objets* and collages published on the occasion of the Breton retrospective in Paris in 1991. Paz places the *poèmes-objets* firmly in the emblem tradition (the other commentators mentioned restrict themselves to the immediately preceding intertexts, such as the Cubists and Magritte). The advantages of placing the *poèmes-objets* in the emblem tradition are several. First, although Paz approvingly cites some seventeenth-century writers who make the same kind of totalizing claims encountered above, e.g. Scipione Ammariato, who wrote that the impresa (or device) was 'a mystical mixture of paintings and words',[13] he accepts that the verbal aspect predominates in the emblem as it does in the *poème-objet*. The object becomes, as he puts it, a rhyme of the text,[14] and a decoding of the *poème-objet*, as of the emblem, requires a reading, or, as he puts it, 'a conversion of the image into a sign'.[15] (This is not the same as the views expressed above, which stress the reciprocity of the two elements, the object objectifying the written signs.) The images used in the emblems are a vocabulary of symbols corresponding to archetypes, and the author of the emblem, Paz claims, sees the universe as a book. This view to some extent resolves the issue of how the visual and verbal elements of the *poème-objet* interact. As I suspect that common sense would anyway dictate, it is clear that the written text structures the whole object for the readers in the majority of cases, which is why I use the term 'reader' rather than, say, 'viewer' or 'observer'. I shall test this hypothesis below, showing how a reading of the *poème-objet* can yield an interpretation, although it is my view that an archetypal, or, following Breton, what we could call a 'cryptogrammatic'[16] reading will always be inadequate, for two reasons. The first is the extremely personal nature of a network of correspondences in a rationalist environment (hence Breton's compulsion to comment on several of the *poèmes-objets*). The second lies in a second aspect of the *poème-objet* discussed by Paz, and to which I now turn.

Paz links the *poème-objet* to the emblem, suggesting that both are fascinating or monstrous objects in the strong seventeenth-century sense of the word. As Paz reminds us, emblems were often referred to as 'beaux monstres' by the baroque poets,[17] i.e. they represented something which broke with the natural order by their combination of the verbal and the visual. This seems to me to conflict with the previous point, namely that

these objects encourage a deciphering, a 'reading'. A monstrous object of fascination is more likely to be a metaphor for the impossible, for the radically different, in other words for the unreadable, rather than for a network of correspondences which presupposes connections in spite of differences. These objects can repulse any attempt to merge them into some hypothetical unity, a point to which I shall return.

A third and final point which links the *poème-objet* with the emblem, according to Paz, is their simultaneity, at the price of a lack of development or narrative, something commented on by authors of seventeenth-century treatises. As Paz puts it in his punning Spanish, emblems and *poèmes-objets* are 'instantes sin antes', literally, moments without a time before.[18] This may be true of their formal aspect, but it is clearly not true at a different level. Breton's *poèmes-objets* are usually precisely dated and, when dedicated, dedicated to women, particularly those with whom he happened to be living at the time. They therefore present themselves to readers as commemorations of a private moment, re-presentations of something now absent. Cardinal makes the same point of Schwitters's collages – 'emblems are substitutions, not actualities'[19] – and what he goes on to say about how we might react to Schwitters's Merz mementos can be equally applied to Breton's *poèmes-objets*:

> The notion of metonymic immediacy may ... be obliged to yield to one of metaphoric suggestivity, the colour of distance. When we in our turn encounter the Merz memento ... we may not be picking up whiffs of actual desire, evinced at a certain time and place, but more re-enacting the desperation of the fetishist who must always stumble upon the scene after the fact.[20]

The notion of fetishism is an interesting one, and I shall return to it in an attempt to resolve the problem of how we read the *poème-objet*.

The discussion on the temporality of the *poème-objet* has shown how the *poème-objet* is a paradox for readers, at several levels. We relive a personal event by proxy, an event of which we are aware, but which we cannot know. In so doing, what was originally metonymy shades into metaphor, as Cardinal suggests. This oscillation between the shown and the hidden, between metonymy and metaphor, between verbal and visual, located in a non-narrative moment which is past but also immediately present to us by virtue of the real objects it contains, but where those same objects which turn the *poème-objet* into something tangible are themselves metonymies for an unknown past event, justifies our calling the *poème-objet* not simply a paradox, but, following the lead given by Paz, a monstrous trope. Literally, this means a 'shown found object'; it is figuratively monstrous not just because it combines the verbal and the visual, but because its

function, as Paz reminds us, is 'to hide so as to reveal'.[21] Neither metonymy nor metaphor; neither verbal nor visual; neither present nor past; but, in each case, it is, rather, a vehicle for constant shuttling between the two terms, analogous to the physical shuttling of the eye between the two elements, a point to which I shall return. All we are left with is a mobile space of fascination. It is this which is the key to the *poème-objet*, rather than an interpretative 'reading'. The *poème-objet* is an object of fascination, not least because it does indeed seem to encourage a 'reading'. I shall, therefore, allow myself to fall into the trap laid by the object, before standing back to show how the *poème-objet* could be judged the perfect Surrealist text, which resolves the apparent antagonism between verbal and visual by *not* resolving it, but by forcing the interpretative mind to consider its limitations.

The text of the *poème-objet* I would like to consider – ['Le torrent automobile…'], number (iii) in my list – reads as follows (see figure 5.2):

> Le torrent automobile de sucre candi
> Prend en écharpe un long frisson végétal
> Etrillant des débris de style corinthien
>
> The automobile torrent of sugar candy
> Strikes sideways on a long vegetable trembling
> Curry-combing the débris of Corinthian columns out

In narrative terms, the written text is relatively clear:

(a) There is a subject: a complex three-layered subject, formed by a torrent, a car, and sugar candy. The reader is likely to see this subject as more car than either the water or the candy with which it is associated, largely because the formula 'prendre en écharpe', meaning to hit something sideways, is so commonly used of a car.

(b) There is an action: the monstrous car hits some foliage; the 'frisson' is a metonymy, the foliage trembling as a result of the impact.

(c) The action has a consequence: it draws out of the foliage fragments of Corinthian column. This is also more metonymy than metaphor, since the defining characteristic of the Corinthian column is the acanthus-shaped capital; i.e. the impact has turned a vegetable (foliage) into mineral (stone).

The question for readers is how to make sense of the real object, the penknife, which is attached to the card below the text. We try to bind it to

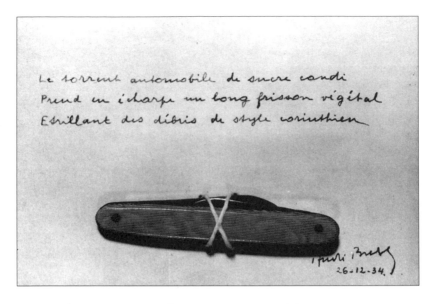

5.2 André Breton, *Poème-objet*, 'Le Torrent automobile', 1934
(© SPADEM/ADAGP, Paris and DACS, London 1996)

the written text by a movement of consolidation schooled into us by the rules of narrative and rhetoric. But this compulsion to consolidate is thrown off course by the unstable nature of the object. Is it metaphor or metonymy? If it were a metaphor, it might signify 'like a tied-up penknife'. This connection can be made because there are a number of supporting co-ordinates:

(a) it is pink, so connected with candy;
(b) it is long, like the comb understood in 'étrillant';
(c) its streamlined shape echoes the car;
(d) it is also long like a column ('corinthien').

The penknife might equally well be considered as metonymy. It is what one uses to sharpen pens or quills with, as the English word makes clear, and it could thus be seen as a projection of the written text rather than as a metaphorical illustration. This metonymic side to the object is to some extent supported in the text by another meaning of 'style corinthien', in the sense of a writing style (or even stylus), of which we are told that there can be seen only débris, i.e. something of the past, débris which we are engaged in deciphering.

Clearly, such a formal analysis, although it confirms the unstable nature of the *poème-objet* by virtue of the mobility of the tangible object it

contains, does no more than describe its functions. It does not neces-
sarily elicit meaning. Even searching for clues in the text for references to
events, such as a possible connection with Isadora Duncan, who intro-
duced Greek dance (the link with 'corinthien'), and who died in 1927
strangled by her scarf which had caught in the wheel of her car (the link
with 'écharpe'), does not necessarily get us very far. For the latent mean-
ing to become apparent, we must, appropriately, consider what, is in this
case, physically hidden. The *poème-objet* is dedicated, as many of them
were, to a woman. This one is not visibly dedicated, but on the reverse
of it there is the inscription 'Château de fougère ... Pour Valentine'
(Castle of ferns ... For Valentine). At the very least, this inscription turns
the *poème-objet* into the commemoration of a private event. Valentine
Hugo was passionately attracted to Breton, and, although Breton rejected
her advances over a number of years, they had a physical relationship
probably in the period July 1931–May 1932. This finished abruptly and
somewhat violently. She remained an active member of the Surrealist group
for several years after this, however. The dedication could refer to either
or both of the following: the ferns which Valentine Hugo provided for
Breton on a regular basis, according to Jean-Pierre Cauvin;[22] the castle
in the Breton town of Fougères, through which Breton travelled in July
1931 – i.e. at the beginning of his physical relationship with Hugo – on his
return to Paris after a trip to Brittany with Hugo and several other friends
(who all went on ahead of Breton to Paris).[23] A biographical, even autobio-
graphical reading seems legitimate in the circumstances. It is, furthermore,
supported by an automatic text written during the same period as the
poème-objet.

The automatic text starts by staging an amorous encounter, where we
find the unusual use, for Breton, of the image of candy:

> Du lit qui est fait de poings serrés comme l'approche d'une rixe
> Et de torsades de sable qui s'élèvent vertigineusement
> S'éloignent les apparences de deux têtes
> Dont l'une est la mienne
> Cette tête est le talon d'Achille de la nature
> Une chose qui attire les guêpes et dans la composition de laquelle
> entrent du sucre candi et de la vapeur

> From the bed made of tightened fists as when a brawl approaches
> And of coils of sand which rise vertiginously
> The appearance of two heads move off
> One of them is mine
> That head is the Achilles' heel of nature
> Something which attracts wasps and in whose composition enter
> sugar candy and steam[24]

A more complex reading of the *poème-objet* now becomes possible. The text of the *poème-objet* refers to vegetation, and this is recalled by the dedication ('château de fougère'): the acanthus and the fern have similar configurations. Hugo would have been associated with ferns by Breton. The automatic poem suggests that candy could be read as a metaphor for Breton himself. The *poème-objet* thus creates a monstrous metaphor, either for the union of Hugo and Breton spread over time, where the car/candy (Hugo/Breton) crash, destroying and metamorphosing the fern (Hugo), or for more punctual sexual congress, as the first two lines of the text might have suggested even in the absence of other information; it does not take much imagination to see what torrents of candy associated with trembling might suggest. Once again, however, we are left with the problem of the penknife.

Bearing in mind Paz's point that the visual element of the emblem calls for a 'reading', we might be tempted to accept Pierre's view that the object is 'the equivalent of a fragment of writing, of a few verses', and read the object as the visual representation of a written sign or signs. How might this work in practice? What could the penknife represent if it were a written sign? Trained to seek patterns, and to impose them if they are not evident, we might be further tempted to assume that the formal strategies in the written text could be mapped on to the object. The most interesting aspect of the written text in formal terms is the way in which it uses a familiar phrase ('prendre en écharpe') to link two radically different semantic fields: water, whose movement and appearance are metaphorized as a car and candy respectively; and the animal 'frisson'. We might be tempted to assume that the object could be represented by a similar type of phrase. Such a phrase would be 'donner un coup de canif dans un contrat', the contract broken being usually understood as the marriage contract.

The *poème-objet*'s meaning apparently becomes clearer. It is a commemoration of the failure of the Hugo/Breton relationship. In this reading the penknife is a metaphor for Breton, who initiated the split with Hugo. This is supported within the *poème-objet* by three factors:

(a) the contiguity of Breton's signature which suggests appropriation, if not equivalence;
(b) the homophonic echo of 'canif' with 'candi', which, as we have seen, occurs during this period as a transparent reference to Breton himself. I have called the penknife a metaphor for Breton, but synecdoche might be a more appropriate term, because, although Breton found the object, he has handled it by attaching it to the page. This physical activity seems to me to be of some importance, and I shall return to it;

(c) the pun created by the object: its closed and obsessively tied blades
signifying the incomplete word 'l'amour' ('lames').

Breton himself has encouraged this type of reading by his analysis of
the function of the found object in an article written in the same year as the
production of the *poème-objet*, and later included as Chapter 3 of *L'Amour
fou*. In the article, he writes: '*The finding of an object serves here exactly the
same purpose as the dream, in the sense that it frees the individual from para-
lysing affective scruples, comforts him and makes him understand that the
obstacle he might have thought insurmountable is cleared.*'[25]

Although we may find this attempt at an interpretation convincing, I
would suggest that it is precarious, and that its characteristic is instability,
largely due to the inferences required of the reader by the object within
the *poème-objet*. The experience of reading a *poème-objet* is one of disequi-
librium and destabilization. There is disequilibrium between the verbal
and visual aspects of the production, in the sense that the verbal element
has a narrative development, unlike the visual element, and in that the
verbal element, by its patterning as well as by its development, allows an
interpretative story to be imposed upon it, whereas the visual element is
an object whose opacity encourages resistance to interpretation. If we
assume that the same type of interpretation can be applied to the object
as is applied to the written text, we find that the object is not only desta-
bilized in itself (it is no longer merely an object, but becomes a complex
of signifiers), but, by virtue of its polyvalence, it destabilizes the interpre-
tation accruing from the written text. Disequilibrium and destabilization
go hand in hand with fascination, as the elements of text swirl and eddy
in a confusion of possibilities more radical than a purely written text, by
virtue of the mixing of the media.

The trap is to assume that the media can be homogenized. This is all
the more acute in the case of Surrealism, with its highly imaged texts, and
Breton's insistence on problematizing the relationship between the verbal
and the visual. To attempt to integrate them within a narrative, whether
at the biographical level or the purely formal level, is to deny the obvious
distance, if not antagonism, between them. A more fruitful approach is the
psychoanalytical one, since it can both cope with the paradoxes raised by
the *poème-objet* and theorize the position of the reader. I shall use the psy-
choanalytical tools developed in film theory.

I would like to pick up on Cardinal's lead concerning fetishism, and suggest
that the object within the *poème-objet* is a fetish for Breton in the everyday
sense of 'an object irrationally reverenced' (OED). But Breton's contention,
quoted above, that the found object 'libère l'individu de scrupules affectifs

paralysants, le reconforte',[26] suggests that it functions more specifically in the same way as the fetish in psychoanalysis. Freud remarked that the fetish is 'a token of triumph over the threat of castration and a protection against it'.[27] The notion of paralysed desire in Breton's formula is too close to be coincidental; the found object functions as a means of overcoming the paralysis of castration.

In the Freudian scenario the fetish is a 'substitute for the woman's (the mother's) penis that the little boy once believed in'.[28] Recent work by Barbara Creed has taken Freud to task for failing to recognize the woman as castrator rather than castrated. The creation of a fetish might just as well suggest that the male wishes 'to continue to believe that a woman is like himself, that she has a phallus rather than a vagina. In this context, the fetish stands in for the *vagina dentata* – the castrating female organ that the male wishes to disavow.'[29] Creed's revision of Freud is helpful in interpreting this particular *poème-objet*, where the penknife, I would suggest, is the representation of the person to whom it was offered. Valentine Hugo was a threatening *femme castatrice,* in the sense that she represented a challenge to Breton's authority by seeming his equal, if not his superior: equal in that she was a published writer and painter; superior in the sense that she was nine years older than he was, she was a member of the *haute bourgeoisie* and, as such, relatively affluent, owning several cars, and therefore able to ferry Breton and his friends about. Paralysis as castration surfaces in 1930 at which point Hugo was pursuing him assiduously. Breton wrote her a letter in which 'he entreats her not to repeat a statement she recently uttered in his presence – most probably an avowal of affection. It is, he [wrote], so serious a matter that it induces paralysis. "Even hostility makes me more at ease".'[30] To offer this woman a *poème-objet* which includes a penknife in bondage strikes me as more than just coincidental. The obsessively tied knife, whether we take it as a castrating stylet or a representation of Hugo as competing writer (her 'style', fantasied as débris in the written text), functions in the same way: it is not a means of fetishizing the woman so that she becomes the phallic woman, site of castration, but, rather, it is a means of symbolically silencing her, of disavowing her power to castrate.

The use of fetishism as a tool to read the *poème-objet* from the point of view of the author yields an interpretation which may be felt to be more satisfying than the formal or biographical interpretations above. It is, however, deficient for the obvious reasons that it still relies on biographical elements for corroboration (indeed, a problematically hidden biographical element in the form of the dedication on the reverse of the object), and that it only holds good for this particular *poème-objet*. The only general point of principle that I would like to retain is that the object within the artefact functions as a fetish, since this helps us to understand the role of

the reader in meaning-production. Again, work done in film theory will help us understand how the *poème-objet* functions, both in general and in this particular example of it.

Metz draws a parallel between fetishism and the film spectator, based on the psychoanalyst Mannoni's view of the theatrical illusion. Metz points out how we maintain a paradox: ' "All human beings are endowed with a penis" (primal belief) and "Some human beings do not have a penis" (evidence of the senses).' The child, Metz suggests, will 'retain its former belief *beneath* the new one, but it will also hold to its new perceptual observation while *disavowing* it on another level'.[31] Metz parallels this structure with the willing suspension of disbelief in the theatre, following Mannoni, who asks who it is who is both credulous and incredulous at the same time: 'This credulous person is … another part of ourselves, he is still seated *beneath* the incredulous one … it is he who continues to believe, who disavows what he knows (he for whom all human beings are still endowed with a penis).'[32] Just as Metz believes that Mannoni's conclusions are applicable to film, so I think that they are also applicable to the *poème-objet* in general.

The reader of the *poème-objet* is caught in a similar structure in the attempt to make sense, to synthesize the two apparently antagonistic elements of the *poème-objet*. The title of Mannoni's study is: 'Je sais bien, mais quand même …' ('I know full well, but all the same …'). The reader of the *poème-objet* is saying 'I know that the two elements are antagonistic and unsynthesizable, but, nevertheless, I shall seek a mechanism to synthesize them.' In other words, the reader says, 'the *poème-objet* as fetish denotes castration, but I shall choose to ignore this'. What is castration? It is sexual difference, loss of non-differentiation from the mother. The *poème-objet* – any *poème-objet* – will therefore connote castration and loss. Freud's discussion of the archetypal object of fascination, the Medusa's head, is crucial here. Freud points out how the Medusa's head is a site of castration ('to decapitate = to castrate'), but that the object 'offers consolation to the spectator' because the sight turns him into stone, and 'becoming stiff means an erection'.[33] The *poème-objet* – any *poème-objet* – will therefore connote castration and loss, but will also have a counterphobic force, affording consolation for that loss.

An obvious objection to the fetish paradigm is that the disjunction it implies between the verbal and visual elements of the *poème-objet* does not work if the *poème-objet* is of the illustrative type. My view, however, is that the illustrative *poème-objet* is considerably less interesting at a theoretical level than the disjunctive type which I am addressing here. Even if there were only one of the disjunctive type, rather than the two that I have claimed exist in Breton's work, there would still be a need for an

interpretative model. Furthermore, it is my contention that such productions are crucial, however small in number, because of the way in which they articulate fundamental problems in relation to the notion of the surreal. How, then, can the metapsychological structures of the model that I am proposing help us to establish a reading in the literary sense?

At a general level, the *poème-objet* functions as the site of a gesture towards the surreal. Because of the mixed media, it is a more compelling confrontation between two images from distant realities, to take up Reverdy's famous description of the poetic image adopted by Breton in the first manifesto as a definition of surreality. Like the emblem, then, the *poème-objet*, as Paz reminds us, suggests the possibility of a network of correspondences, at the same time as, by its very nature, it presents radical antagonism between its elements, and therefore the impossibility of that network; i.e., like the fetish, the *poème-objet* and the emblem are vehicles for loss and consolation for the loss.

At a particular level, this specific *poème-objet* also graphically illustrates the same issue: it is a *mise-en-scène* of the castrating object *par excellence*, a knife. But it also has a counterphobic force, for two reasons. First, because the mother's absent penis, which the knife as fetish has replaced, is so clearly a phallic object; the mother's penis, is magically replaced. Second, because the knife's castrating power is so clearly contained: the blades are not just retracted, but obsessively restrained by crossed string. Indeed, we could say that 'x' marks the spot of ambivalence. It marks it in more ways than one, since the cross also marks the site of a very visible physical activity. It is the implications of this body in the text that I would like to consider before concluding.

The 'x' formed by the string is a crucial component. Like a clumsy signature, it imposes the materiality of the hand which chose this object from amongst others, which held this object and tied it to the page. It does so with more force than the written text might impose the materiality of the hand which held the pen, largely because of the way it underlines the materiality of what is more object than sign, by stressing its bulk, its weight. It could be objected that the presence of the author is strongly felt because of the handwriting. I do not think that this is the case, because the incorporation of handwriting on a canvas was already a familiar device in Surrealist painting.[34] The sense of physical presence imparted by the object has an effect on the interaction of the two elements. It is not so much the text which personalizes the object, but the object which reintroduces the body to the impersonality of the graphic sign system, however 'personal' the automatic text may seem. This sense of the body in the text is helped, I would suggest, by the physical nature of the reader's reaction to the disjunction of the verbal and visual elements, as the eye shuttles to and fro to incorporate them, both in the sense of reducing the

antinomies between them, and in the sense, admittedly more fanciful, of introducing the reader's body into the text. The *poème-objet* becomes doubly presence and sign. It is double presence, the presence of the object within the *poème-objet* (materialized by the hand which placed it there) and the reader's presence (materialized by the movement of the eye). And it is also a double sign, the signs represented, however differently, by the verbal and visual elements.

This way of conceptualizing the interaction of the verbal and visual elements has the advantage that it does not try to deny or resolve the antagonism between them; the antagonism remains intact, merely bridged by the trace of a hand, the trace of an eye. The *poème-objet* does not so much defy or repulse interpretation (the hypothesis I formulated when discussing Paz's point concerning its monstrosity), as solicit interpretation at the same time as it undermines it. It is perfectly possible to interpret it, if by interpretation we mean the kind of totalizing reading which attempts to impose a unitary meaning on the elements present. But such an interpretation fails, I would contend, because the reader's gaze is returned: the fascination of the monstrous trope does not prevent interpretation, it simply bounces the interpretation back. The more sense the artefact appears to make, as in, for example, the formal/biographical interpretation that I outlined above, the more the interpreting mind becomes aware of the precariousness and contingency of the interpretation (the penknife is and is not consonant with the text which precedes it), helped in this by the sense of personal presence vehicled in the object.

It is, to use Cardinal's phrase, a 'stimulating bewilderment',[35] but, whereas Cardinal sees this as 'the prelude to unsuspected revelation',[36] I would suggest that the bewilderment *is* the revelation: revelation is the revelation of the impossibility of revelation. Bewilderment is the leading astray of the rational mind, out of the normal path it takes (the path of totalizing interpretation), and the mind's sudden realization of its own limitations. The *poème-objet* is, in this respect, the most perfect Surrealist product, combining verbal and visual, art and craft, body and mind, metaphor and metonymy, in a single moment where the mind contemplates its own destruction as it attempts to encompass and resolve the irresolvable, the fact that we are irredeemably split, just as is the *poème-objet*, and split from the bliss of non-differentiation with the Mother, before the circulation of signs and the move into the Symbolic. That it might be possible to regain access to non-differentiation, or the surreal in Breton's view of the same structures, is, of course, hypothetical. This does not mean that the surreal, or that non-differentiation, did not exist once, but that they cannot be regained. As such, the surreal has the same structuring force as myth in some so-called primitive societies, where the myth has always been myth half-believed as reality, and where the reality in question is no more

than a memory of non-differentiation. Consider what Mannoni, reported by Metz, says of such societies where ethnologists hear their informers:

> Regularly declare that 'long ago we used to believe in the masks' (these masks are used to deceive children, like our Father Christmas, and adolescents learn at their initiation ceremonies that the 'masks' were in fact adults in disguise); in other words, these societies have always 'believed' in the masks, but have always relegated this belief to 'long ago': they still believe in them, but always in the aorist tense (like everyone). This 'long ago' is childhood, when one really was duped by masks; among adults, the beliefs of 'long ago' irrigate the unbelief of today, but irrigate it by denegation (one could also say: by *delegation,* by attributing credulity to the child and to former times).[37]

The author and reader of the *poème-objet* are in the same position as the adults in such societies, I would contend. Like the spectators in the theatre, or in front of a cinema screen, they believe in the possibility of non-differentiation between the two elements of the *poème-objet* as a metaphor for non-differentiation in general, whether one conceives of this as an esoteric network of correspondences or the psychoanalytical pre-Oedipal phase, while at the same time knowing that this non-differentiation is not possible any more.

I rehearsed a first objection above to the fetishism paradigm, and it is time to rehearse a second set of objections, this time more particularly to the use of fetishism as a paradigm within film theory. This will only be to jump more forcefully and finally into the abyss of the object. A first objection, then, is that it is inadmissible to use elements of film theory for an analysis of the *poème-objet*, since films and *poèmes-objets* are not coterminous, even if they might be analogous as artefacts. While this is true, I would suggest that, for the reader/spectator, the screen on the one hand, and the canvas or board on which Breton places his text and objects on the other, are not merely analogous, but equivalent. The canvas is less a page, despite the text, than it is a screen which contains signs whose materiality (see the discussion above on the 'signature' of the crossed strings) inflects them, whether they are visual or verbal, towards the less mediated presence of the film image. The two media therefore have equal value in terms of their effect on the spectator. Additionally, to the extent that there is a well-established current in Surrealist criticism which relies on psychoanalysis, and specifically on fetishism as a paradigm,[38] it seems to me that using fetishism as elaborated in film criticism, where it has been in evidence since the mid-1970s, and has therefore led to

considerable theoretical sophistication, can illuminate the problems raised
by the *poème-objet*. This is all the more the case for my second objection,
which is the old chestnut that fetishism and its relation to the Oedipus is
theoretically inadequate since it takes little if no account of the position
of the female reader/spectator.

Film theory's response to this problem has, during the late 1980s, led
to a shift of emphasis away from fetishism to masochism, using Freud's
analysis of what he calls feminine masochism, one of the three types of
masochism, and a position, despite its epithet, available to both sexes.
Its three main characteristics are that the death drive is turned inwards;
there is a 'wish to be beaten by the father [which] stands very close to
the other wish, to have a passive (feminine) sexual relation to him, and is
only a regressive distortion of it'; and, lastly, guilt.[39] In masochistic fan-
tasies the subject slides from one subject position to another, and indeed
from one gender to another.[40] Sandy Flitterman-Lewis usefully summa-
rizes it thus:

> Freud demonstrates the possibilities for the subject of fantasy to par-
> ticipate in a variety of roles sliding, exchanging and doubling in the
> interchangeable positions of subject, object and observer. He does this
> by engaging with different forms of the fantasy in terms of the linguistic
> pronouns they imply: 'My father is beating the child,' 'I am being beaten
> by my father,' and 'A child is being beaten' (I am probably looking on).
> During the three stages of this fantasy, the subject (a woman) takes
> the place of the father who is doing the beating, the child being beaten,
> and the viewer of the scene. The subject of the fantasy thus becomes
> a mobile and mutable entity rather than a particular gendered indi-
> vidual.[41]

The mobility of subject-positions thus counters the objection that a psy-
choanalytic paradigm refuses to engage with the position of the women
spectator – or reader in the case of my application of the paradigm to
the *poème-objet*. It also emphasizes a point I have already made, and on
which I shall conclude, that the *poème-objet* encourages a kind of ludic
masochism, a play with the interaction between presence and sign which
constantly defers what it apparently might most ardently have desired,
the collapse of the two in a moment of non-differentiation.

If we accept this view of the *poème-objet*, then there is a difference
between it and the emblem and the device. The latter are, properly speak-
ing, 'conceits', in the sense of fanciful expressions, residues from a time
when the universe was accepted as a book, and when correspondences,
whether intended to serve as morality tales in the case of emblems, or

intellectual or pedagogic exercises in the case of devices, were felt to give the universe form. The Surrealist *poème-objet,* which, by the radical disjunction of its elements, is apparently close to the device, is nevertheless not so much a conceit, as what I would like to call a 'conception', in the sense of a framing of the mind, i.e. an activity, indeed, at least in intention, a method of rebirthing. It is in this function, which applies equally well to its author as its reader, that the most fundamental split of all for any artefact, that between its producer and its receiver, begins to blur in a cataclysmic moment of loss and consolation.

Non-differentiation is deferred. Indeed, how could it be otherwise if the object is to exist ? As a conclusion, I would like to return to the idea that the canvas of the *poème-objet* can be seen as a screen, and to recall the thirteenth-century origins of 'screen' itself. This will encapsulate the extent to which the rebirth to be expected, the passage from darkness to light, the moment of illumination, which, in Breton's definition of convulsive beauty as 'érotique-voilée, explosante-fixe, magique-circonstantielle' (veiled-erotic, fixed-explosive, magic-circumstantial),[42] is a moment of blinding terror. The screen serves as an apotropaic trace of that moment of terror, a screen-shield, a guarantee, as the Glossaire de Douai has it, against 'l'ardeur d'un foyer', or, as the sixteenth-century lexicographer Estiennes puts it, an object which both dissimulates and protects.[43]

Notes

1. He talks of the need to create objects seen in dreams as early as 1924 in 'L'Introduction au discours sur le peu de réalité'. See André Breton, *Œuvres complètes* II (Paris: 1992), pp. 265–80 (p. 277).
2. See Christopher Fijalkowski, 'The Surrealist Object: Proof, Pleasure and Reconciliation' (Ph.D. thesis, University of East Anglia, 1990), for an extensive history (especially pp. 14–16).
3. 'La Beauté sera convulsive' (1934); 'Equation de l'objet trouvé' (1934); 'Situation surréaliste de l'objet' (1935); 'Crise de l'objet' (1936). The first two of these texts were integrated in *L'Amour fou* (1937). All can be found in *Œuvres complètes* II.
4. They are reproduced, together with various collages, *cadavres exquis,* and drawings in André Breton, *Je vois, j'imagine: poèmes-objets* (Paris: 1991). They are as follows (I exclude collages, and I give the *poèmes-objets* in chronological order, with identifying first lines for the several items without titles, and with a note of those which have commentaries by Breton):

i) 'Communication relative au hasard objectif' (1933, p. 16). Commentary.
ii) 'Page-objet' (1934, p. 19).
iii) 'Sans-titre' ['Le torrent automobile …'] (1934, p. 20).
iv) 'Sans titre' ['Yeux zinzolins …'] (1934, p. 27).
v) 'Sans titre' ['A l'intersection des lignes …'] (1935, p. 21).
vi) 'Rêve-objet' (1935, p. 25). Commentary.
vii) 'L'Océan glacial' (1936, p. 28).
viii) 'Sans titre' ['Madame vous m'êtes apparue …'] (1937, p. 37).
ix) 'Sans titre' ['Carte resplendissante de ma vie …'] (1937, p. 39).
x) 'Portrait de l'acteur A.B. dans son rôle mémorable l'an de grâce 1713' (1941; p. 9). Commentary.
xi) 'Sans titre' ['Ces terrains vagues …'] (1941, p. 31). Commentary.
xii) 'Un Bas déchiré' (1941, p. 35).
xiii) 'Jack l'éventreur' (1942–3, p. 33).
xiv) 'La Lampe' (1944, p. 30).
xv) 'Pan hoplie' (1953, p. 46).

5. Phil Powrie, 'Reflections on/from the ruined eye', *SuperReal: The British Journal of Surrealism* 1 (1992), pp. 7–13.
6. André Breton, *Le Surréalisme et la peinture* (Paris: 1965), p. 284 (text dated 1942). All translations are mine except where otherwise indicated.
7. Breton, *Œuvres complètes* I (1988), p. 382.
8. Fernand F. J. Drijkoningen, 'Comment lire un poème-objet ?', in *Le Plaisir de l'intertexte: formes et fonctions de l'intertextualité: roman populaire, Surréalisme, André Gide, nouveau roman: actes du colloque à l'Université de Duisburg* (Frankfurt am Main, Bern and New York: 1986), pp. 91–110 (pp. 97–8).
9. Fijalkowski, 'The Surrealist Object', p. 201.
10. Ibid.
11. Ibid., p. 180.
12. José Pierre, 'André Breton et le "poème-objet"', in Jacqueline Chénieux-Gendron and Marie-Claire Dumas, eds, *L'Objet au défi* (Paris: 1987), pp. 131–42 (p. 136).
13. Breton, *Je vois, j'imagine*, p. viii.
14. Ibid., p. x.
15. Ibid.
16. This refers to Breton's statement in *Nadja*: 'il se peut que la vie demande à être déchiffrée comme un cryptogramme' (*Œuvres complètes* I, p. 716). The statement is made following a series of apparent coincidences in the company of Nadja which lead him to suspect that they form part of a network, which he later called 'le hasard objectif'.
17. Breton, *Je vois, j'imagine*, p. viii.
18. Ibid., p. ix.
19. Roger Cardinal, 'Collecting and Collage-Making: The case of Kurt Schwitters', in John Elsner and Roger Cardinal, eds, *The Cultures of Collecting* (London: 1994), pp. 68–96 (p. 94).

20. Ibid.
21. Breton, *Je vois, j'imagine*, p. vi.
22. Jean-Pierre Cauvin, 'Valentine, André, Paul, et les autres, or, the surrealization of Valentine Hugo', in Mary Ann Caws, Rudolf Kuenzli and Gwen Raaberg, eds, *Surrealism and Women* (Cambridge, Mass. and London: 1991), pp. 182–203 (p. 192).
23. See the 'Chronologie' in Breton, *Œuvres complètes* II, p. xxxv. Breton might well have been attracted to the castle for one of its thirteen towers, the 'tour Mélusine'. Melusina plays an important part in the 1944 text, *Arcane 17*.
24. Breton, *Œuvres complètes* II, p. 652. Previously unpublished; the editor, Marguerite Bonnet, suggests that it might have been written in the period 1931–5.
25. Breton, *Œuvres complètes* II, p. 700 (Breton's emphasis). Translation by Mary Ann Caws (Lincoln Nebraska and London: 1987), p. 32.
26. See note 25.
27. Sigmund Freud, *Standard Edition*, Vol.21 (London: 1961), p. 154.
28. Ibid., pp. 152–3.
29. Barbara Creed, *The Monstrous-Feminine: Film, Feminism, Psychoanalysis* (London and New York: 1993), p. 116.
30. Cauvin, 'Valentine', p. 189.
31. Christian Metz, 'Disavowal, fetishism' in Metz, *Psychoanalysis and Cinema: The Imaginary Signifier* (London: 1982), pp. 69–78 (p. 71). Translated by Ben Brewster. Metz is referring to 'Je sais bien, mais quand même …' in Octave Mannoni, *Clefs pour l'imaginaire ou L'Autre scène* (Paris: 1969).
32. Ibid., p. 72. Metz's emphasis.
33. Freud, *Standard Edition*, Vol. 18, p. 273.
34. See, for example, Miró, 'Le Corps de ma brune' (1924); 'The Writer' (1924), and Magritte, 'The Key of Dreams' (1930), and his notorious painting of a pipe with the legend 'This is not a pipe' in 'The Wind and the Song' (1928–9). Magritte also contributed an important piece entitled 'Words and Images' for *La Révolution surréaliste* 12 (15 December 1929), pp. 32–3, which reflects on the disjunction between the two; reproduced in René Magritte, *Écrits complets* (Paris: 1979), pp. 60–1.
35. Roger Cardinal, *Breton: Nadja* (London: 1986), p. 12.
36. Ibid.
37. Metz, 'Disavowal', p. 73. Metz's emphasis.
38. See, for example, Rosalind Krauss's comments on the Surrealist photograph, where she points out that the logic of fetishism 'turns on the refusal to accept sexual difference'. Rosalind Krauss, 'Corpus delicti', in *L'Amour fou: Photography and Surrealism*, Catalogue of the exhibition at the Hayward Gallery, London, July–September 1986, edited by Rosalind Krauss and Jane Livingston (London: 1985), pp. 57–100 (p. 95).
39. Sigmund Freud, 'The Economic Problem of Masochism', *Standard Edition*, Vol. 19, pp. 155–70 (p. 169).
40. Sigmund Freud, 'A Child is Being Beaten: A Contribution to the Study of the Origin of Sexual Perversions', *Standard Edition*, Vol. 17, pp. 175–204.

41. Robert Stam, Robert Burgoyne, Sandy Flitterman-Lewis, *New Vocabularies in Film Semiotics: Structuralism, Post-structuralism and Beyond* (London and New York: 1992), p. 154.

42. Breton, *Œuvres complètes* II, p. 687 (Breton's emphasis). Translation by Mary Ann Caws, p. 19.

43. Both cited under item 'Ecran' in *Trésor de la langue française: Dictionnaire de la langue du XIXe et du XXe siècle (1789–1960)*, Vol. 7 (Paris: 1979), p. 701.

Desmond Morris, *Public Figure*, 1976

André Masson and Automatic Drawing

Roger Cardinal

'There are no forms, no objects. There are only events – outbursts – apparitions.'
André Masson [1]

Automatic drawing might seem to be the *sine qua non* of Surrealist visuality, yet it is a curious fact that its concerted actualization within the Paris group flourished for only a few months in the early 1920s. My discussion situates a significant theoretical text by Max Morise, 'Les Yeux enchantés', alongside actual drawings by the foremost visual automatist of the time, André Masson. [2]

During the early years of French Surrealism, its paradigm of the inspired, unconstrained creative subject took shape only in fits and starts, and a preoccupation with specifically textual practices effectively postponed by a matter of years its recognition of the relevance of automatism to the visual arts. The experiments in hypnosis which the group conducted in late 1922 – the so-called Period of Sleeps – had certainly placed the phenomenon of liberated verbal expression at the forefront of concern. Following his enthusiastic report about these experiments in 'Entrée des médiums' ('The Entry of the Mediums', 1922), where he draws a decisive equation between the neologism *surréalisme*, the procedures of psychic automatism and the state of dreaming, [3] André Breton proceeded to compose his epoch-making definition of Surrealist automatism in his 1924 *Manifesto of Surrealism*, in terms which unabashedly privilege linguistic expression. [4] Indeed, even on the occasions when the *Manifesto* betrays a symptomatic enthusiasm for the exemplary creations of mediums and the insane, its allusions are rigorously confined to their writings, as distinct from their drawings. [5]

Thus, by late 1924, automatic writing had been consecrated as the primary mode of expression for Surrealism, which could boast a considerable bibliography of examples dating back to the pages of *The Magnetic Fields* which Breton and Philippe Soupault had compiled in 1919, not to mention Breton's more recent 'Poisson soluble' ('The Soluble Fish'), which, significantly, came out under the same covers as the first *Manifesto*. The outside observer could be forgiven for supposing that, at this juncture,

Surrealism was entirely blind to the visual potential of the automatic tech-
nique. True, there had been talk of the hallucinations experienced by those
who undertook automatic writing,[6] yet the fact that the Period of Sleeps
also gave rise to automatic drawings seems to have been little advertised.[7]

No doubt the explanation for such reticence has a lot to do with Breton's
apparent reluctance to commit the movement at this stage to a belief in
the visual arts as conducive to true Surrealist expression.[8] All the same,
it must have seemed axiomatic, even then, that a theory of creativity
premissed on the relaxation of control over the hand's expressive motions
should, in principle, allow that spontaneous drawing is as likely to arise
out of these conditions as spontaneous writing. Certainly, it can be said
that, by late 1924, a mature assessment of the potential of automatic
drawing was long overdue.[9]

Within seven weeks of the publication of the *Manifesto of Surrealism*, a
key article was to appear in the first issue of the new Surrealist maga-
zine, *La Révolution surréaliste*, under the title 'Les Yeux enchantés' ('The
Enchanted Gaze'). Its author, Max Morise, was a veteran of the Period of
Sleeps, albeit one who had remained – as had Breton, Eluard and Ernst –
immune to hypnosis. One can only speculate as to whether Morise himself
attempted automatic drawing. (A cartoon credited to him which appears
on page 6 of that same issue can be discounted as a consciously contrived
image.) Nonetheless, it is clear that, at long last, a Surrealist is prepared
to broach in positive terms the issue of Surrealist visuality and therefore
of visual automatism.

Morise's text opens boldly by announcing that it is time to extrapolate
the automatic principle from the purely verbal sphere to other fields as yet
unexplored. He gives to understand that, having revolutionized literature,
Surrealism may now be expected to revolutionize painting, photography,
cinema and any other visual medium. A brief discussion of the landscapes
of de Chirico allows Morise to establish a significant category of painterly
practice, namely the more or less lucid transcription of (recollected) dream
images and hallucinations. Significantly, Morise doubts that such activity
is altogether consistent with Surrealism: 'A picture by de Chirico cannot
be considered typical of Surrealism: the images are Surrealist, their expres-
sion is not.' Having thus sketched the idea of what we might call 'mimetic'
Surrealism, an idea which Breton was subsequently and grudgingly to
accommodate within his own theories on Surrealist painting, it remains for
Morise to examine an alternative mode of expression, the visual counter-
part of automatic writing.

Morise's two-page essay climaxes in an appeal to Surrealists to emulate
the exploits of madmen and mediums: 'Let us admire the madmen and the
mediums who find a way to impart fixity to their most fleeting visions,
just as, on a slightly different footing, the man dedicated to Surrealism

tends to do.'[10] His contention is that such creators usually opt for one of two approaches. Somewhat echoing what he had said about de Chirico's method, Morise speaks first of the rapid transcription of configurations arising within consciousness. Such hasty and usually incomplete attempts to capture an indivisible visual ensemble cannot, he implies, be very successful. The preferable strategy – one which he characterizes as more authentically Surrealist – consists in the generation of 'forms and colours [which] dispense with an object, and are organized according to a law which cannot be premeditated, and which takes shape and falls apart at the very moment of its manifestation'. Such spontaneous images, Morise insists, are a precise equivalent of 'the most imperceptible undulations of the flux of thought'. (His formula obviously echoes Breton's classic definition of psychic automatism as a facsimile of the 'real functioning of thought'.)

Morise now proceeds to speculate on the difficulties of the automatic process. Earlier in the essay he had spoken of the problem of the speed with which images succeed one another in Surrealism, and now hints that, if allowed to drag on too long, the automatic flux may forfeit its authenticity. One problem had already been encountered by the automatic writer, namely the difficulty of sustaining one's production without consciously responding to it: 'The whole difficulty lies not in starting up, but in *forgetting what has just been produced*, or rather in *ignoring it'* (Morise's emphasis). Stratagems such as closing one's eyes, covering over what one has just produced, or directing one's gaze toward the corner of the canvas, are dismissed by Morise as childish and inadequate.

In his essay, Morise explicitly cites only three artists: de Chirico, Picasso and Man Ray, none of whom is put forward as a true practitioner of automatic drawing. In fact, with a non-committal deviousness which I cannot but see as symptomatic of a desire to occult what is most precious, the essay comes to a close without actually having essayed the explicit formula of 'automatic drawing'. Morise takes leave with an exhortation to Surrealism concerning the potential of 'une plastique surréaliste' ('a Surrealist visuality'). It is true that, as his mention of brushes and canvas implies, this seems designed as a prelude to the discussion of Surrealist painting which Breton would shortly take up. Nevertheless, an emphatic visual hint is given in the form of an untitled ink drawing by André Masson, tipped into the text just above the passage about madmen and mediums (see figure 6.1). This little work must surely count as the first formally registered specimen of Surrealist automatic drawing.[11]

On examination, the image reveals several features of the artless, commonplace doodle: casual scrawls and squiggles, scribbled hatching, carelessly reiterated strokes, and one or two bold or dotted lines indicative of a more conscious intent. Though the sketch seems unemphatic, it

6.1 André Masson,
Untitled Ink Drawing,
c.1924 (© ADAGP, Paris
and DACS, London
1996)

does contain some nodal points, between which straight lines (and at least
one zigzag) create a link; so that the total image does begin to resemble
a diagram of a real or notional structure. A couple of more insistent lines,
along with two interpolations of the letter 'x', with its associations of 'mark-
ing the spot', could encourage the viewer to take the drawing as a modest
map communicating a set of spatial relations and priorities. (It might be
likened to the sort of diagram that a workman, such as an electrician,
might hastily scrawl so as to articulate certain aspects of a wiring job.)

 It is known that when Masson began making automatic drawings in late
1923, they still bore traces of the Cubist style with which he had recently
been flirting. [12] Indeed, several of his paintings of the period, such as *L'Ar-
mure* (The Suit of Armour), might more properly be assigned to Synthetic
Cubism than to Surrealism. [13] On the same grounds, one might be tempted
to disqualify the 'automatic drawing' that we are considering. Arguably,
it comprises a few of those little 'quotations' from ordinary life which
characterize Cubist art: in the top right-hand corner we may see a narrow
flight of steps, and in the bottom right-hand corner a pyramid mounted
on a pedestal. However, these forms might also be read as overlapping flat
zones, as though the drawing were mimicking the layered appearance of

papiers collés. Elsewhere, one or two shapes could suggest a nose or an eye, while a certain 'schizophrenic' incongruousness might be held to recuperate the drawing for Surrealism after all. [14]

On the whole, Masson's drawing seems stilted and slightly laboured, the product of bored rumination rather than ecstatic entrancement. It lacks fluency and brio, and is a comparatively wan response to Morise's lyrical equation of the 'fleeting visions' of madmen and mediums with the work of the Surrealist. It does seems disappointing that this lacklustre image should have wound up on this particular page. But what could be more disappointing is its air of deliberateness, as if Masson had produced it to order, thereby breaking the primary rule of automatism, the suppression of conscious control.

Fortunately, page 14 of the same issue of the magazine offers an alternative and superior specimen of Masson's Surrealist style (albeit a drawing whose insistent references to hands, knives and birds might still be judged a little programmatic); and automatic drawings by Masson were to become an obligatory feature of the official Surrealist publication, nine of them being featured across the first eight issues from 1924 to 1926. Some of these are juxtaposed to explicitly labelled 'Surrealist texts', i.e. samples of automatic writing, with the implication that they are complementary specimens, i.e. 'automatic drawings' (though no such caption appears). (On page 15 of the second issue, the Masson drawing is an ambiguous gathering of lemons, hands, breasts and other anatomical allusions. Since it is placed alongside prose replies to a questionnaire on suicide, its origins in unconscious process are ironically problematized.)

Though we have noted that it ignored drawing, Breton's first *Manifesto* had advanced a definition of Surrealism as 'pure psychic automatism' in which was stressed the need to empty the mind of its ordinary preoccupations in order to set inspiration free. André Masson must surely have had this passage in mind when, in a lecture he gave in 1961, he articulated for the first time his own recipe for automatic drawing.

The procedure Masson describes runs as follows: taking pen and ink to paper, one dispels all thought from consciousness – 'one must create an emptiness within oneself' ('il faut faire le vide en soi'). [15] Almost at once, it seems, the hand begins its scribbling, acting out an 'unpredictable birth'. Masson describes the initial phase of automatism in terms of a marvellous gestural spontaneity: 'the first graphic apparitions upon the paper are pure gesture, rhythm, incantation'. Only a moment or two later, the process enters on its second phase, characterized by the emergence of a perceptible *image*: 'The image (which had been latent) now asserts its rights. Once the image has appeared, it is time to stop.' [16]

If we are indeed prepared to accept a statement made in 1961 as fully relevant to procedures followed in the 1920s, it follows that authentic

automatic drawing can only be conducted over a brief period. A drawing starts out as a clutch of idle marks, mere scribbling, so to speak – yet this is very soon superseded by a compositional reflex. In the same way that Freud had warned that, in the dream-work, primary process might be subject to secondary elaboration, so does Masson warn us that consciousness is likely to pervert the pure graphic impulse. In a sense, there is no point in trying to block this development, if indeed we see pure kinetic activity with no intellectual input as what we might term 'mere scribbling', bereft of meaning. The second stage might be termed 'doodling', in the sense of impromptu mark-making with some glimmering of significance. [17]

But it is important to realize that Masson insists that too much secondary elaboration will ruin the composition: 'Once the image has appeared, it is time to stop. This image is no more than a vestige, a trace, a piece of wreckage [*épave*].' Masson's phrase is striking in its intimations of disaster, as if (shades of Mallarmé) the pure automatic drawing were expected to dwindle to a mere glimmer of meaningful form, a haunting because 'fleeting vision'. And indeed, if automatic drawing is to be equated with 'a concretization of the Unconscious upon the surface of the drawing paper', as Andreas Vowinckel suggests, [18] we need to reckon with the fact that any conscious apprehension of such concretization throws up the issue of whether the mind can ever negotiate a proper relationship to the spontaneous image after the fact: once the Unconscious has made its living mark, the conscious mind is left to prey over a dead residue, mere wreckage.

I suggest that an alternative way of going about reading the fragile image is to try to forestall the mind's tendency to reduce visual signs to a legible *Gestalt*. At the first stage of the automatic process, if indeed the person handling the pen or pencil has nothing in mind and intends no particular representation, then the marks left on the paper should, by definition, remain entirely unreadable, resistant to being construed. They should not even look like 'drawing', properly speaking. Or rather, as Masson is disposed to argue, such marks should hover on the brink of illegibility just so long as it takes for construal to begin. If it is possible for the agitations of the hand to be arrested at this precise moment, then the traces it leaves behind should achieve a paradoxical balance between illegibility and legibility. Which is to say that the automatic drawing that Masson has in mind is simultaneously abstract (a sample of 'mere scribbling' in its uneven swirl of lines) and also representational (a sample of 'doodling') in so far as those lines cohere (though only just) as a perceptible visual reference. [19]

Masson's definitional tightrope-walking may be seen to embody two principles or stages of development which, as Breton's own aesthetic system confirms, are essential to Surrealist art. One is the principle of non-rational spontaneity, which, at base, is not inconsistent with the model

of gestural immediacy that we might associate with expressionistic paint-
ers like Chaim Soutine, or indeed an Abstract Expressionist like Jackson
Pollock, in whose paintings trickles and stabs of paint are no longer asked
to resemble, or allude to, things in the world, but instead linger on the
canvas as unfeigned indices of the artist's gesturing. (Arguably, Pollock's
least legible canvases are equivalent to 'mere scribbling' with no intellec-
tual content.)

The second principle is perhaps complementary, rather than antithetical,
to the first. It has to do with what might be called 'unconscious refer-
ence', or perhaps 'libidinal expressivity', in so far as we are, after Freud,
prepared to suppose that the residue of the automatic process consti-
tutes a formation which is not in fact arbitrary but governed by mental
processes, albeit unconscious or only semi-conscious ones. The paradox
in the twinning of the two principles lies in the apparent swiftness with
which the evacuation of the mind in the first phase gives way to the replen-
ishing of awareness in the second phase. (Another way of putting this
would be to say that an initial 'blind' release of non-rational energy is
overtaken by a reflex of intellectual construal – the implication being that
it is practically impossible to subdue the reflex of 'making sense', however
hard one tries to remain detached.)

Let us clarify this theoretical discussion through practical example by
looking at two examples of automatic drawing from Masson's heroic
period. The fifth issue of *La Révolution surréaliste* contains a fine drawing
which, unusually, bears a caption: 'La Naissance des oiseaux' ('The Birth
of the Birds') (see figure 6.2). Significantly, it has been placed at the end of
Breton's 'Lettre aux voyantes' ('Letter to the Clairvoyants'), as if to remind
us of the mediumistic resonances of automatism. Though by no means
simple, the image does submit to a fairly straightforward identification of
its components. We can discern a naked female torso, with legs and breasts
indicated by tentative dottings and a belly drawn in arabesques. Less
legible forms tremble at the periphery, as if awaiting release. These forms
are perhaps instances of those vacillating traces of which Masson speaks.
The caption itself insists that we notice birds on the wing, though I also
see hands and vegetal fronds in the picture. My inclination is to find 'The
Birth of the Birds' a pleasing image, though perhaps not entirely an auto-
matic one. More plausibly, Masson is offering an allegory of Surrealist
invention, a vision of how the latent image hovers on the verge of defin-
ition. Most importantly, the female body and the bird on the wing recur
with sufficient frequency across Masson's output for their presence to
imply at the very least a semi-conscious symbolism (sexually aroused
woman = creativity; flying bird = inspiration).

Another untitled drawing from this same period (though not repro-
duced in the magazine) is a yet more striking instance of the development

6.2 André Masson,
*La Naissance des
oiseaux, c.* 1925
(© ADAGP, Paris and
DACS, London 1996)

of legible *Gestalt* (see figure 6.3). Here, elements of separate naked bodies can be made out: a male rib-cage, female breasts, a female belly and pubis; there are various arms and hands which seem to grope, caress, or probe. At the centre of the complex, a phallus seems linked to a hand. Though the contours of complete bodies are lacking, the image seems to imply a couple making love. In and around this configuration, other shapes seek to assert themselves, as if projected out from a central whirl of forms. Again, the trope of inspired flight seems to be present; again, we tend to elicit secondary formations from the primary, unconscious mass of scribbling. By now, we could hardly miss Masson's talismanic bird, launching itself toward the top of the picture, while a swirling leaf and horizontal lines resembling steps suggest spatial depth at the bottom.

Scrutiny of other automatic drawings would, I believe, confirm these findings. There is, after all, a discernible vocabulary of visual references (steps, leaves, bodies, birds, and so forth). Most undeniably, these drawings have a strong erotic tinge, and it might be simplest to admit that this is nothing other than the involuntary trace of repeated drawing routines, given that Masson pursued eroticism throughout his career as a conscious theme. On the other hand, if these are genuinely automatic images, we

should be surprised to discover their relative narrowness of invention, their reiterations, their stylistic sameness. Does Masson's Unconscious harbour only an obsession with sex and flying? There is, I think, no doubt that his automatic drawings of (*c.* 1923–6) not only form a stylistically consistent series, but are also of a piece with his more conscious drawings and paintings. This is hardly a reason to reject them as fascinating aesthetic propositions, yet, as documents of a scientific experiment, one could argue that they too often betray the presence of the professional draughtsman, and thereby fall short of the criteria of spontaneity and selflessness.

It is a curious fact that, whereas Masson seems to have deliberately constructed himself as the Perfect Automatist, in practice, the Surrealists themselves were not particularly fond of his drawings. In 1961, a rueful Masson reminisces that he never once sold an automatic drawing to a Surrealist associate (the same goes for his no less exemplary Surrealist experiments in sand painting). [20] If true, Masson's complaint would suggest that Surrealism was indeed more inclined to place value upon the crafted products of the painter's brush than on those of his nonchalant pen. Automatist authenticity was, in this sense, more an article of faith than an unfeigned preference, and many of the more convoluted arguments which André Breton felt obliged to develop in defence of Surrealist art lie encoded here. (I am thinking in particular of a passage in an essay of 1941, where automatism is deemed integral to all Surrealist art, if only

6.3 André Masson, Untitled Ink Drawing, *c.*1923–6 (© ADAGP, Paris and DACS, London 1996)

'sous roche' ('flowing underneath the bedrock'), a concession which allows a latitude to premeditation and conscious manipulation that would have been inconceivable in the mid-1920s.[21]

By 1926, Masson had indeed abandoned all pretention to perfect automatism, and had settled upon a painterly strategy wherein impulsiveness is offset by conscious artistic control. Such a compromise will hardly surprise anyone who has read statements by Surrealist painters, for whom satisfactory configurations could hardly arise without some element of deliberateness or conscious elaboration. Indeed, some might argue that all art, Surrealist or otherwise, requires at least a quotient of willed reflection, at least some touch on the rudder, as it were, else it will founder into the turbulence of arbitrary non-meaning, and express nothing. (Another view might be that there is no point in expecting to 'read' the Unconscious if it is not encouraged to meet us halfway: a scribbled message absolutely impervious to conscious construal may be genuine, but communicates precisely nothing to consciousness.)

Let me round off this survey of Masson and automatism by considering another creative model by which the artist was influenced, that provided by Taoism and Zen Buddhism. In 1930 Masson was to meet the Japanese writer Kuni Matsuo, who introduced him to Zen and to Oriental art. During his wartime exile, he spent time in the Boston Museum looking at Chinese landscape paintings of the Sung dynasty. Through the years 1950–5 he claims to have made a serious study of Zen Buddhism.[22]

Of course, Masson was not alone in the postwar period (one thinks also of artists like Michaux and Mark Tobey) in seeking to adapt some elements of Oriental calligraphy to his own European style. Chinese ink drawings of the classical period are typically premised upon gestural immediacy, a minimum of signs being directed toward a maximum of suggestivity. Zen masters of the art of drawing recommend lengthy spells of meditation in which the artist banishes superficial intellection in order to draw upon deeper, transpersonal resources. 'One must create an emptiness within oneself' could be just as much a Zen as a Surrealist motto; and Masson's knowledge of Eugen Herrigel's celebrated treatise on *Zen in the Art of Archery* would have initiated him into the ethos of the 'Master of the artless art',[23] the gesture-maker for whom ratiocination and prior purpose are anathema, and whose triumphant hitting of the centre of the target – akin to the eloquent flourish of a drawing – is but the external manifestation of an internal state of spiritual serenity and dispassionate equipoise, or what the Taoist scholar Chung-yuan Chang has called the 'direct opening of one's innermost being'.[24] As Masson himself understood, the important discovery is that this inner emptiness is no longer something negative, but 'fullness, the plenitude of a being divested of all mental deviation'.[25] This could also be taken to mean that the Perfect

Automatist eventually aspires not to a meandering plurality of smudged equivocations, but to a perfect focus upon the most startling and compelling of forms.

A more cautious analyst would probably hesitate to ratify the parallels I have suggested between procedures acceptable in the East and the activities of Western artists, however concerned the latter may be to escape their conditioning. Scientifically speaking, it might be very hard indeed to prove that the evacuation of the self and the inspired lunges of the brush of a Japanese master like Sesshū are in all respects consistent with the procedures of 'pure psychic automatism' outlined above. Perhaps I may have to concede that certain vital analogies voiced in Surrealism have a more emblematic than literal status. There is an audible strain of pure hyperbole in references like Morise's 'Let us admire the madmen and the mediums ...'; or Masson's fervent vote of thanks to the Sung painter Yü-chien for his 'meteoric' vision of a mountain village glimpsed through mist;[26] or, again, Breton's quaint encomium to the French postman Ferdinand Cheval as 'the uncontested master of mediumistic architecture and sculpture'.[27] Extravagant cross-cultural references of this kind may not always stand the test as literal authentications of Surrealist method, but can sensibly be read as political gestures, expressions of a generous solidarity with marginalized creators across the world.[28]

But whatever the final bearing of such startling parallels and of declared affinities more intuitive than intellectual, we should at least give credit to Masson for his single-handed endeavour in the 1920s to keep faith with automatist principles and to furnish evidence of a Surrealist visuality compatible with the movement's seminal definitions – perhaps above all with those early, sometimes blundering automatist formulae through which Breton breathed life into the Surrealist project, as when he announced that – 'we shall reduce art to its simplest expression, which is love'.[29]

Notes

1. André Masson, *La Mémoire du monde* (Geneva: 1974), p. 144.
2. Max Morise, 'Les Yeux enchantés', *La Révolution surréaliste* 1 (1 November 1924), pp. 26–7. I should at once acknowledge the limits of my enquiry, which is based upon a strict definition of automatic drawing, grounded in the classic Surrealist conception of psychic automatism. Masson is the most obvious exemplar in this respect. A more eclectic survey of the phenomenon would need to address artists both within Surrealism and on its margins, such as Yves Tanguy, Hans Arp, Joan Miró, Paul Klee, Antonin Artaud,

Unica Zürn, Adrian Dax, Wols, Henri Michaux and Camille Bryen, each of whom produced ink or pencil drawings while in various states of diminished intellectual control, whether deliberately or involuntarily assumed.

3. 'We have agreed to take [Surrealism] as designating a certain psychic automatism which corresponds fairly closely to the state of dreaming', asserts Breton (André Breton, *Œuvres complètes* I (Paris: 1988), p. 274).

4. For a discussion of the discovery of verbal automatism in Surrealism, see Bernard-Paul Robert, *Le Surréalisme désocculté* (Ottawa: 1975); and my article 'André Breton. Wahnsinn und Poesie' in Bernd Urban and Winfried Kudszud, eds, *Psychoanalytische und Psychoathlogische Literaturinterpretation* (Darmstadt: 1981), pp. 300–20. Surrealist notions of psychic automatism were most certainly coloured by knowledge of the phenomena of the mediumistic trance and the mental aberrations associated with psychosis. It may be added that Breton's 1922 report evokes a 'magic dictation' so rapid that the transcriber was obliged to use abbreviations (see 'Entrée des médiums', in *Œuvres complètes* I, p. 274). At one time Breton speculated on the possibility of using shorthand to capture the automatic message; so that we might be tempted to situate the shorthand typist beside the medium and the madman as forerunners of Surrealism.

5. I have little space to argue here that, by the early 1920s, an alert Surrealist would have associated psychosis and mediumism with both verbal and visual production. Hans Prinzhorn's classic 1922 study *Artistry of the Mentally Ill* (Berlin and New York: 1972 [1922]) was circulating within the group, offering evidence of the co-existence of writing and drawing in the expressions of the insane; while Théodore Flournoy's well-known 1900 monograph – *Des Indes à la planète Mars* (Paris: 1983 [1900]) – on the medium Hélène Smith had amply shown that the mediumistic trance could stimulate both verbal and visual messages. Marguerite Bonnet has pointed out that the Period of Sleeps coincided with a public vogue for mediumistic practices, which must have highlighted its procedures and formats (see her notes to 'Entrée des médiums' in Breton, *Œuvres complètes* I, pp. 1300–1).

6. In *Une Vague de rêves* ('A Wave of Dreams', 1924), Louis Aragon points out that automatic writing conduces to visual hallucination, a contention echoed in Breton's 1933 statement that 'automatic writing, when practised with a certain fervour, leads directly to visual hallucination' (*Œuvres complètes* I, p. 390).

7. The fact that Robert Desnos produced drawings as well as writings while in a trance-state is barely mentioned in Breton's 'Les Mots sans rides' ('Words without creases', 1922), in *Œuvres complètes*, I, p. 286. A spread of nine anonymous pages from the Period of Sleeps was to appear in 1991 in the catalogue *André Breton. La Beauté convulsive* (Centre Georges Pompidou, Paris: 1991), p.1100. These comprise scrawled texts and only a few rather unconvincing sketches.

8. In fact, as José Pierre has pointed out, Breton had placed the issue of painting on the Surrealist agenda in his Barcelona lecture of November 1922, given shortly after the first trance experiments (José Pierre, *André Breton et la peinture* (Lausanne: 1987), p. 80. It is as if Breton simply needed time to

mull things over before at last embarking upon the essay 'Surrealism and Painting' as the visual counterpart to the verbally-biased *Manifesto*. The final spur to action was provided by Pierre Naville's gibe 'there is no such thing as *Surrealist painting*'. This was printed in *La Révolution surréaliste* in April 1925 (issue No 3, p.27), a few months after Max Morise's essay of November 1924. Breton's essay came out in successive issues, beginning with the fourth, in July 1925, when he took over as director of the magazine.

9. I shall not venture here to discuss the many other cultures of automatism in Surrealist painting, collage, exquisite corpse drawings, sculpture and object-making, not to mention Surrealist incursions into architecture, photography, film, dance, arguably even music. Brassaï's photographic records of 'involuntary sculptures' in the shape of unconsciously deformed bus tickets are a reminder that impromptu automatism can manifest itself in the most mundane contexts, a point consistent with the notion of unconscious gestural expression examined in Freud's *Psychopathology of Everyday Life*.

10. It is interesting to note the eagerness and naturalness with which Morise invokes psychotic and mediumistic antecedents, and the fact that he feels the two to be 'perfectly comparable'. Prior to 1924, psychotic drawings had scarcely been discussed in Surrealist publications, and there is little tangible evidence that actual works by the insane were by now in circulation. The fifth issue of *La Révolution surréaliste* (October 1925) did contain a double-page spread, devised by Monny de Boully under the heading 'The Vampire', of caricatural drawings done by mental patients from a clinic in Belgrade. Unequivocal proof that the Surrealists had for some while been passionate about mediumistic art is also hard to establish, the first reproduction of a specimen in a Surrealist context occurring in July 1925, when a mediumistic drawing by a Madame Fondrillon, aged 78, was reproduced on the opening page of the fourth issue of their magazine, as a kind of frontispiece to Breton's editorial. (Like several other talismanic images, it was to be recycled in his classic *Minotaure* article 'Le Message automatique' ('The Automatic Message') of 1933.) In *André Breton et la peinture* (pp. 121–5), José Pierre surveys the various mediumistic prototypes of Surrealist visual automatism, listing artists like Victorien Sardou, Victor Hugo, Hélène Smith and Léon Petitjean, but giving no information as to the accessibility of their works.

11. Ironically, it would seem that Masson's drawing ended up being printed back to front, as Eluard realized when he examined his copy of the magazine. (See note by Françoise Will-Levaillant in André Masson, *Le Rebelle du surréalisme. Écrits* (Paris: 1976) p. 60. There were other illustrations in this same first issue, including a doodle by Desnos, a semi-architectural sketch by Pierre Naville and three caricatural vignettes by Max Ernst (supplementing the multiple vignettes he had supplied for the penultimate issue of *Littérature*). I believe none of these could be considered unequivocal specimens of automatic drawing.

12. See Dawn Ades, 'Movement and Metamorphosis', in André Masson, *Line Unleashed* (London: 1987), pp. 18–44 (pp. 21–33).

13. *L'Armure* was reproduced in *La Révolution surréaliste* in July 1925 (issue No 4, p. 22). Several other paintings by Masson appeared in the magazine during this same period, coinciding with the serialization of 'Surrealism and Painting'.

14. A classic instance of a schizophrenic drawing based on the accumulation of incongruous figures would be the 'Achilles shield' drawn by the mentally disturbed Nadja on a restaurant serviette. It was first reproduced in Breton's *Nadja* in 1928 and then recycled in 'The Automatic Message' in *Minotaure* in 1933. While Nadja's alleged insanity itself remains a thorny issue, it is interesting to note that the first printing of the image situates it in a context of mental aberration and conceptual confusion, while its second printing, amid mediumistic images establishes its visionary status. In a sense, Breton uses it as a *passe-partout* to facilitate the amalgamation of separate types of aberrant image-making.

15. What Dawn Ades terms 'the suspension of the self' ('Movement and metamorphosis', p. 34) corresponds perfectly to Breton's insistence on the automatist as one who functions impartially, as a 'modest *recording mechanism*' (*Manifeste du surréalisme* in Breton, *Œuvres complètes* I, p. 330).

16. André Masson, 'Propos sur le surréalisme', in *Le Rebelle du surréalisme*, p. 37.

17. In a later issue of their magazine, the Surrealists published a double-page spread of doodled blotting-pads stolen from the table after a government cabinet meeting. (See *La Révolution surréaliste* 6, March 1926, pp. 16–17.) Aragon's accompanying commentary asks: 'Can one distinguish one minister from another on the basis of their drawings? That is the question', and suggests that the baroque formations in the bottom right-hand corner are indistinguishable from the work of a lunatic. High praise indeed! Naturally, the document may be no more than a spoof; but, if it is taken seriously, we need to reflect whether we are prepared to disparage these images as stereotypes, or to admire the way unconscious expressivity can bubble up in an otherwise formidably anti-Surrealist context. After all, as documents, the ministerial doodles are as authentic as any other in the magazine.

18. Andreas Vowinckel, *Surrealismus und Kunst, 1919 bis 1925* (Zurich and New York: 1989), p. 319.

19. In a major article on the ambiguities of doodling, David Maclagan proposes that we see in it 'an "organic" idiom that is beyond conventional distinctions between figurative and non-figurative.' David Maclagan, 'Solitude and Communication: Beyond the Doodle', *Raw Vision* 3 (Summer 1990), pp. 34–9 (p. 39).

20. See Masson, *Le Rebelle du surréalisme*, p. 35. All the same, we should note that at least Breton showed an interest, as witness the letter dated February 1925 which indicates his readiness to compose a preface to a planned (though never realized) album of Masson's automatic drawings (see *André Breton. La Beauté convulsive*, p. 175).

21. See Breton, 'Genèse et perspective artistiques du surréalisme', in *Le Surréalisme et la peinture* (Paris: 1965), p. 70.

22. See Masson, *La Mémoire du monde*, pp. 139–40.

23. Eugen Herrigel, *Zen in the Art of Archery* (London: 1953), p. 89. Masson refers to Herrigel in *Le Rebelle du surréalisme*, p. 172.

24. Chung-yuan Chang, *Creativity and Taoism. A Study of Chinese Philosophy, Art and Poetry* (New York: 1963), p. 108.

25. Masson, *La Mémoire du monde*, p. 142. My article 'The Later Works of Wols, Abstraction, Transparency, Tao', in Peter Inch, ed., *Circus Wols* (Todmoren: 1978), pp. 33–44 makes a parallel case for seeing Wols's non-referential ink-drawings in much the same Taoist or Zen-like spirit.

26. See Masson, *Le Rebelle du surréalisme*, p. 172. The painting in question is reproduced, with details, in Hugo Munsterberg, *Zen and Oriental Art* (Charles E. Tuttle, Rutland VT and Tokyo: 1965), pp. 44–7.

27. André Breton, in 'Le Message automatique' (1933), in *Œuvres complètes*, II, p. 383. That same key text – which represents Breton's late yet splendid acknowledgement of so many of the mediumistic references he had previously seen fit to occult – contains a further miscellany of models for Surrealist automatism, including the visionary imagery of Gustave Moreau (some of whose late watercolours are almost certainly 'automatic' in the Surrealist sense), and the formal properties of art nouveau designs, which Breton sees as an implementation of mediumistic styles. He lists their common properties as: a stereotyped yet strictly unrepeated patterning which conduces to discrepant proliferation; a delight in curves reminiscent of such natural forms as ferns, ammonites, and embryos; an obsession with minutiae to the detriment of overall effect; the triumph of ambiguity and complexity; and a certain affinity with the arts of Ancient Asia or the Americas (Breton is no more explicit than this, but possibly has in mind Ancient Khmer and Mayan designs). José Pierre suggests that many such features are also characteristic of schizophrenic art, citing Gatson Ferdière on stereotyping, iteration and cramming. But Pierre rightly refrains from seeing psychotic and mediumistic art as identical (*André Breton et la peinture*, p. 124).

28. See my article 'Les Arts marginaux et l'esthètique surréaliste', in C. W. Thompson, ed., *L'Autre et le sacré, surréalisme, cinéma, ethnologie* (Paris: 1995), pp. 51–71.

29. Breton, 'Poisson soluble', in *Œuvres complètes* I, p. 359.

Conroy Maddox, *Spectre of the Child*, 1994–5

Magritte and the Cinema

Robert Short

Rectangle for rectangle, much less critical attention has hitherto been paid to the interaction between the white canvas and the silver screen than to, say, the painting and the photo. In part, this is because the cinema is, relatively, such a new form, with fifty years less history than photography. But mainly it is because painting and photography share a common fixity; their images can be reproduced in the same terms. In this respect, the relationship is close. Cinema, on the other hand, both benefits and suffers from a visual fluidity that stills cannot capture. Even armed with video zapper, the cinema effect is fugitive, cinema being a time art. [1]

Magritte, for one, was acutely aware of this difference and the problems that it caused when efforts were made to make movies about his pictures. After the 1960 première of Luc de Heusch's sensitive documentary about him, Magritte acknowledged in an interview that cinema in the hands of a Dalí or a Buñuel could be a fine vehicle for Surrealist myths, but added: 'Personally, if I know the rudiments of the cinematographic art, I could only express my ideas through painting. Cinema is an art of movement, and the reproductions of my work that you see on the screen are – in the very nature of things – static.' He stated flatly: 'I am involved in cinema as a spectator only.' [2]

Donning the bowler hat of the Brussels *petit bourgeois*, he took pleasure in debunking the pretentions of art cinema: 'My favourite films are *Babette s'en va en guerre* and *Madame et son auto*, he declared defiantly in the late 1950s. The first mentioned was a Christian Jacques pot-boiler for Brigitte Bardot, the second a tacky comedy by Robert Vernay. His letters to friends are scattered with mostly frivolous comments about the latest films he had seen. His yardstick was a simple one: films were either 'boring' or 'amusing', with the latter sort becoming increasingly uncommon. James Bond films, 'with all their gadgets and underwater sports', he found 'boring in the extreme'. Hitchcock was 'an imbecile of great talent'. His most savage anathemas were reserved for what he called 'moral cinema' typified by Truffaut's *Les Quatre Cents Coups*: 'I can't stand cinema that tries to teach me something or present an argument; that kind of cinema bores me …

Like the boring lesson, it lacks morality, Lack of pretention paradoxically leaves the indispensable morality intact.'[3]

Such apparent philistinism on Magritte's part with regard to film might suggest that the subject 'Magritte and the cinema' is lacking in mileage. And the paucity of references to film in both Sarah Whitfield's catalogue to the 1992 Magritte retrospective at the Hayward Gallery and in David Sylvester's recent monograph for Thames and Hudson might confirm that it is unpromising.[4] However, regarding Magritte's own cavalier attitude, one can find reassurance in George Melly's remark about Magritte's later writings that they either 'only illustrate the obvious, or negate everything'. And if Magritte's views about individual films were often dismissive and anti-intellectual, there is no doubt about his enthusiasm for the medium as a regular film-goer, right from his youth in belle époque Charleroi to old age in 1960's Brussels. Patrick Waldberg evoked the twice-weekly treats of the teenage Magritte brothers in the early 1910s: 'Mystery, violence, love, these in their purest form René and Paul met with on Thursdays and Sundays when serials, thrilling and silent, were shown at the local cinema-tographic theatre in Charleroi.'[5] An exception to Breton's generalization that there is 'an age of cinema' roughly corresponding to adolescence and the years before marriage, Magritte kept up the film-going habit to the end of his life, patronizing any Brussels flea-pit in his locality that would also tolerate his Pomeranian, Loulou. Emulating the first generation of twentieth-century avant-garde painters and poets, such as Apollinaire, Jacob and Picasso, Magritte seems to have enjoyed from the start an unstudied familiarity with popular cinema. For him, as for his Surrealist contemporaries, it was a constant, if only half-conscious, source of visual information and stimulation.

So perhaps there is something after all to be got out of juxtaposing the terms 'Magritte' and 'Cinema'. José Vovelle, Suzi Gablik and Patrick Waldberg have certainly thought so.[6] It is in their footsteps that this little article initially treads – to ask first of all whether and how film may have influenced Magritte's paintings, and second – reversing the equation – whether and in what ways the forms and images of Magritte's paintings may have been subsequently transposed into cinematic terms.

No doubt, Magritte's passion for the cinema in the period that gener-ated his main pictorial scenarios and strategies – that is to say to the end of the 1920s – was powered by the same affectivity as that of other Sur-realists of the first generation. Many of the earliest publications of founder Surrealists, such as Breton, Aragon, Soupault and Desnos, were about film or inspired by it. Initially, this was an unqualified appreciation of the medium as such, irrespective of the quality of individual movies. The Sur-realists loved the cinema for the way in which it confused common-sense distinctions between the states of dream and waking life. As Buñuel once

put it: 'The cinema seems to have been invented to express the power of the subconscious whose roots penetrate so deeply into poetry ... The film seems to be the involuntary imitation of the dream.'[7] In the cosy, dark cocoon of our seat in the cinema, the film experience is oneiric, the projected lights and shadows hallucinatory. The spectator is open to these solicitations of the marvellous. The cinema can lend verisimilitude to such wild fantasies. Thanks to our naïve assumption that the camera cannot lie, *mises-en-scène* can present Méliès's grimacing heads as black notes on a music score or Buñuel's cow on a bed with the same realistic persuasiveness as documentary footage of fishermen or coalminers. Thanks to the power of editing to bring together the most incongruous of events and the most distant of locations, any leap of the imagination can be lent conviction.

Not only was the cinema a potential treasure-house of extraordinary images, it also marshalled these images into narratives. As narrative, it paralleled those fractured stories that tended to emerge from Surrealist practice with automatic writing and matched the implied narratives within so many Surrealist paintings. Thanks to the directness of its communication and the power of its illusions, it undermines differentiation between reality and its representation. It causes us to suspend disbelief and to identify with the shadows on the screen, sharing their laughter and their tears. To quote Robert Desnos: 'However bad the scenario, however detestable the direction, it is still about a flesh and blood hero, no less real than those of our dreams.'[8] Furthermore, it invites us to transgress the frontiers between public and private domains – at the start of Welles's *Citizen Kane,* the camera, bearing the spectator's gaze along with it, ignores the signs saying 'No trespassing', enters Xanadu and advances to Kane's bed, to the very threshold of his dying lips. Noting cinema's incorrigible intrusiveness into the most private worlds, Breton extolled its unmatched capacity thereby to speak of love – to 'concretise the powers of love': 'There is a way of going to the movies as others go to church and I think that, from a certain angle, quite independently of what is playing, it is there that the absolutely modern mystery is acted out.'[9]

When it came to differentiating between films rather than valorizing the medium itself, the Surrealists' preference went for popular cinema. They made an anathema of the pretentions of 'the seventh art' along with the formalist experimentation of the aesthetic avant-gardes. In this sense, Magritte's insouciance of the 1960s recalled earlier was quite consistent with early Surrealist positions. Cinema endeared itself on account of its humble and unrespectable fairground origins, by the fact that it was despised by high-culture snobs and was as yet untouched by deadening academic criteria. They loved the films of Mack Sennett, of Keaton, Chaplin and Harry Langdon, Pearl White serials and *The Mysteries of New York.* The

very imperfections of early cinema – its technical clumsiness, narrative incongruities and lapses of continuity – opened up a space for the reveries of the spectator. It is clear from Magritte's letters to his friends that he used the cinema as a kind of 'workshop of chance' or 'trampoline for the imagination'. Along with other Surrealists, he would wilfully misread films. Resisting the narrative drift, he would tease out congenial latent meanings within the most banal manifest texts. By the same token, whole films could be 'saved' by a single *trouvaille*. Magritte's enthusiasm for Pierre Etaix's comedy of 1962, *The Suitor,* was accounted for by a single gag: an English girl learning French as a guest in a French family, with her grammar book in her hand, astonishes her host as he enters the salon by solemnly declaring, 'Le livre est sur la table'. [10] The joke must have appealed to Magritte because it displayed the same sense of humour as *Ceci n'est pas une pipe.*

It might be said that the Surrealists' early position on the cinema was close to the one that they adopted towards advertising. Both were most often treated as a kind of 'given', as part of the natural and unproblematic flora and fauna of the modern city – 'innocent' material to be exploited by the poetic imagination as it prospected for 'everyday marvels'. This meant that, initially at least, they tended to ignore the ideological functions of mainstream cinema, just as they ignored the 'cretinizing' role of advertising in the service of capitalism. They were willing dupes of the seductive masks of what, in other respects, they denounced as an exploitative economic system. Putting it differently, the welcome they gave to cinema and advertising – and Magritte in the 1920s earned most of his income from his commercial art – was another way of cocking a snook at established culture's hierarchizing of art forms and genres. There was, inevitably, a downside to this 'innocence'. It meant that they made an abstraction of the commercial and industrial determinants of film as a commodity in the market economy. Nearer home, it also meant that they chose to be blind to the work which went into making films, in contrast, say, to much less-mediated forms of expression, such as automatic writing or painting. Their patronizing lack of appreciation of what went into making a film was eventually too much for the patience of a 'practitioner' like Buñuel. Their initial refusal to acknowledge the material realities of cinematic production accounts both for their subsequent disillusionment with mainstream cinema and for the paucity of a specifically Surrealist cinema.

It is one thing to discuss Magritte as a consumer of films and to relate the quality of his spectatorship to that of the Surrealists in general in the 1920s. It is altogether another thing to find examples of the influence of the cinema in his work as a painter. We do know that, when José Vovelle and Louis Scutenaire put the idea to him in an interview that there might

be cinematic sources for some of his pictures, Magritte accepted the possibility quite cheerfully.[11] The debt that has been most confidently and fully explored is the one that Magritte owed to the serial film, *Fantômas* (1913–14), directed by Louis Feuillade, and itself based on the pulp novels of Pierre Souvestre and Marcel Allain that had started appearing in 1911. According to Patrick Waldberg:

> Poets were stirred by those films of dark adventure. Apollinaire and Max Jacob adored them and the noble Robert Desnos celebrated them in his famous ballad. The actors who incarnated the heroes of that fantastic *chanson de geste* became the Magritte boys' idols, and something in René still catches fire [Waldberg was writing in 1965] at the mention of their names: René Navarre (Fantômas), Bréon (Juve), Georges Melchior (Fandor), Renée Carl (Lady Beltham).[12]

An indisputable example of Magritte's homage to his favourite director is *The Murderer Threatened* of 1927 where the staging, with its two foreground figures in ambush, derive directly from the *mise-en-scène* of stills from Feuillade's *Fantômas*. In his treatment of this pair of figures, Magritte substitutes overcoats and bowler hats for their leotards and masks and arms them with net and bludgeon in place of baulks of wood. This is, in fact, the first appearance of Magritte's famous bowler-hatted men, here waiting to pounce on the suave murderer; they are straight borrowings from the dumb detective clones commanded by Inspector Juve elsewhere in the *Fantômas* serials. David Sylvester goes further:

> But beyond such particular images there is the pervasive influence of Feuillade's way of seeing the world – an impassive gaze at acts or threats of violence or aberrations of nature or states of madness presented in a tidy, formal, often symmetrical setting, a gaze from a constant position at the level of the scene and squarely facing its centre. This is how Magritte's art also coolly confronts the world in all its terrible mystery.[13]

Fantômas was so congenial because he simultaneously terrorized and mystified Paris in the way that the Surrealists, with their public provocations, campaigns of insults and incipient violence, also sought to do. Fantômas was a kind of pulp-fiction Maldoror in the lineage of the venerated de Sade. 'The genius of crime' delighted in cruelty and treachery, especially at the expense of the rich and privileged. He was also the man with a hundred faces. His malleable metal mask enabled him to don any disguise. In this, he stood for the forces of transfiguration and transformation that lie behind Magritte's art. He could be anywhere and nowhere, even apparently two people simultaneously. He always outwitted the

police, substituting some hapless proxy on the guillotine even as the blade descended. In the episode, 'Messenger of Evil', the uncatchable man in the mask escapes from justice by donning gloves made from the skin of a dead man's hands; in *The Red Model* (1935) Magritte offers us a pair of shoes made from a woman's feet. Fantômas became an alter ego for the painter, as numerous self-portraits such as *Le Barbare* testify. Perhaps Magritte's strategies for an anonymous and inconspicuous life-style were his version of Fantômas's incognito. According to Patrick Waldberg:

> Like a Fantômas looming over the dome of Les Invalides hurling his defiance at a mesmerised Paris, the Master of Mysteries is about to hatch his plot against formal art and stagnating attitudes. But contrary to the Master of Crime, he'll not go for material goods; he'll satisfy himself with being an intellectual dynamiter ... Magritte will concentrate his cunning and his forces on the Great Assault, the one absolutely desirable assault: that which free hearts deliver against the poverty of everyday life. [14]

Alongside the many drawings and paintings of the mid-1920s evoking Feuillade's anti-hero, Magritte also took to writing his own filmscripts, like this fragment quoted by Suzi Gablik (Juve has tracked down Fantômas to his subterranean hideaway):

> Fantômas is close by, sleeping deeply. In a matter of seconds, Juve has tied up the sleeper. Fantômas continues to dream, of his disguises as usual ... Juve, in the highest of spirits, pronounces some regrettable words. They cause the prisoner to start. He wakes up, and, once awake, Fantômas is no longer Juve's captive. Juve has failed again this time. One means remains for him to achieve his end: Juve will have to get into one of Fantômas's dreams – he will try to take part as one of its characters. [15]

The figure in a skin-tight rubber suit or body stocking had a privileged place in Magritte's art of the mid-1920s. A classic icon was *L'Homme du large* (1926) – the title was borrowed from Marcel L'Herbier's silent film of 1920; Sarah Whitfield called this hero from the Surrealist pantheon, who appears to have ridden in from the sea, 'the embodiment of forces that menace the stability and order of society'. [16] The masked figure in the black body stocking was part of the mythology of the 1920s, not just in Feuillade but in Fritz Lang's *Spies* (1919) and as the somnambulist Cesare in Wiene's *The Cabinet of Dr Caligari* (1919). Opening the Cabinet Maldoror in Brussels in 1925 with his talk, 'Introduction to the cinema', Magritte's friend and apologist, Paul Nougé, said that the anonymous silhouette in

the black tights represented 'the very image of our disquiet'. [17] And it could sheathe a woman just as well as a man. The Surrealists made as big a cult of the actress Musidora's Irma Vep, the leader of the Vampires' gang in Feuillade's 1915 eponymous serial as they did of Fantômas. The 1929 Surrealist special number of *Variétés* included several photos of Musidora with the caption: 'What we were in love with during the war'. Magritte dressed his wife Georgette up in a black leotard and photographed her lying on a marble mantlepiece in homage to a frame from *Les Vampires*.

It has to be admitted that the derivation film/painting is not exclusive, nor always watertight. Controversy rages over the source of Magritte's famous spherical bell with the lateral slit and over the skittle objects that recur throughout his work. José Vovelle finds the origin of the first in the curtain of a music hall made of ribbons hung with giant bells in a scene from Lang's 1922 thriller *Dr Mabuse the Gambler,* and the source of the balisters in a nightmare scene from *The Testament of Dr Mabuse.* Likewise, Richard Calvocoressi traces the great eye in Magritte's *The False Mirror* to a still from Karl Gruhne's expressionist *The Street,* reproduced in a 1928 number of *Variétés.* [18] Of course, the inspiration could have been multiple. For example, like Desnos with his ballad, 'La Complainte de Fantômas' or Tanguy's painting of 1925, the inspiration for many Magrittian images could have come from the original serial novels by Alain and Souvestre as much as from the Feuillade films. We know that Magritte was a fan of pulp fiction and comics – such as Nick Carter and Nat Pinkerton. He also went in for the detective stories of Rex Stout and later Dashiel Hammett; Simenon's hero Maigret appealed to him because of the similarity of their names. Many of the titles of Magritte's paintings – *Le Corps bleu, Le Dormeur téméraire, Le Temps menaçant* – recall those of episodes in the original Fantômas volumes – *L'Aube tragique, La Douche de sable, Le Génie du crime*, etc.

Contestable as the origins of individual Magrittian images may be, the matter of linkage between screen and canvas does not end there. Both more profound and more interesting than specific *paroles* is the issue of the broader Magrittian *discours* – that is, evidence of structural and syntactical upheavals in his painterly language which may have been provoked by the new mode expression – his cultivation of pictorial equivalents to filmic devices such as framing, montage, camera movement, simultaneity, point of view, depth of field and narrative sequentiality.

Pictures composed of multiple, repeated frames, albeit with minor changes between the frames, such as *Man Reading a Newspaper* and *Murderous Sky* of 1927, suggest the frames of a movie film and the passage of time through successive frames. The fragmented nude portrait of Georgette, titled *L'Évidence éternelle* of 1930, is like a series of individual close-ups. A constant of cinematic expression is its play with concealing

and revealing, both spatially, via the crop, through the framing of individual shots, and temporally, via editing, through ellipsis. The film director Nicholas Roeg highlighted Magritte's suggestive exploitation of framing in the 1993 BBC2 documentary *Talking about Magritte* when discussing the 1928 picture, *Person Meditating on Madness:* 'We can't understand where he is looking; it's just outside the frame. We are as it were waiting for the next shot. It's another story we can't know but only conjecture about.' Recognizing his cinematic strategy, Alfred Hitchcock, if we are to believe Michael Gould, paid discreet homage to Magrittian framing in *The Birds*.[19] And, indeed, Hitchcock himself might well have spoken these words from a Magritte interview of 1964:

> Everything we see hides another thing, we always want to see what is hidden by what we see. There is an interest in that which is hidden and which the visible does not show us. This interest can take the form of quite an intense feeling, a sort of conflict one might say, between the visible that is hidden and the visible that is apparent.[20]

In all sorts of ways, Magritte's dislocations of everyday reality matched the cinema's repertory of special effects. Objects in *Le Château des Pyrénées* or *La Légende dorée* challenge gravity in the way the hero of a 1900's movie by Ferdinand Zecca flew over the roofs of Vincennes on a giant cigar. In *La Géante* and *Personal Values*, Magritte takes liberties with scale and proportion with the same dash as Méliès in his 1890's film *The Rubber Man*. 'The dominion of light' is an enigma rooted in the 'day for night' special effect that the French call 'la nuit américaine'.

More generally, the melodramatic mood that prevails in Magritte's paintings of the period 1926–8 matches that of much silent cinema in its last years. In this period Magritte was producing numerous macabre images tinged with eroticism, such as *Titanic Days* and *Young Girl Eating a Bird*. Unlike the puzzle pictures of later years which pose perceptual riddles, these seem to be narrating fragments of stories. The choice of titles such as *L'Histoire centrale* and *La Lectrice soumise* also underscores the narrative thrust. It is as if Magritte was trying to endow his imagery with a force comparable to that generated by the cinematic techniques of Griffith and his successors.

It is tempting to try to identify quotations in Magritte's paintings from specifically Surrealist cinema. The substitution of one part of the anatomy for another that occurs in the seduction sequence from *Un Chien andalou* is the primary conceit in Magritte's 1934 *The Rape*. The confusion of a dress and its wearer fetishistically provoked by Buñuel in *L'Age d'or*, finds its Magrittian counterpart in his 1936 painting *La Philosophie dans le boudoir*. And a drawing for his 1944 series of illustrations to Lautréamont's *Les Chants de Maldoror* – with the caption 'He felt his body splitting in two

from top to bottom' – is a literal rendering of a trick photography shot from Germain Dulac's and Antonin Artaud's 1927 film *La Coquille et le clergyman*. But it is more fruitful to look for affinities between Magritte and Surrealist cinema in terms of a common 'way of seeing' rather than in individual images. And we need to be clear how much of a disappointment most commercial cinema has been for the Surrealists, only redeemed by their own labour, as passionate spectators, of wilful misreading, of 'delirium of interpretation', or by the happy discovery of *trouvailles,* against the odds, in a mass of product that forever failed to deliver on what the Surrealists saw as cinema's marvellous potential. André Breton, in *As in a Wood* (1951) summed up their position:

> One cannot refrain from a certain nostalgia for the idea of what the cinema might have become and to allow that the sordidness of the epoch and of its exploitation were enough to clip its wings as soon as it flew the nest. Nowhere else but in the cinema could we be fitted to receive that 'Key to the Opening' which Malcolm de Chazal speaks of, that can make the mechanism of correspondences operate as far as the eye can see. But of course, to keep to a theatrical type of action has been preferred. I have said that 'Poetry must lead somewhere', but the least one can say is that the cinema has not taken one step in that direction.[21]

With *Un Chien andalou* and *L'Age d'or*, however, we have cinema as, for the Surrealists, it really might have been – truly delivering on its promise to 'make the mechanism of correspondences operate as far as the eye can see'. Of course, Breton was referring here to the inner eye of the imagination, not to the retinal eye. In this sense, the notorious prologue to *Un Chien andalou* can be read as a filmic equivalent to Magritte's strategies for aggressing the very faculty which is addressed by cinema and painting. Jean Vigo said of this opening sequence: 'It leaves us with no alternative but to admit that we will have to view this film with something other than the everyday eye.'[22] And Linda Williams added more recently: 'Blindness, as every poet knows, is but a figure for a different kind of sight.'[23] It was not for nothing that Magritte, in perhaps the most famous of all the group portraits of the Surrealists, the 1929 photomontage around his painting *The Hidden Woman,* presents them all with eyes closed. No one, by subverting the world of objective appearances, has done more than Magritte to privilege the 'inner eye' of the imagination. Magritte's work can be read as a sustained meditation on ways of seeing – a never-exhausted problematization of vision.

The preceding has made a stab at examining some of the ways in which cinema may have been a determinant of Magritte's painting. Let us now turn the coin over to look for a possible Magrittian impact on the 'seventh art'.

I have already quoted from a pastiche *Fantômas* script written by Magritte in the 1920s. Like other Surrealists from the first generation – Soupault (who claimed to have written 'cinematographic Surrealist poems' as early as 1917[24]), Péret, Desnos, Artaud – Magritte wrote a number of short film scenarios. Such proposals for films – deconstructions of the dominant models provided by commercial cinema – could be said to have become a Surrealist genre in their own right. But it was really a literary genre. These texts aspired to the freedom with which Surrealist poets credited cinema while flaunting their own unfilmability.[25] When visual artists such as Marcel Duchamp, Man Ray or Fernand Léger turned to the cinema, it was with a view of film-making as an extension or creative prolongation of the activity of painting. At a different level, Jean Cocteau used *Le Sang d'un poète* as a shopwindow for his drawings and wire sculptures. The ethos of Paris avant-garde silent cinema encouraged such an attitude and such a usage. Labels like 'Impressionism' and 'Photogénie' deliberately underscored the avant-garde's prioritizing of the pictorial arts over Hollywood's investment in narrative and psychology drawn from the novel and the theatre. Magritte's own scenarios seem to have their place somewhere between those of the other Surrealist poets and the visual artists. A typical example, co-written by Magritte and Paul Nougé, and variously dated 1928 and 1932, was *L'Espace d'une pensée*. It is not clear whether this was ever shot or whether it was subsequently lost or destroyed. Whatever the case, Nougé has said that it was no great loss since such works were 'valuable only in their intentions'.[26] The script of *L'Espace d'une pensée* amounts to a string of descriptions of iconography which might have been drawn directly from Magritte's paintings of the time: 'The night opens on a man viewed from behind, holding in his hand a mirror in which one sees a painted picture'; 'Empty sky, a cloud, a piece of cloth blowing'; 'Seated woman with head veiled.'[27]

Another unrealized project, this time with Henri Storck in 1936, was *L'Idée fixe*. Liberally scattered with Magrittian motifs, such as the burning tuba, the locomotive in the fireplace, trees with horsebells for fruit, *L'Idée fixe* also seems to have borrowed from Buñuel's *L'Age d'or*, with its scene of an orgy with couples rolling on the ground intercut with a shot of a cemetery and a sequence of notables and priests walking with a martial step, carrying flags, amid explosions.[26] In the mid-1950s, Magritte had acquired his own 8mm cinecamera and began to make short comedies starring his wife and their friends. These were later transferred to 16mm and restored in 1976 with the title *La Fidélité des images*. The flavour of production can be gauged from Magritte's letter to Louis Scutenaire of 2 October 1956:

So that we can enjoy later on seeing and reseeing the film that I am going to make in Ostend, will you be good enough to think of a few

scenes that will be easy to film. For example, Irène sucks one of Scute-
naire's thumbs and Georgette the other. Or Irène and Georgette are
sleepwalking with their heads leaning on pillows they are holding –
but that involves props – as far as possible do without props![28]

Most of the sequences involve unlikely goings-on in bourgeois house-
holds, all executed with broad humour – burlesque, dressing up, disguise,
games of concealing and revealing. Like the unrealized or lost films of the
inter-war period, Magritte's 'home movies' of the 1950s eschew narrative
continuity, offering instead a succession of *tableaux* or sight gags, mostly
fairly literal renderings of familiar tropes from his paintings. Magritte's
honeymoon with his new toy was brief. In November 1956 he wrote to
Maurice Rapin that he was hoping for a fortnight's peace to do another film:
'It's tiring though and hardly remunerative, all things considered – so
much to set up for such fugitive and dubious results.' Finally, in January
1957, he wrote 'I have to bury my cinema, the interest of which seems to
me more and more problematic.'[29]

It is undeniable that Magritte's own œuvre as a film-maker was fairly
meagre. What we know suggests that the combination of expense and
the work involved deterred him. He was no Andy Warhol. Magritte's films
have not excited nor do they deserve the degree of interest recently shown
in his still photography. Neither the Virmaux, nor J. H. Matthews, in their
respective books on Surrealism and film, even mention Magritte.

But what of the influence of Magritte's work as a painter on the cinema
at large? There would certainly seem to have been a legacy to Surrealist
film-makers, such as his compatriot Marcel Mariën in *Imitation du cinéma*
(1959) and Jacques Brunius in *Violons d'Ingres* (1945). Homage has been paid
to him by animators such as Raoul Servais in *The Harpy* (1979) and Gerald
Frijdman in *Scarabus*. Debts and references ranging from the truly signif-
icant to the merely incidental can be found in more mainstream films such
as Paul Cox's *Man of Flowers*, Nicholas Roeg's *Performance,* Terry Gilliam's
Time Bandits, Jaco Van Dormael's *Toto the Hero* as well as in the décor of sev-
eral Godards. The presence of a Magritte reproduction on a wall is often
an unobtrusive metonymy standing for enigma in the European art film
and its successors.

But if there has undeniably been a Magrittian impact on the cinema, it
still needs explaining, perhaps, why what Robert Leedham once called
'the bowler legacy' has been relatively slight in the case of film when set
beside, say, the legacy to advertising.[30] Magritte's posterity is very evident
among painters – Robert Rauschenberg, Jasper Johns and Roy Lichten-
stein, to mention only three. His images, or pastiches of them, have been
widely pirated for the covers of paperback books. They were enormously
in vogue on pop vinyl record sleeves in the 1960s and 1970s. They figured

in the credit sequence for the fifth series of commercial television's *The South Bank Show*. The marketing of Magritte has unquestionably been most extravagant in marketing itself – that is, in advertising. One need look no further than recent campaigns by Benson and Hedges, TDK cassettes and InterCity. David Lee has said that Magritte's credits in advertising would fill a telephone directory. Deftly sheering Magritte's enterprise of its subversive intent, the admen have latched for all they are worth onto the power of his imagery to entertain while provoking, to pose intriguing puzzles and to linger in the mind when other brand images fade away.

If Magritte's legacy to cinema has been relatively insignificant, the same is true for Surrealism in general. What explains the first also helps explain the Surrealists' disappointment with the medium. Outside the evocation of nightmare, madness or the supernatural, Surrealist deformations of space and perturbations of the order of things have never sat comfortably with mainstream cinema's concern with verisimilitude. Surrealist imagery is intended to disorientate and disturb while the implicit ideological function of classical cinema is ultimately to reassure the spectator and to reinforce conventional representations of reality. The principal rhetorical figure of mainstream cinema is the metonymy rather than the metaphor beloved by Surrealism. In the interests of maintaining the integrity of the spatial/temporal continuum, commercial cinema makes its figures via objects and motifs that have a common-sense linkage with the principal characters and locations; Magrittian/Surrealist figures deliberately flout such linkages. In so doing they make holes in the seamless fabric of narrative and destroy the transparency of that illusionary window through which mainstream cinema invites us to look into its imaginary world. Surrealism's cinematic dislocations and subversions have been largely quarantined in the ghettos of the historic avant-garde, of animated film and MTV-style pop videos.

Of all the Surrealists, it might seem, on first consideration, that the Magrittian vision, like the Dalinian, ought to translate most readily into filmic terms, because his pictorial style renders objects with such photographic fidelity. As has been suggested, Magritte's images, although static, often appear to suggest a movement that could be cinematic. They have a dynamic character that seems to call out for lap dissolves, jump cuts, action just outside the frame. Pierre Demarne wrote in 1961 that Magritte sought to represent the movement of consciousness and to stimulate the same in the spectator.[31] Film's time dimension permits it to represent the actual movement of the mind in the association of ideas, to record the itinerary of thought as it unfolds. Hence it ought to have been the ideal medium for Magritte.

Yet, for all this, film and Magritte never made a good match – much less good than Dalí, if one thinks of Dalí's celebrated collaboration with

Hitchcock on *Spellbound*. The reason is that Magritte's images lose by being set in motion. The transfer from *peinture* to *cinéma* does not suit them. This is partly because – as David Sylvester reminds us – while Magritte is primarily an image-maker, the efficacy of his image is dependent on how it is painted, on the composition and the harmonization of colour, for instance. A dissipation of power occurs when Magritte is transposed to a different medium, not unlike that described by Sylvester when he evokes the vast composite mural of Magrittian figures assembled in *The Enchanted Domain* for Knokke Casino in 1953: 'It is like a child's picture-book or a pantomime, where normally menacing images have had their poison removed. And the removal of the poison is mainly the result of making the imagery panoramic rather than iconic so that the separate images are drained of their integrity and thereby of their potency.'[32]

Much the same loss of potency seems to occur with the transfer of Magrittian figures from the canvas to the screen. While they may tantalizingly imply movement, they just as determinedly resist it. Magritte paints ideas – *idées fixes* – not processes. 'Ceci n'est pas une pipe' cannot be constructed in time; it is a constant. With Magritte's enigmas, the transmutation of one object into another – the challenge of one quality in the world of appearances by another – is a movement of our thought, not a movement in the entities themselves. If there is process – narrative even – it is an internal one. The very firmness of the outline of Magritte's objects, compared with, say, Duchamp's *Nude Descending a Staircase*, contradicts movement. Magritte's figures exhibit that kind of 'convulsive beauty' that Breton qualified as *explosante-fixe*. The chance meeting of a sewing-machine and an umbrella on an operating table is not a meeting like *Bonjour Monsieur Courbet*. Is is a situation rather than an action. The famous *frisson* – Breton's 'sensation of a gust of wind about the temples' – provoked by the paintings of Magritte, derives from the tension between the suggestion of a movement or of a transformation in the image, and the fact of its fixity. With Magritte, the cinema effect can only dissipate the painting effect.

Notes

1. For a general discussion of the interaction between painting and cinema, see, Germain Viatte, ed., *Peinture, cinéma, peinture* (Marseille: 1989).
2. René Magritte, *Écrits complets*, ed. André Blavier (Paris: 1979), pp. 497–503.
3. Ibid.
4. Sarah Whitfield, ed., *Magritte* (London: 1992); David Sylvester, *Magritte* (London: 1992).
5. Patrick Waldberg, *René Magritte* (Brussels: 1965), p. 96.
6. José Vovelle, 'Magritte et le cinéma', *Cahiers Dada Surréalisme* 4 (Paris: 1970),

pp. 103–10; also in Viatte, ed., *Peinture, cinéma, peinture*; Suzi Gablik, *Magritte* (London: 1970); Waldberg, *René Magritte.*

7. Luis Buñuel, 'Cinema, instrument of poetry' (1953), quoted in Francisco Aranda, *Luis Buñuel, A Critical Biography* (London: 1975), pp. 273–5.

8. Robert Desnos, quoted by Linda Williams, *Figures of Desire* (Illinois: 1981), p. 23.

9. André Breton, 'Comme dans un bois', in *La Clé des champs* (Paris: 1967), p. 243; also in trans., 'As in a Wood', Paul Hammond, ed., *The Shadow and its Shadow* (London: 1978), p. 43.

10. Magritte, *Écrits complets,* p. 502.

11. Vovelle, 'Magritte et le cinéma, p. 104.

12. Waldberg, *René Magritte,* p. 106.

13. Sylvester, *Magritte* p. 104.

14. Waldberg, *René Magritte,* p. 117.

15. Quoted in Gablik, *Magritte,* p. 48.

16. Whitfield, ed., *Magritte,* note to plate 17.

17. Paul Nougé, 'Introduction au cinéma' in *Histoire de ne pas rire* (Brussels: 1956), p. 38.

18. Richard Calvocoressi, *Magritte* (London: 1979).

19. Michael Gould, *Surrealism and the Cinema* (London, 1976), pp. 112–14.

20. Quoted by Sylvester, *Magritte,* p. 24. Magritte, incidentally, wrote the name of the master of suspense, 'Hichkoc'.

21. Breton, 'Comme dans un bois', pp. 245–6, and in Hammond, ed., *The Shadow,* p. 45.

22. Jean Vigo, 'Vers un cinéma commercial' (1930), quoted in Luis Buñuel and Salvador Dalí, *L'Âge d'or and Un Chien andalou: Films by Luis Buñuel* (London: 1963), pp. 75–81.

23. Linda Williams, 'The prologue to *Un Chien andalou:* a Surrealist film metaphor', *Screen* 17, 4 (Winter 1976/7), p. 33.

24. J. H. Matthews, *Surrealism and Film (*Michigan: 1971), p. 51.

25. Examples of such scenarios can be found in Hammond, *The Shadow*, and Alain and Odette Virmaux, *Les Surréalistes et le cinéma* (Paris, 1976).

26. Quoted in Magritte, *Écrits complets,* p. 73.

27. Ibid., p. 66.

28. Ibid., p. 71.

29. Ibid., p. 427.

30. Robert Leedham, 'The Bowler Legacy' in *The Guardian* (9–10 May 1992), p. 7.

31. Quoted in José Vovelle, 'Magritte et le cinéma', p. 111.

32. Sylvester, *Magritte,* p. 278.

Pictures of the Mind:
Artaud and Fondane's
Silent Cinema

Ramona Fotiade

The Surrealist search for a distinctive film aesthetic and practice competed during the 1920s and 1930s with various and sometimes conflicting theories of film, ranging from 'purism' and abstract cinema to Impressionism. The problematic relationship between Surrealism and early French cinema comes out most strikingly from the experimental writing and film–making generated by writers like Artaud and Fondane, who were not initially included in historical and critical accounts of Surrealist cinema. The interest in a purely visual, non-verbal mode of expression, which brought Fondane's and Artaud's individual projects in contact, situates the encounter between the two authors on a controversial boundary with the Surrealist movement, a margin at which the shared interest in 'the new eye of the camera' becomes the source of conflicting notions of vision.

One of the earliest critics of Surrealism in relation to cinema, Jean Goudal, established a close parallel between Surrealism and cinema, based on their apparent common grounding in a dream state. This interpretation encouraged the persistent belief that the Surrealist and the cinematic deployment of visual techniques corresponds to the dream-like 'succession of images that is a *simulacrum* of the real world'.[1] The explicit mention of *simulacrum* and artificiality in relation to the status of images in films and in dreams accounts for the enduring success of Goudal's opinion, which has thus been incorporated into the rationale of even the most recent analyses of Surrealist cinema, such as Linda Williams's *Figures of Desire*. After introducing the notion of *simulacrum*, with reference to Goudal's contention about film and dream images, Williams relates this early critical position to Christian Metz's well-known theory of the 'imaginary signifier', and argues that 'in the dream and the film one sees the image of something that is not really there in an illusion similar to that of a mirror'.[2] This conception of the film image as specular illusion relies on a misleading understanding of the cinematic visual signifier from within a theory of representation and semblance, whose psychoanalytic foundation remains largely unquestioned. The Surrealist approach to cinema, as illustrated by Artaud and Fondane, involved a critique of representation which, as I shall

try to show, runs counter to the presumed correspondence between the dream image and the film image, grounded in specular illusion.

Recent analyses of the Surrealist conception of cinema along the lines of Goudal's original thesis have come up against the difficulty of providing a non-contradictory account of the famous debate between Artaud and Germaine Dulac, surrounding the making of *The Seashell and the Clergyman*. Trying to argue for the basic similarity in the two authors' understanding of film as oneiric production seems a daunting enterprise if one has in mind Artaud's protests against Dulac's rendition of the scenario, and his adamant rejection of any attempt to interpret *The Seashell and the Clergyman* as being 'made of a single dream',[3] or as 'a dream on the screen'.[4] Nevertheless, this is precisely the argumentative stand taken by one of the most prolific critics and promoters of Dulac's work in recent years, Sandy Flitterman-Lewis, who declares that Artaud's 'dissatisfaction with the film has been greatly misunderstood', and that the 'basic similarity in the thinking of Dulac and Artaud' can be acknowledged within the very context of the controversial press release announcing the film as 'a dream on the screen'.[5] The necessary presupposition for this acknowledgment, like in the case of Linda Williams's previously mentioned study, concerns the possibility of describing both film and dream as 'fantasmatic productions'. Whether Freudian or Lacanian, the resulting interpretation of 'the confluence of film and dream' places the unconscious processes, which relate the 'cinematic text' to the discourse of dream, in the foreground, and obliterates the incompatibility between this psychoanalytic framework and Artaud's constant rejection of the supposedly oneiric mechanisms of film production and consumption.

The occasional remarks that Artaud makes on cinema as a medium for translating dreams (e.g. in 'Witchcraft and Cinema'[6]) are qualified by his persistent belief that cinema invalidates the representational game of language and of discursive thought. Artaud's preoccupation with the processes of thought and consciousness in film radically opposed the conventional psychological assumptions of Impressionist cinema. According to his own assertions, the idea of *The Seashell and the Clergyman* was to uncover the distinctive, truly magical element of cinematic vision, which nobody seemed to have found up to that date. Artaud believed that this unique element was, on the one hand, independent of any kind of representation attached to images and, on the other, involved what he called the vibration and the birth of thought.[7] This peculiar, close link between thinking and cinematic language bypassed the fallacious interposition of dreams as magical reflection, or specular illusion of a deeper reality. More adequately, *The Seashell and the Clergyman* may 'resemble' the 'mechanic of a dream' without really 'being a dream itself', which goes to show to what extent this film 'restores the pure functioning of thought'.[8]

According to Paul Ramain, another film critic of the 1920s, the identical nature of dreams and cinema finds theoretical support in Freud's remark that dreams remain 'untranslatable in words, [and] can only be expressed by means of images'.[9] But Artaud described himself as a 'bad dreamer' (*le mauvais rêveur*), whose experience revealed a fundamental lack of consistency of dreams, both in the waking state and in sleep, and precluded any form of coherent visual representation:

> My dreams are first of all a liqueur, a kind of nauseating water in which I dive and which rolls bloody micas. I cannot reach the height of certain images, I cannot settle in my continuity, either in the life of my dreams, or in the life of my life. All my dreams are deadends, lacking either a castle or a town-plan. A musty collection of severed limbs.[10]

This dissolution of the basic elements of dreams – i.e. images – this lack of continuity and focus, as it were, comes from a more profound dissolution of the self. All the disparate, fragmentary perceptions have no solid foundation, do not converge or manage to articulate the point of view of a thinking subject. There is only 'a musty collection of severed limbs' instead of a constituted self, solidly anchored in reality. The inconsistency of both dreams and reality, which Artaud uncovers, does not properly belong to psychology, or, rather, it exceeds psychological investigation in so far as it poses the question of a fundamental powerlessness of thought. What Artaud discovers in his perpetual effort to piece together the fragments of his life, and of his self, is that thought does not simply exist, is not simply given, but has to be created, to be engendered each time.[11] Articulated verbal language displays the petrifaction or the paralysis of thought, caught in the grammatical and logical structures of a reasoning cut off from life, of a spirit cut off from the body. Thought is not inborn, as Artaud remarks, and articulated verbal language only testifies to our sheer thoughtlessness and powerlessness. This is where cinematic expression comes in. A vibration or a shock must occur between image and thought, so that life can replace the stillness and discontinuity of that 'musty collection of severed limbs'. The cinematic image can breathe life into disparate fragments of thought precisely because it is not an inborn, given rational discourse, it is not a static visual representation, it is not a representation at all: it asserts itself as 'image-movement' (*image-mouvement*), according to Deleuze, or, rather, as something closer to the immediate manifestation of life. Cinema does not simply pose the 'super-reality' of dream, which remains a superficial solution to the problem of thought, but first and foremost exposes the powerlessness (*impuissance*) of thought, and its impossibility of being, as Deleuze observed with reference to Artaud.[12]

The film image, in its interlocking with the reality of the mind (as

envisaged by Artaud), radically undermines the type of visual experience which can be associated with the mode of inscription characteristic of appearance. [13] Unlike other Surrealists (e.g. Desnos) committed to the correspondence between film and dream, Artaud used the cinematic visual signifier in order to achieve a direct, immediate access to things, interrupting the mechanism of mediated representation and of reference. In fact, the unique cinematic quality, so closely related to the possibility of generating thought (according to Artaud), can neither be found in the indirect mode, the referential character of the appearance, nor can it be described in terms of 'semblance', i.e. 'a modification of the manifest, of something manifest which it pretends to be but is not'. [14] In its ideal, unique manner, which Artaud endeavoured to disclose, film image eliminates both the mode of *semblance* – i.e. only pretending to be, rather than actually being – and the mode of *appearance* – i.e. that of reference, of mere representation. Ideally, the film image uncovers an authentic realm of being, which partakes of the process of visual rather than verbal generation of thought. This is an ontological, as much as an epistemological, problem. It does not truly belong to psychology, or the investigation of dreams, as Artaud insisted. [15]

Psychology, Artaud argued, had to be 'engulfed by actions' so that film would achieve the quality of an entirely visual performance. [16] In contrast to this, Germaine Dulac's emphasis on the psychological meaning of such technical devices as the close-up or the dissolve remained within a literary and theatrical tradition of interpretation which Artaud most strongly rejected. The Impressionist avant-garde in the cinema, including filmmakers like Abel Gance, Marcel L'Herbier, Louis Delluc and Germaine Dulac, promoted the autonomy of the visual language of film in terms of technical innovations, and of an aesthetic stand related to Impressionist painting and music. Dulac defined this trend in terms of 'psychological film' and 'subjective cinema'. Although she insisted on the flexibility of silent film in contrast to the theatre and 'the syntax regulating writing and speech', she ended up proposing a visual 'rhetoric', which challenged neither the presupposition of the psychological drama, nor the formal regularities and logical structure of the narrative:

> The shot is the image in its most isolated expressive form, underscored by the lens's framing ... The shot simultaneously defines the place, an action, and a thought. Each different image that is juxtaposed is called a shot. The shot is a small piece of the drama; it is a small touch that unites in a conclusion ... It is the only means that we have to create a bit of the inner life in the midst of the action. [17]

The inner life disclosed by the shot was supposed to be not only intelligible, coherent (i.e. defined in terms of a single 'thought'), but also

inherent to every other similar unit of meaning juxtaposed in a continuum (i.e. 'drama'), a succession of images that ultimately 'unites in a conclusion'. This understanding of the process of thought, and of individual psychology in relation to film, was in every way opposed to the approach of Surrealist film-makers, and especially to the extreme, peculiar conception developed by Antonin Artaud. In contrast to the intelligible, coherent meaning assigned to the 'psychological shot' by Dulac, and to her idea of a visual continuum which logically unites in a conclusion, Artaud denounced the use of situations and images evolving around 'a clear meaning'.

It is true that Dulac provided an almost literal rendition of Artaud's scenario. She attempted to capture that spectral instinctual glitter of the female character by using a wide range of technical devices, which she thought would adequately translate Artaud's notion of a film made out of 'purely visual situations'. However, precisely because of her genuine preoccupation with giving a faithful rendition of Artaud's scenario, Dulac remains too close to the text itself, and at the same time too attached to a kind of nostalgic sentimentality, which prevents her from grasping the meaning of those 'purely visual situations'. As Artaud explained, they were meant to provoke 'a shock designed for the eyes, a shock drawn … from the very substance of our vision and not from psychological circumlocutions of a discursive nature which are merely the visual equivalent of a text'.[18] Dulac's Impressionist notion of 'inner life', disclosed through the close-up (or the 'psychological shot' as she called it), and her previous exploration of female fantasy in *The Smiling Mme Beudet* (1923), which, despite some technical audacities, is disappointingly conventional, led to a rather edulcorated portrayal of the woman in *The Seashell and the Clergyman*. The spectral, haunting apparition which was associated, throughout Artaud's scenario, with the clergyman's horrified expression, becomes, in Dulac's vision, a passive object of desire: the shock designed for the eye is reduced to rapt contemplation of an elusive image.

Artaud was not the only one at the time working on the boundaries of Surrealism, as it were, and articulating a radical conception of cinema as an alternative to the problems of overcoming theatrical representation and discursive language in general. Although rarely connected to Artaud, or to the Surrealist movement (which he critically analysed in his writings), Benjamin Fondane arrived, at about the same time, at an uncompromising rejection of the limitations posed by the rational discourse, while pursuing his own investigations into avant-garde theatre, and trying to uncover the potential of a non-verbal, visual language of poetic/cinematic expression. In 1933, a special issue of *Cahiers jaunes*, devoted to cinema, included both Artaud's article, 'The Premature Old Age of the Cinema', in which he insists that 'the illustration and completion of the meaning of

an image by speech show the limitations of the cinema', [19] and Benjamin Fondane's article 'Cinéma 33'. Alongside similar considerations on the adverse effects of the introduction of sound, Fondane refers at one point in his article to the cinematic vision inherently present in Artaud's theatre manifesto: 'read his manifesto *The Theatre of Cruelty*: one would say that he seeks only one thing: the lost path of cinema'. [20]

Benjamin Fondane, who came to Paris from his native Romania in 1923, had closely followed Artaud's projects for the theatre, and shared both his enthusiasm for a radical renewal of theatre performance, and his interest in the cinema. The letter which Fondane sent to Artaud, [21] concerning the brochure 'Le Théâtre Alfred Jarry et l'hostilité publique' (which came out in March 1930), mentions all the performances which marked the short-lived activity of the Jarry theatre. Himself the founder of an ephemeral theatre group *Insula* (The Island), set up in Bucharest, in 1922, Fondane turned to silent films when he became disillusioned with language. Neither the aesthetic justification of his early poems, nor his attempt to create a total theatre (based on similar principles to those which inspired Artaud's enterprise) seemed to provide a valid alternative to rational discourse and the inherent limitations of a text-based performance.

On several other occasions Fondane, unlike Artaud, had the chance to work both within and outside the constraints of the film industry, as a screen writer and/or as a director. In 1929–30, he worked with the Paramount studios, without, however, adopting in his own experimental projects the so-called classical Hollywood narrative, which was already established by the late 1920s and which dominated American film production. In 1934, Fondane actively participated in the making of *Rapt ou la séparation des races*, an adaptation for the screen of a novel by Ramuz. Although Fondane's role was apparently restricted to writing the scenario of *Rapt* while the director of the film was Dimitri Kirsanof, the collaboration between the two allowed for a greater input from the screenwriter than in the case of *The Seashell and the Clergyman*.

In 1933, Fondane noted: 'If I was free, really free, I would make an absurd film on an absurd topic, to satisfy my absurd taste for freedom'. [22] This chance came a few years later, in 1936, when Vitoria Ocampo invited Fondane to Argentina to make his own film. The result of this was *Tararira*, an outrageous musical, featuring the Aguilar brothers, a well-known Argentinian quartet, and an original musical score composed by Paco Aguilar. Unfortunately, the producer of the Buenos Aires company Falma Film refused to distribute *Tararira*, probably on account of its daring critique of morality and its sarcastic portrayal of religion and of the clergy. Fondane brought an incomplete copy of the film with him on his return to France, but *Tararira* has not been released to this day, and no copies of it have been traced either in Buenos Aires or in Paris. The scenario has also

been apparently lost, but one can nevertheless get some idea of the film from the letters exchanged between Fondane and Vitoria Ocampo, as well as from photographs of the cast, and stills taken during shooting, all of which were published in the volume of Fondane's *écrits pour le cinéma*, edited by Michel Carassou.

There is also similar evidence of an earlier, Romanian film, which Fondane made in Paris in 1930, using a Romanian cast and the crew of a production company from Bucharest. Again, no copies of this film, *Televiziune* (Television), have been preserved. A photograph of the cast and crew was published in the volume of collected poems by Fundoianu (Fondane), which came out posthumously in Bucharest in 1978. It must be said that this film, *Televiziune*, preceded Fondane's collaboration with Kirsanof in the making of *Rapt*. To this date, it remains the only project known from the years when Fondane worked with Paramount, during which he may also have contributed to other films as a writer, or even as a director. Despite the present incomplete state of research, one can assume that *Tararira* was the last film made by Fondane. His plan to go back to Argentina and work as a film-maker with other production companies was never realized, mostly because of the failure to distribute *Tararira* and capitalize on its expected impact on avant-garde circles in Buenos Aires and, possibly, in Paris.

Probably one of the most significant aspects of Fondane's and Artaud's conception of cinema is their commitment to silent film, and their resistance to the introduction not only of intertitles, but also of sound. It is hardly surprising, therefore, that *Tararira*, which seems to have been Fondane's only talking movie, was a musical. The articles on cinema which Fondane published between 1929 and 1933 argue strongly in favour of silent film, as the opportunity 'to abolish any speech, and any logic which supports speech and any human conception which supports logic'.[23] Fondane's subtle distinction between 'speech' and 'sound' in relation to the film image defines a cinematic/poetic mode of thinking in terms of temporality and movement, as opposed to spatial representation. 'Speech immobilizes,' he says, 'it is spatial'; in contrast to the effect of speech in film narrative, which slows down the flow of images and hinders the speed and arbitrary nature of editing, sound does not have a 'body': 'sound has a body no more than it has a concept: it is swift and short, quicker than the image itself '.[24] According to Fondane, sound or even noise, as well as speech itself, should only take the place of the superimposition (*surimpression*) in the cinema, should contribute to the intensity of film image and to its 'thickening' (*épaississement*). This notion of *épaississement,* however, rejects the inscription of speech and sound into what Fondane paradoxically calls the 'texture' of film narrative. Film is neither *text* nor *écriture* to Fondane. The unique, unmediated mode of presentation which

defines film involves a complex relationship between sound, speech and image: 'Film must remain silent. I can see very well speech, noise accompanying film, not inserted in its texture, but only as giving it depth [*l'étoffant*], … impressing it [*l'impressionant*]'. [25] The insertion is not textual but visual, and the 'mark' left by the 'impression' (*impression*) of speech or noise on to image is that of a superimposition (*surimpression*) which adds depth and volume to the image, without interfering with its movement, or even attempting to translate, as with intertitles, 'that which in our thought moved at the level of intuitive attention'. [26] There is a clear separation between the visual dimension and speech or noise in Fondane's understanding of *surimpression*. Paradoxically, the mark or imprint belongs to the visual element, which alters the corporeal, spatial nature of speech. As Artaud argued: 'Voices are there [i.e. in film] as objects *in space*. It is on the visual level that one, if I may say so, has to *accept* them' (Artaud's italics). [27]

Like Artaud, Fondane was engaged in a passionate fight against the rigid structures of logical reasoning, a fight for the values of life and individual experience, which led him to existential philosophy, through his decisive encounter with the thought of Leon Shestov. Coming out of the four years of silence which followed his exile, Fondane began to cry without words ('j'ai commencé à crier sans mots'). This moment marks his sudden transition from articulate, verbal language to visual cinematic expression. In 1928, he published his first volume in French, *Trois scenarii – ciné-poèmes*, with a preface in which he defined cinema as 'the lyric apparatus, *par excellence!*' [28] *The Seashell and the Clergyman* had its première the same year, in February, and Fondane indirectly refers, in the preface of his *Trois scenarii*, to Artaud's first theatre manifesto for the Theatre Alfred Jarry, criticizing the choice of a classical repertoire. Cinema, Fondane argues, is the only art which has never been classical, which has refused to accept 'the taming [exerted] by reason, its orthopedic devices, its plaster corsets', and the classical spirit of Hugo's or Shakespeare's works cannot be made to serve the aims of a radical revolt against rational language, as Artaud seemed to suggest. [29]

The *ciné-poèmes*, which Fondane wrote after years of silence, provided a paradoxical answer to questions which Artaud's manifesto of 1927 also attempted to answer. Fondane presented his three scenarios as unfilmable – '*scenarii intournables*'. According to Peter Christensen, this statement suggests that these scenarios 'exist as events in the reader's mind' – i.e. 'they do not harden into works of art'. [30] Similarly, Artaud's own rejection of the work of art can be said to have influenced his understanding of the film image and film narrative in terms of an action or event which has a direct, intuitive impact on the viewer's mind.

Fondane rightly sensed that cinema might provide the answer to some

of the problems which were only partly solved by the critique of representation as formulated in Artaud's manifestos for the theatre. His letter of 1930 encouraged Artaud to put an end to the 'text which looks at the auditorium' (*le texte qui regarde dans la salle*), and replace it with a kind of lyrical process, 'the text which is played for its own sake' (*le texte qui se joue pour lui-même*). This, however, did not refer to the transition from one type of text or 'writing' to another. What Fondane had in mind was the sudden change from discursive language to a non-verbal, visual mode of expression approaching the image of silent film. Like Artaud, Fondane especially valued 'the arbitrary of the gesture, of the movement', and considered that the most significant aspect of the new theatre was 'the clear conception of today's sense of the tragic' (*la conception nette du tragique d'aujourd'hui*). From Fondane's point of view, the modern conception of the tragic could only be captured through the discontinuity and arbitrary character of a visual performance which disrupts the articulation of logical thought and discourse.

The three 'unfilmable' scenarios which Fondane published in 1928 recall, in their paradoxical finality, the remark made by Artaud, in the first manifesto of the Theatre Alfred Jarry, about the exclusive sonic value attached to the text, corresponding to the 'displacement of air which enunciation provokes'.[31] The critique of representation, initially aimed at the predominant role of text and articulated speech in the theatre, was taken one step further by Artaud and Fondane into the purely visual field of silent film. As early as 1920, Fondane was arguing for a 'theatre without words': 'For this theatre has no contour and no limit, because the soul has no contour and no limit. In life there are moments when the abyss is so close that even the cry is dissonant. Man loses his gestures and his logic. He cannot talk. He is silent.'[32]

The subversive power of the disarticulated cry which brings out the arbitrary and absurd character of life in the theatre, the dissonance inscribed in the etymological meaning of *absurdus*, i.e. 'out of tune', 'irrational', is pushed to its limit: silence effaces the last residuum of logical thought, by replacing rather than merely interrupting speech. Fondane's position recalls the early notes on the activity of the *Bureau de recherches surréalistes* in which Artaud was addressing 'the sufferers of aphasia caused by a tongue arrest', in contrast to the inexhaustible murmur encouraged by automatic writing.

According to one of Fondane's critics, Monique Jutrin, the *ciné-poèmes* published in 1928 attempted to create a new type of reading, closer to the mode of perception which characterizes the 'reading' of cinema images. Fondane himself introduced his unfilmable scenarios by referring to 'the creation of a provisional state of mind which memory consumes during the act of reading'.[33] This creation corresponds to Artaud's envisaged

relationship between cinema image, movement and the process of thought. But the provisional 'state of mind', which Fondane tried to achieve through his unfilmable scenarios, subverts rather than re-inforces the process of reading a literary text.

In his preface to the three *ciné-poèmes*, Fondane notes that 'the genuine scenario is naturally difficult to read, and impossible to write'. The compromise which he nevertheless reached in presenting his so-called 'unfilmable' scenarios as *ciné-poèmes* is based on a paradoxical relationship with the conventional process of writing and reading. The poetic image is displaced, and functions as a purely visual, cinematic signifier in a text structured as a continuity script or a *découpage*. The 'unfilmable' yet 'cinematic' image thus aims to uncover the process of thought in a fragmented, arbitrary succession which would ultimately disrupt the representational character of verbal discourse. Reading asymptotically approaches screening: the text acquires the 'lyric quantity' of the cinema, and the image no longer relies on verbal puns, on metaphor, simile or the conventional poetic process of reference and deferral of signification. In Fondane's *ciné-poèmes*, a summer fan does not indirectly refer to a gramophone, does not look like a gramophone, but actually is the direct manifestation of two or more things in turn. Buñuel used the same device in *Un Chien andalou* in the series of illogical transformations starting with the hole in the man's hand, infested by ants, and continuing with the shot of underarm hair, dissolved into a sea urchin, which leads, through another dissolve, to the high-angle iris shot of the androgyne. What relates this series of shots to the quick succession of contrasting images, involving a similar process of illogical transformation in Fondane's cinematic poems is the absence of a metaphorical, referential mode, underpinning a psychological interpretation. Buñuel's use of dissolves as a means of linking the above mentioned shots in *Un Chien andalou* might seem to authorize Linda Williams's analysis of the sequence as a chain of metaphors, having a psychological, gender-related referential function, which apparently permeates the entire narrative of the film, starting with the opening metaphor of moon and slit eye.[34] At a closer examination, however, the presence of dissolves in *Un Chien andalou* discloses a parodic intention, replicated by the use of intertitles and of close-ups, all of which signal the deliberate distancing from the conventions of the psychological, Impressionist cinema. There is a constant undermining of the transposition of verbal, poetic metaphors into the illogical succession of film images, which makes no attempt to provide an indirect, referential meaning, a possible unifying psychological clarification of situations to which false motivational and temporal determinations are nevertheless assigned, in order to disorient the viewer, and frustrate his narrative expectations. In Fondane's cinematic poems, the series of strange metamorphoses, which seem to anticipate Buñuel's sequence in

Un Chien andalou, similarly attempt to disrupt rather than visually translate the mechanisms of verbal metaphorical reference, as in this fragment from 'Paupières mûres':

(change of rhythm)
127 a red heart is drawn in a deck of cards
128 an edelweiss in the heart
129 the heart in the hand of a young man
130 the place in his chest from which it was uprooted/huge red flower
131 a hand throws the heart
132 it appears at the feet of the woman in the street
133 she looks at it bends over and lifts up
134 a summer fan
etc.[35]

The continuity script format, based on editing, camera set ups, framing and frame illustrations, which Fondane uses to transcribe his scenarios, situates the poetic effect on the paradoxical boundary between the purely visual, yet 'unfilmable', image and the contested 'literary' expression – difficult to read, 'impossible' to write. This is neither an attempt to visualize automatic writing and make it into a virtual 'film' (as was the case with the earlier *film raconté* format used by Surrealists), nor a mere transposition of film narrative into fragmentary writing, through a chain of poetic metaphors meant to read as a literary text. Each image corresponds to a shot, and each shot is numbered. The rapid cuts, and the emphasis on actions and movement aim to capture the rhythm of the cinema 'image-movement', disrupting the viewer/reader's effort to establish metaphorical or logical links between shots. The quick transitions from one shot to another seem to preserve a certain minimal link – e.g. the recurrent motif of the heart – but the recognition of this link is constantly undermined, through the absurd, sudden change of context: the drawing of a figure in a deck of cards does not really 'stand for' or suggest metaphorically the action which should logically precede the image of the heart in the hand of a young man – i.e. the man 'uprooting' his heart from his chest. There is no logical cause or metaphorical substitute for the cause supposed to trigger this unexpected effect, and lead to the subsequent 'transformation' of the heart into the summer fan which the woman lifts up. Do we really witness this transformation, or is it rather a playful juxtaposition of disconnected actions? The rapid alternation of close-ups, the absence of an identifiable point of view, the disruption of spatial and temporal continuity, all make it very difficult to decide whether the shots function as visual analogues of poetic metaphors or, rather, use

conventional metaphors (i.e. an edelweiss in the heart) in the manner of collage experiments or 'ready-made' objects, which subvert the mechanism of representation and semblance. The rhythm is that of random and almost simultaneous snapshots, which not only defy any logical continuity, but also disrupt the reading of the text as a chain of related metaphors. In Fondane's cinematic poems there is a deliberate parodic subversion of both discursive, logical thought, and poetic, verbal expression. As Leonard Schwartz remarked with reference to 'Paupières mûres' (which he translated as 'The Maturation of The Eyelids'), 'what needs to be understood about this text is that Benjamin Fondane wanted it to disappear'.[36] The title of the ciné-poème, 'Paupières mûres', signals the intention of uncovering a new type of vision, which Fondane, like Artaud, considered to be closely associated to an investigation of the processes of thought, and of the subtle link between cinematic movement and the irrational substratum of life.

The final shot of Fondane's ciné-poème is a close-up of the author's head as photographed by Man Ray. The monstrous deformity of the head – shown both upright and upside down in the same frame – recalls the obsessive motif of the head in The Seashell and the Clergyman. The image of a head enclosed in a glass globe, and then placed on a shell from which the clergyman drinks at the end, attempts to create 'a shock to the eye' by presenting a figure of disembodied thought rather than physically mutilating the eye, as in Buñuel's opening sequence. Fondane, like Artaud, considered that thought was the real problem of cinema: the centrality of rational sight, linked to the pre-eminence of verbal language, had to be tackled at the level of thought.

While striving to overcome the referential status of mere appearance, cinema image also promised to escape from the limitations of a phenomenon. The direct, visual manifestation of things was not coupled, in Fondane's and Artaud's understanding, with the disclosure of some objective, self-identical meaning. The creation of thought by means of cinematic language corresponded to discontinuity and ambiguity of meaning, especially in the absence of sound and intertitles, which shaped the space and time of visual perception. Both Fondane and Artaud deliberately tried to exclude from their scenarios and films the literary conventions and the whole rational articulation of both writing and speech.

The notion of 'pure film' which Fondane relates to abstract art, especially Cubism, does not emerge, as he says, from a reaction of the film-maker against cinema, which might be similar to the painter's reaction against art. Fondane shares Artaud's rejection of appearance and semblance, of the representation inherent to the work of art. He believes that cinema, or at least 'pure film', is not an aesthetic reaction to an existing tradition, but a complete negation of the work of art. The 'intolerance' or resistance

of film images to the literary and artistic tradition is only an appearance, because their inherent principle does not correspond to a 'reaction' within the existing system of language and thought, but to what Fondane calls '[the] manifest idleness' (*désœuvrement manifeste*).[37] This idleness makes manifest the sense of human tragedy, which Fondane thought was equally present in Artaud's project for the Theatre Alfred Jarry. The language of pure film, according to Fondane, disproved the rational assumption that thought cannot be communicated outside the categories of reason. 'Don't believe this', Fondane says, and adds, in perfect agreement with Artaud's ideas from *The Theatre and the Plague*: 'This type of thinking spreads like hate in a crowd, like plague on a boat, like scarlet fever through thin peels.'[38] This is also the sense in which Fondane talked of humour in Artaud's theatre, but especially in relation to cinema, as 'the feeling of tragedy, the violent feeling of human nothingness within the reach of our contemporary spirit'.[39]

Ultimately, what Fondane and, one can probably add, Artaud sought to achieve in the cinema, was not a new form of speech or writing, but a depth of silence, which could nevertheless communicate and make manifest the residuum of any rational analysis. The critique of representation uncovered, in its most radical rejection of speech and writing, a purely visual expression based on movement, a type of thinking closely linked to time perception in the mode of silence: 'The silence from which one would have achieved, through the contrast between speech and noise, an unexpected efficiency in depth, a kind of silence which would not only have surface but indeed volume.'[40] Fondane's critique of representation takes the form of a radical critique of rationality from the point of view of existential thought. Like Artaud, Fondane believed that the purely visual language of silent film could not only undermine the aesthetic of representation, but actually uncover a new type of knowledge. Film images, Fondane argued, do not represent anything, 'they do not respond to the call of artistic taste. They are a new means of knowledge'.[41] Cinema was a mode of thinking rather than a new language to Artaud and Fondane. It opened up an irrational dimension of thought and a new realm of being; it revealed the arbitrary, absurd nature of reality 'under the species of silence'.

Notes

1. Linda Williams, *Figures of Desire. A Theory and Analysis of Surrealist Film* (Berkeley, Los Angeles and Oxford : 1992), p. 18.
2. Ibid., pp. 18–19.
3. See Antonin Artaud, *Œuvres complètes* III (Paris: 1961) – from now on indicated as *OC* III – footnote 11, pp. 312–14. The account of the incident provoked by the Surrealists on the opening night, at the *Studio des Ursulines*, can be found in the new edition of the same volume (Paris: 1978), pp. 326–7. All the translations in the article are mine, unless otherwise indicated.
4. Anonymous, 'Un rêve à l'écran', *Cinégraphie* 2 (15 October 1927), p. 32; quoted in English by Sandy Flitterman-Lewis, 'The Image and the Spark: Dulac and Artaud Reviewed', in Rudolf Kuenzli, ed., *Dada and Surrealist Film* (New York: 1987), p. 110.
5. Ibid., p. 111. All subsequent quotations in this paragraph are from the same article. It is worth mentioning that the author marks the difference between Artaud's and Dulac's understanding of the cinematic image (i.e. Dulac's Symbolist notion of image as a 'site of fusion' and of film as 'a condensation of associations' vs. Artaud's Surrealist-based 'principles of displacement and dissociative juxtaposition'), while insisting on the 'basic similarity' in their conception of the 'confluence' of film and dream (see ibid., pp. 110–11).
6. See Antonin Artaud, 'Sorcellerie et cinéma', in *OC* III, p. 81. For a commentary on Artaud's apparently ambiguous position in relation to the part played by dreams in the conception of film scenarios, see Alain et Odette Virmaux, *Les Surréalistes et le cinéma* (Paris: 1976), pp. 28–30; 42–9.
7. Cf. Antonin Artaud, 'La Coquille et le clergyman', first published in *Cahiers de Belgique* 8 (October 1928), reproduced in *OC* III, pp. 77–8.
8. Ibid.
9. Paul Ramain, 'L'Influence du rêve sur le cinéma', in *Ciné–ciné–pour tous* 40 (1 July 1925), p. 8; trans. in Richard Abel ed., *French Film Theory and Criticism – A History/Anthology, 1907–1939*, Vol. I: 1907–1929 (Princeton: 1988), pp. 362–3.
10. Antonin Artaud, 'Le Mauvais Rêveur', *Le Disque Vert* 3 (1925); reprinted in *Œuvres complètes* I (Paris: 1956), p. 224.
11. See Gilles Deleuze's comments on the question of thought and creativity in Artaud: cf. *Difference and Repetition,* trans. by Paul Patton (London: 1994), pp. 146–8. Deleuze, however, does not connect this fundamental question to Artaud's radical critique of representation, and to his rejection of any psychological interpretation attached to his experiments with non-verbal means of expression such as silent cinema.
12. Gilles Deleuze, *Cinéma 2. L'Image Temps* (Paris: 1985), pp. 215–16.
13. 'Appearances are appearances of something which is not given as an appearance, something which *refers* to another entity. Appearance has the distinguishing feature of *reference*. What distinguishes reference is precisely this: that to which the appearance refers does not show itself in itself but merely represents, intimates by way of mediation, indirectly indicates' (my

italics). Martin Heidegger, *History of the Concept of Time. Prolegomena*, trans. by Theodore Kisiel (Bloomington Indiana: 1985), p. 82.

14. Ibid.

15. 'This screenplay is not the reproduction of a dream and should not be considered as such … This screenplay seeks the sombre truth of the mind in images which have issued solely from themselves and which do not derive their meaning from the situation in which they develop but from a kind of powerful inner necessity that casts them in a light of inescapable clarity.' Antonin Artaud – 'Cinéma et réalité', in *OC* III, p. 23; trans. by Helen Weaver, in Susan Sontag, ed., *Antonin Artaud. Selected Writings* (Berkeley and Los Angeles: 1976), p. 151.

16. Ibid.

17. Germaine Dulac, 'The Expressive Techniques of the Cinema', in Abel, *French Film Theory and Criticism,* p. 309.

18. Artaud, 'Cinéma et réalité',*OC* III, p. 22.

19. Antonin Artaud, 'La Vieillesse précoce du cinéma', in *Cahiers jaunes* 4, special issue 'Cinéma 33' (1933), p. 24; trans. by Helen Weaver in Sontag, ed., *Antonin Artaud,* p. 313.

20. Benjamin Fondane, 'Cinéma 33', in *Cahiers jaunes* 4 (1933), p. 19.

21. Benjamin Fondane, 'Lettre ouverte à Antonin Artaud sur le Théâtre Alfred Jarry', published with a presentation by Michel Carassou, 'Fondane-Artaud, même combat', *Europe* 667–8 (November–December 1984), pp. 84–93.

22. Benjamin Fondane, 'Cinéma 33', in *Écrits pour le cinéma. Le Muet et le parlant* – from now on indicated as *EC* – (Paris: 1984), p. 105.

23. Benjamin Fondane, 'Du muet au parlant: grandeur et décadence du cinéma', *EC*, p. 75.

24. Fondane, 'Cinéma 33', *EC*, p. 105.

25. Fondane, 'Du muet au parlant: grandeur et décadence du cinéma', *EC*, pp. 83–4.

26. Ibid., p. 75.

27. Antonin Artaud, 'La Révolte du boucher', *OC* III, p. 47.

28. Benjamin Fondane, *Trois scénarii – ciné-poèmes de Benjamin Fondane* (Bruxelles: 1928); reprinted in *EC*, p. 17.

29. Ibid., p. 16.

30. Peter Christensen, 'Benjamin Fondane's "Scénarii intournables"', in Kuenzli, ed., *Dada and Surrealist Film*, p. 73.

31. Antonin Artaud, 'Théâtre Alfred Jarry. Première année. – Saison 1926–1927', in *Œuvres complètes* II (Paris: 1980), p. 20.

32. Benjamin Fondane, *Imagini si carti* (Bucharest: 1980), pp. 280–1; quoted in Monique Jutrin, *Benjamin Fondane ou le périple d'Ulysse* (Paris: 1989), p. 33. Eric Freedman remarks that Fondane called his plays 'unstageable' (according to the preface of *Philoctète*), and further comments that: '[Fondane's] voice is the cry of exile, the exile of language and myth, and his transcription takes the form of dramatic works called *poèmes dramatiques* or *mystères* (misteries, from the Greek, *musterion*: sealed lips)' – Cf. Eric Freedman, 'The Theatre of Benjamin Fondane: Philosophy on Stage', paper presented at the seminar *Athens and Jerusalem: Issues of Time and Consciousness*, Oxford, 10 March 1995, p. 3.

33. Benjamin Fondane, '2 x 2', *EC*, p. 20.
34. Williams, *Figure of Desire,* pp. 81–2.
35. Benjamin Fondane, 'Paupières mûres', *EC*, p. 28.
36. Leonard Schwartz, 'Benjamin Fondane – The Genesis of the Cine-Poem' (introducing a translation of 'Paupières mûres', i.e. 'Six Sequences in the Maturation of The Eyelids'), *Frank. An International Journal of Contemporary Writing and Art* 5 (Spring 1986), pp. 24–5.
37. Benjamin Fondane, 'Présentation de films purs', *EC*, p. 65.
38. Ibid., p. 67.
39. Ibid., p. 68.
40. Benjamin Fondane, 'Du muet au parlant: *EC*, p. 85.
41. Benjamin Fondane, 'Présentation de films purs', *EC*, p. 65.

Picasso, Surrealism and Politics in 1937

Francis Frascina

This paper was prompted by Robert Short's important essays, from 1966, on 'The Politics of Surrealism, 1920–36' and on 'Contre-attaque'.[1] When published, they served to remind a 1960's audience interested in Surrealism of the necessity for an historical study of texts, particularly in the context of André Breton's emphasis on the conjunction of Freud and Marx in addressing both psychic and social repression under capitalism.[2]

The historical study of specific texts, theoretically and methodologically grounded, provides a necessary corrective to what Edward Said has recently called 'the massive, intervening, institutionalized presence of theoretical discussion'.[3] For Said and others, this institutionalized presence has been a phenomenon of the period since the late 1960s, and 1968 in particular. In studies on Surrealism we can observe, for example, the effect of the American journal *October* in its emphasis on the writings of Georges Bataille as a part of its own broader theoretical agenda; an emphasis which has one root in Surrealist divisions and another in recent ideological struggles.

A well-known Surrealist division occurred in 1929 with Breton's 'Second Manifesto of Surrealism' and Bataille's journal *Documents*. Breton's criticisms of Bataille at that time were similar to those levelled at *October* in recent years: a 'return to old anti-dialectical materialism, which this time is trying to force its way gratuitously through Freud …'[4] Breton was critical of what he regarded as Bataille's neglect of Marx, his pessimistic obsessions and avoidance of 'making himself useful for anything specific'.[5] One aim of this paper is to consider how, in the circumstances of 1936 and 1937, Bataille's writings became 'useful' at a specific moment in Picasso's practice and in Surrealist debates about the relationship between art and political or social activism.

A contemporary root for *October*'s project, begun in 1976, has, arguably, been the sublimation of post-1968 political activism and emphases on historical materialism into radical theory, where dialectics are divested of specific causal circumstances. In a recent critical analysis of *October*'s enterprise, the artist and writer Joseph Kosuth argues that the journal's

main authors are engaged in a 'new breed of polemical theory'. He regards
this as a dangerous creative enterprise, in which elements are added or
omitted for reasons of the editorial board's desire to secure *October*'s ins-
titutional power in the interpretation and history of past and present
modern art.[6] Such an enterprise, he argues, is at odds with those studies
of texts and visual representations that are interested in an historical
understanding of the dialectical and contradictory conditions in which
they and their meanings were produced.

With reference to Picasso's *Guernica*[7] this entails exploring the visual
image in the light of its political significance – a significance originally
determined by a causal nexus of Surrealist politics, responses to the
Spanish Civil War, attitudes to the Popular Front, relationships between
Picasso as a symbolic figure within contemporary rhetoric and Picasso's
own lived experience as, for example, Paul Eluard's close friend and Dora
Maar's lover in 1936 and 1937. Such issues have been introduced by
Sidra Stitch in her 1983 article on 'Picasso's Art and Politics in 1936'.[8]

'Guernica' and Political Significance

In 1937 Guernica produced a number of representations; one of them
was the mural-size painting by Pablo Picasso. What this particular image
represented, including its political effect, was then, and has since been,
intensely disputed in, for example, various accounts of the Spanish Civil
War, the politics of Surrealism, the history of the Communist Party and
the artworld's political left wing. Within the academic discipline that we
call 'art history' the painting *Guernica*, the artist Picasso and his work
from various decades, including that of the 1930s, have been the disputed
sites for securing significance. In Jutta Held's terms: 'The political signi-
ficance of a work of art is never given once and for all, it does not have a
fixed ontological status, but must be reaffirmed and fought for over and
over again'.[9]

Two related examples, which act as points of reference and limits on
the extent of my concerns, can be cited. The first takes us back to the
meaning of Picasso's *Guernica* in the late 1960s in the USA. In 1967, thirty
years after its production, the painting was used as a symbol of dissent
for those active in anti-Vietnam war protests. For example, part of the
image was quoted in a poster produced by Rudolf Baranik for 'Angry Arts'
week in February 1967.[10] Two years later it again became a focus of
attention. In the months from November 1969 onwards, the slaughter by
American soldiers of Vietnamese adults, children and babies at My Lai in
1968 had become public knowledge, and dominated TV, radio, newspapers
and journals. Amongst artists and intellectuals a parallel was made between
the events of Guernica and My Lai. Picasso's representation *Guernica* was

then housed in the Museum of Modern Art, New York (MOMA). The painting was to remain in the Museum, at Picasso's request, until Spain had become once again a republic rather than a Fascist state.[11]

For many anti-Vietnam war protestors the Museum of Modern Art, citadel of Modernism and container of one version of Surrealism, represented the interests of the US nation. MOMA was regarded by them as an agent for the social construction of culture, identity and taste. It was also considered to be run by trustees who were directly and indirectly linked to industries supplying arms and chemicals for the war.[12]

On Saturday 3 January 1970 My Lai, MOMA and *Guernica* became a public focus of protest, intervention and performance by members of the Guerrilla Art Action Group (GAAG), the Destruction in Art movement (DIA), and the Art Workers' Coalition (AWC). The GAAG in particular saw itself within the tradition of intervention connecting Dada and Fluxus. They infiltrated the Museum of Modern Art, gathering on the third floor in front of Picasso's *Guernica*.[13] Four wreaths were placed against the wall underneath the painting. Stephen Garmey, an Episcopalian minister and a chaplain at Columbia University, came forward and began reading a memorial service for dead babies. His service interposed extracts from the Bible with extracts from a major article with photographs of My Lai in *Life* magazine, 5 December 1969, and finished with a poem by Denise Levertov. Supporters held copies of the AWC's *And Babies* poster which was a photographic record of the My Lai massacre reproduced in the same issue of *Life* magazine. At another demonstration, on 8 January, the AWC used the poster as a sandwich board and staged a lie-in before *Guernica*. In both the statements by protestors and in press reports, parallels were made between My Lai, Guernica, Lidice and Oradour. The last two were massacres perpetrated by the Nazis: Lidice, 1942, in Czechoslovakia; Oradour, 1944, in France. Various media in the USA were full of statements of disbelief and incredulity at the capacity for human violence, carnage, retribution and irrational drives. With reference to My Lai, such reactions were to the capacity of supposedly civilized American GIs committing acts of murder, mutilation, rape and sodomy on civilians. There is considerable evidence of GIs during the war mutilating the bodies of Vietnamese, including cutting off the ears of the dead to make bandoliers, or necklaces for the supposed victorious soldiers. Both in accounts of such acts and in the media's spellbound fascination with My Lai there are deep concerns with the dual notions of slaughter and of sacrifice. These range from a horror at the ritual slaughter, assault and mutilation of innocents, to arguments that such acts are the inevitable sacrifices of war.[14]

The second example focuses on the significance of the destruction of Guernica in Spain when Picasso's painting was transferred to Madrid, in October 1981, to be housed in the Casón del Buen Retiro, which was

part of the Prado. In the following month a special issue of the Falangist journal *Heraldo Español* commemorated the sixth anniversary of the death of General Franco on 20 November 1975. A month after the arrival of Picasso's painting the journal included a special four-page article, 'Los 3 cuadros de la Guerra'. [15] This began with a full-page colour reproduction of Dalí's *Presagio de la Guerra Civil*, followed by a double-page spread of *Los fusilamientos de Paracuellos* by Izquierdo y Vivas. On the same scale as Picasso's *Guernica*, y Vivas's painting, from 1943, is housed in the Museo del Ejército, the army museum. This museum and the first Madrid home for Picasso's painting are the only surviving buildings of the Buen Retiro Palace, built in the seventeenth century by Philip IV. The contrast between the army museum's presence and contents and that of the new museum housing *Guernica*, all of the preparatory studies and other related works by Picasso, prompted the *Heraldo Español* to argue about the political significance of their three chosen paintings of the war. On the last page of the article a smaller reproduction of *Guernica* is accompanied by text which calls the painting a 'symbol of *red* Spain, the artistic banner of those Spaniards who in 1936 fought on the side of the Republic, password of the "*Opposition*" during Franco's Regime'.

The *Heraldo Español* claims that it would be unjust to regard Picasso's painting as the only symbol of that 'war and all of the Spaniards who fought in it … It says nothing in favour of the "*reconciliation*" spoken today by those "*beaten*" yesterday.' One other symbol is that which 'symbolises the tragedy of the "*other*" Spain, the Spain that in 1936 gave a step forward and was prepared to die for la Patria [which can be translated as Country, Motherland or Fatherland]'. *Los fusilamientos de Paracuellos* marks an event in November 1936 when, according to the text, more than ten thousand Spaniards, i.e. nationalists, were killed by republican forces. [16] The second claimed symbol is *Presagio de la Guerra Civil* in which: 'the great Dalí has formed in Surrealist characters the "*madness*" of those years preceding the tragedy […] when the life of a Spaniard was worth less than a glass of water. The "*madness*" of that Spain that was divided politically between "*reds*" and "*nationalists*".' For the *Heraldo Español*, all three paintings should be housed in the same room in the Prado. 'Spanish children' would then know what happened at Guernica and Paracuellos and be aware of 'the prologue of the tragedy; those years of the Second Republic …' [17]

1937

When first exhibited in 1937, and in the following couple of years, Picasso's *Guernica* divided the political Right and Left in predictable ways and

these reactions have been well documented. Within the Left, in general, a common dilemma focused on the legacies of socialist realism as enshrined in the Soviet Writers' Congress of 1934. The painter Julián Tellaeche and a handful of Basque politicians even tried to get *Guernica* replaced in the Spanish Pavilion at the 1937 World Fair in Paris by works regarded as more comprehensible to a mass audience and more directly raising an active call to arms against Fascism. Their preference was the work of Aurelio Arteta, now noted for his triptych from 1938: *The Front*, *The Exodus*, *The Rearguard*.

A common way of explaining *Guernica* has been to stress both Picasso's antipathy to representations which could be read as direct expressions of political opinions and the precedents in his own work of the 1930s. Clearly, these are important but I want to explore other possibilities and questions. How can analysis give due regard to the conversations, envisaged audiences, both actual and imagined, and commitments and references which make up, and transform, an artist's paradigm of representation? How can an account acknowledge the specific effects of personal relationships without confusing representation with biography?

Between January 1937, when Picasso accepted the commission from the Spanish government for a mural to be housed in the Spanish Pavilion of the Paris World Fair, and his deadline of June, he addressed a number of charged issues. These issues, I will argue, were factors in the production of *Guernica*. To consider these factors as they can be decoded from the image is to regard the painting as having a significance that is specific to these six months; that this significance is also the product of contradiction may be to account, in part, for the political legacy of the painting.

As is well known, Picasso had not started work on the commission at the time of the bombing, by the Condor Legion of the German Airforce, of the historic Basque town of Guernica on 26 April 1937. Picasso, as with many others in Paris, read the reports in papers such as *Ce Soir* – a pro-republican paper founded a month earlier and edited by Aragon – *Le Figaro*, *L'Humanité*, and *L'Exelsior*. On 28 April the front page of *L'Humanité* reported more news about Guernica alongside a report on the death of Gramsci, imprisoned by Mussolini for his political beliefs. Two days later, on 30 April, *L'Exelsior* reported attacks by the Italian airforce, based on Majorca, on the *Barrio Gotico*, an area of Barcelona where Picasso had lived. It was reported that 150 people had been killed. Picasso's mother, aged 81, and his sister Lola, with five children, still lived in Barcelona.

On 1 May more than a million people demonstrated in Paris, the largest recorded number at a demonstration in the city, partly as a celebration of a year of Popular Front government and partly as collective solidarity with the Spanish republicans' defence against Franco's nationalists, backed by the Falange, the Roman Catholic Church and the monarchists.

Between 1 May and 11 May Picasso worked on a series of preparatory studies for his commission. Two of his closest companions at this time were Dora Maar and Paul Eluard. Dora Maar was a photographer who had worked with Man Ray and Brassaï, sharing a photographic dark room with the latter in the 1930s. Both she and Man Ray took photographs of Meret Oppenheim's *Object: Fur Breakfast*, 1936, one of the now famous exhibits at MOMA's *Fantastic Art, Dada and Surrealism* exhibition of 1937. Oppenheim's object is supposed to have resulted from a conversation between Oppenheim, Maar and Picasso in a cafe in 1936.[18] Eluard had introduced Dora Maar and Picasso to each other in October 1935 at the Café au Deux Magots. During 1936 they became lovers. From late 1935 until Eluard's death in 1952 he and Picasso became close friends and shared in their public, if problematic, membership of the French Communist Party (PCF) in the 1940s and 1950s. Eluard died still a member of the PCF.

In May and June 1937, Eluard and Maar were constant visitors to Picasso's studio[19] at 7 rue des Grand-Augustins near to where Dora Maar was living with her parents. She had secured this studio for Picasso in early January 1937, having known it from the time the space had been used for *Contre-Attaque* meetings in late 1935 and early 1936.[20] Maar took photographs of the stages of *Guernica* and talked; Eluard talked and ended up producing his poem 'La Victoire de Guernica'.[21] We cannot know the exact conversations but it is possible to reconstruct some of the context.

The first issue concerns Maar's and Eluard's renewed politicization of Picasso and the legacy of *Contre-Attaque*. According to Pierre Daix, Dora Maar was a political catalyst for Picasso at this time and had an influence on *Guernica,* the depth of which will be impossible to know.[22] We do know that Maar, as with Eluard, was deeply involved in contemporary Surrealist social, political and artistic issues.[23] Eluard was one of thirteen, including Breton, who signed the first publication of the *Contre-Attaque* manifesto on 7 October 1935; republished almost immediately, it was signed by a further twenty-five, including Dora Maar.[24] Georges Bataille became its driving force. Breton's unexpected collaboration can be explained by his interview with *Le Figaro* in December 1935, where he stated that *Contre-Attaque*'s aim was 'to maintain the revolutionary activity that had been betrayed by Moscow'.[25] For Moscow, read Stalin.

Eluard, Maar, Bataille and *Contre-Attaque*

As Robert Short has argued, the 'only conception of the Popular Front which found favour with the surrealists was that of a revolutionary mass movement *above* the parties' (my italics).[26] In July 1935 the seventh world congress of the Third Communist International defined the new Soviet policy of the Popular Front, which shifted the class struggle to a struggle

against Fascism. This shift was designed to unite a broad spectrum of opinion and support against the growing forces of the Right and favourably to dispose non-aligned Marxists and liberals towards the Soviet Union; with Stalin's own internal repressive agenda such a public move had great tactical advantages. In July the PCF took part in a Popular Front oath with the Socialists (SFIO: *Section française de l'internationale ouvrière*) and Radicals. The Franco-Soviet pact of May and the leadership of Blum and Thorez did nothing to convince many Parisian intellectuals of the future of what they regarded as authentic revolution. *Contre-Attaque*, with a membership of between 50 and 70, was an alliance of Surrealists, with Breton's Trotskyist affiliations, and a splinter group, led by Bataille, of Boris Souverine's 'Cercle communiste démocratique', which was non-Stalinist and non-Trotskyist. Dora Maar had been part of the latter.

Contre-Attaque lasted from October 1935 to its official demise on 24 May 1936 with the Surrealists' announcement of its dissolution, largely because of what they regarded as tendencies 'surfacistes' which they claimed had become more and more flagrantly 'fascist' within the group.[27] According to Bataille, the last meeting was held on 21 January.[28] The character and the demise of *Contre-Attaque* have been well covered elsewhere.[29] What I want to draw attention to, briefly, are some aspects which relate to my concerns here.

In his 'Popular Front in the Street', first given at a *Contre-Attaque* meeting on 24 November 1935, Bataille made clear his distrust of political parties and of the Popular Front parliamentary leadership, which he saw as dominated by a *defence* against Fascism rather than by a necessary anti-capitalist *offensive*; he called for a transformation into a Popular Front of combat, drawing upon the emotional strength and revolutionary potential of mass action in the street. Recalling the demonstrations in Paris against Fascism on 12 February 1934, when the Popular Front was 'born', Bataille drew attention to the Communist marchers heading and mingling with the 'socialist masses':

> Many among you, no doubt, can remember the huge old bald worker, with a reddish face and heavy white moustache, who walked slowly, one step at a time, in front of that human wall holding high a red flag.
>
> It was no longer a procession, nor anything poorly political; it was the curse of the working people, and not only in its rage, IN ITS IMPOVERISHED MAJESTY, which advanced, made greater by a kind of rending solemnity -by the menace of slaughter still suspended at that moment over the crowd.[30]

Bataille argued that those in organized parties, either Fascist or Communist, were content with stunning boredom 'which they saw as the mark

of revolutionary seriousness'; 'morose and disagreeable work' of organized action. In a desire to encourage a liberation of workers' full potential, Bataille claimed: 'We must contribute to the masses' awareness of their own power; we are sure that strength results less from strategy than from collective exaltation, and exaltation can come only from words that touch not the reason but the passions of the masses.'[31] Bataille's call was open to a double criticism: from the Surrealists' view, this call could equally be heard by the leaders of Fascist groups; and, from those active in the PCF, Bataille was in the privileged position of a posturing intellectual with no understanding of working-class experience or of the actual threat of Fascism, save for a concern with the cultural and social superstructure.[32]

Dora Maar's intellectual and political relationship with Bataille had become intensified in late 1933 and early 1934 when they were lovers. In Bataille's 'The Sorcerer's Apprentice', published in July 1938, he claimed that 'The world of lovers is no less *true* than that of politics.'[33] Between 1936 and 1938 Bataille's notion of political activism dropped *Contre-Attaque*'s call for a programme of mass action in the streets to focus on an activism based on ritual and myth. The virility of the streets in 1936 became replaced by one which, by 1938, figures in the 'narrowly real world of a bedroom'. He continues: '... knowledge is the ecstatic discovery of human destiny, in this guarded space where science – as much as art or practical action – has lost the possibility of giving a fragmentary meaning to existence'.[34]

Two years earlier, in May 1936, *Contre-Attaque* had folded. By the summer, Bataille had founded the secret society of *Acéphale,* with four small format reviews published irregularly between June 1936 and June 1939. Unlike *Contre-Attaque*, *Acéphale* was not explicitly political. These developments were occurring at the same time as Hitler's remilitarization of the Rhineland in March 1936; the election of the Popular Front government in May, regarded as a socialist victory by French workers, who celebrated it with a wave of strikes and factory occupations; and Franco's military assault on the elected Spanish republican government on 18 July 1936.

As Bataille shrank back from explicit politics with *Acéphale*, Eluard's response to these events was different. He had been in Spain during January and February 1936, partly to lecture in conjunction with a Picasso retrospective in Barcelona which opened on 18 February. This was a period of collaboration between Eluard and Picasso. In June Picasso prepared an etching tribute to Eluard's poem 'Grand Air' with the poet writing text directly on the plate. During the year Picasso produced further illustrations for Eluard's poems.[35] As Sidra Stich has argued, persuasively, May and June of 1936 saw evidence of Picasso's renewed political consciousness and support for the Popular Front, prior to the outbreak of the Spanish Civil War.[36]

Significantly, too, at this time relations between Eluard and Breton began to break, culminating with a major split in 1938, when Picasso sided with Eluard. In April 1936 Eluard wrote to Gala about his concerns:

> I have *definitively* broken with Breton … My decision was brought about by his frightful way of discussing when he is in front of people. It's over, I will never participate in any activity with him again. I've had enough. Because of Breton, all of this too often lacked seriousness. I had decided long ago not to support childishness, triviality nor bad faith.[37]

Although Eluard was not an active member of *Contre-Attaque*, limiting his activity to signing tracts, he would have been keenly aware of the effect of the major differences between Bataille and Breton in the collapse of the movement at this time.[38]

'Poesie de circonstance'

In the midst of the outbreak of the Spanish Civil War, and the bombings of civilians in Madrid, Eluard could no longer adhere to Breton's disapproval of 'poésie de circonstance', poems linked to specific events.[39] He wrote his first explicitly political poem, *November 1936*. Aragon published this in *L'Humanité*, the Communist Party daily newspaper, on 17 December 1936. On the same day Eluard wrote to Gala: 'It's the first time that one of my poems has had a 450,000 run. I wonder what Breton will think of it. But, as long as I don't change my poetry, I don't see why I should not collaborate with *L'Humanité*, read by workers, rather than with the *NRF*, or elsewhere, read exclusively by the bourgeoisie.'[40]

A few weeks later, on 8–9 January, Picasso etched his politically specific *The Dream and Lie of Franco I* and *II* and accompanied the etchings with his own poem full of metaphorical imagery. Produced at the same time as accepting the commission for the Spanish pavilion, these etchings employ a number of religious, symbolic and political references on a directly topical theme. They were made to aid the Spanish refugee relief campaign and represent a more explicit connection between Picasso's political commitments and his art practice. This development is, I think, importantly, related to the relationship between Picasso, Eluard and Maar in the months from mid-1936 to the production of *Guernica,* a period characterized by conversations about the Spanish Civil War, the Popular Front, and the role of images and poetry within Leftist, particularly Surrealist, debates about politics.

Eluard's links with and support for the Spanish republicans during 1936, and his view of the fundamental threat of Fascism to the future of social,

cultural and political life in Europe, produced a shift in his tactical support
for the PCF and an increasingly negative attitude to Breton's position, which
could be called a more doctrinal link between Surrealism and Trotskyism.
In January 1937 Breton spoke before the Trotskyist International Workers'
Party, denouncing the second Moscow Trials. Eluard was differently dis-
posed. On 14 February 1937 he wrote to Gala that he saw Breton 'from
time to time. He is very involved in the proceedings of the Moscow Trials.
Not me.'[41] It can be argued that, from Breton's point of view, to be unaware
of the contradiction between long-range Marxist principles and short-
term Communist tactics was to capitulate to a non-revolutionary future.
Similarly, it can be argued that, in contrast to Breton, Eluard chose an
alternative hypothesis to what Tiersky calls the 'seeming paradox of doc-
trine and tactics', the hypothesis that: 'the Popular Front was a further and
variant stage in the continuing unresolved ambivalence of the relation-
ship of communism to French 'bourgeois' democracy – of a potentially
revolutionary opposition movement acting to gain the greatest possible
advantage in a nonrevolutionary situation.'[42] The revolutionary struggle in
Spain and the growth of Fascism tipped the balance in Eluard's political
commitment during early 1937 towards a more tactical if wary support
for Communist opposition.[43] His conversations with Picasso and Maar,
who was fluent in Spanish, may have resulted in them all considering the
paradox of doctrine and tactics with respect to the problematic relationship
between Surrealism, Communism and, with Picasso, Spanish Anarchism.

Support for this view is Picasso's first political statement in May 1937:
'In the panel on which I am working which I shall call *Guernica*, and in all
my recent works of art, I clearly express my abhorrence of the military
caste which has sunk Spain in an ocean of pain and death ...' The state-
ment was publicized in July 1937, at the time of an exhibition of Spanish
Civil War posters in New York shown under the auspices of the North
American Committee to Aid Spanish Democracy and the Medical Bureau
to Aid Spanish Democracy.[44] Later, in 1945, Picasso reiterated the partic-
ular politics of this work: 'There is no deliberate sense of propaganda in
my painting [...] except in the *Guernica*. In that there is a deliberate
appeal to people, a deliberate sense of propaganda.'[45] Between the first
sketch of 1 May and the full compositional study of 9 May Picasso had
included many of the characters which were to make up the final image.
On 11 May he transferred the basic elements of the sketch to the huge
canvas. Dora Maar's first photograph shows that, from the start, the bull,
horse, soldier, woman with the lamp, grief-stricken women and the woman
with the dead child are established in roughly their final positions. The
most striking difference between this first stage of the mural and the
previous preparatory images is the emphatic clenched fist and raised
arm of the soldier that dominates the space just left of centre. The most

obvious and inescapable connotation was a left-wing salute, common in demonstrations, press photographs and Spanish Civil War posters.[46] By May 1937, however, for Picasso the salute was directly linked to the Communist Party.

Sidra Stich has drawn attention to the clenched fist holding a hammer and sickle symbol in Picasso's sketches from 1936 and, significantly, in two images from 19 April 1937.[47] The first of these two – pen and ink on blue paper – includes the arm, fist and hammer and sickle symbol in a sketch which Herschel B. Chipp argues includes outline sketches of the final shape of the *Guernica* mural.[48] On the same day Picasso drew a figure with the same salute over a main story on the front of the issue of *Paris-Soir*. Significantly, the headline reports a speech by the Foreign Minister Yvon Delbos defending a policy of non-intervention in Spain.[49]

Picasso: Spain and Surrealist Politics

To understand the circumstances in which Picasso removed the Communist salute from early stages of *Guernica*, it is important to consider some of the other images and symbols which link Spain to Surrealist politics. As is well known, the sources for Picasso's immediate references included his work such as the *Minotauromachia* etching from 1935. A main character is the Greek mythological figure of the minotaur which traditionally symbolized the result of the overthrow of reason for the sake of animal passion. The head of a bull, suggesting the Dionysian, the irrational and the hedonistic, has replaced the supposed rational, Apollonian, intellectual human head.

In previous years Picasso had produced images of dead male and female toreros. In the *Minotauromachia* the young woman, semi-dressed in the costume of a bullfighter, is on the back of a horse – traditionally the mount of warriors, kings and nobles – which seems to stagger from a wound in its belly. On the left, a young girl holds a candle, often a conventional symbol of purification, knowledge and of the light of faith amongst darkness. Above her, two women are depicted with doves at a window. To the left, a man is placed on a ladder.

Works such as *Minotaur and Nude* of 1933 utilize imagery from mythology to represent violation and bestiality, themes running through Picasso's work of the 1930s. In *Bull Disembowelling a Horse* of 1934 there are references, on the one hand, to the Spanish corrida, and, on the other, to notions of passion and brutality. The depiction of a female with a candle at a window can be read as either watching or hiding from the depicted disembowelling. In *Bullfight*, 1934, the mythological connotations of a dark bull disembowelling a light horse are evoked in terms, again, of the

corrida. Within the *actual* spectacle, the vocal chords of horses used in the bullring are severed so that the pain they endure is silently expressed. Dead horses are removed before the matador moves in for the final kill of the bull.

In south-west France, on the border with Basque Spain, the corrida was popular. Bull-running in the streets was also traditional in southern France, with climbing of ladders part of the ritual rural events. In *Minotauromachia*, studies 16 and 21 for *Guernica* include a grief-stricken woman with a dead child climbing a ladder.[50]

In Spain the symbolism of the bullfight is highly specific with its actions of nobility of combat between representatives of spirit and animal power and that of human skill. Within the corrida there is also the element of sacrifice, that of the horse and bull. This element, especially the killing of the bull, was a characteristic of Spanish bullfighting as distinct from bullfighting in France in the late nineteenth and early twentieth century. However, by the 1930s, in southern France in particular, Spanish bullfighting became more common. A combination of the falling value of the peseta and the disruption of the Civil War meant that many of the most renowned Spanish bullfighters worked in this area of France in the 1930s.[51]

In February 1933 the first issue of the magazine *Minotaure* appeared in Paris, running until 1939. According to André Masson, its name resulted from an initial informal meeting of Surrealists and literary publishers. He recalled in 1942: 'Bataille and I, who were then concerned with the most mysterious of the Greek and Iranian mythologies, proposed *Minotaure*. This was accepted. It was also decided to ask Pablo Picasso to design a cover for the first number.'[52] Picasso produced a collage reproduced as the cover of the first issue which included an article by Breton on 'Picasso in his Element' with sixty photographs by Brassaï of Picasso's recent sculpture and studio. There were also reproductions of a series of drawings by Picasso after Grünewald's *Crucifixion* and reproductions of other sketches.

Minotaure was a glossy picture magazine without the political edge of earlier Surrealist publications. Bataille wrote for it only once, on Masson (in the eighth issue, 15 June 1936), just after *Contre-Attaque*'s brief political moment and the beginnings of *Acéphale*. We can speculate on Picasso's interest in the magazine, though clearly the symbolic possibilities of the Minotaur, the bull and the crucifixion were part of his practice. He was aware, too, of Bataille's and Masson's concern with Greek and Iranian mythologies, the power of ritual slaughter, sacrifice and tragedy.

In the second year of his journal *Documents* – 1930 – in the third issue called 'Hommage à Picasso', Bataille included a short essay entitled 'Rotten Sun'.[53] Here, he refers to Mithra who, in Iranian mythology, was an omniscient warrior deity born of a rock and armed at birth with a knife and torch. Mithra became known as the creator of life after capturing and killing

the sacred (white) cosmic bull, from whose blood came all the animals, plants, fertile rain and sunlight. Mithra was regarded as the Iranian god of the sun, justice, contract and war. Bataille goes on to discuss the Mithraic cult of the sun which included sacrifice of the bull. He writes:

> Of course the bull himself is also an image of the sun, but only with his throat slit. The same goes for the cock, whose horrible and particular solar cry always approximates the screams of a slaughter. One might add that the sun has also been mythologically expressed by man slashing his own throat, as well as by an anthropomorphic being *deprived of a head*. [54]

In the interview with Jerome Seckler published in 1945, Picasso insisted that the black bull in *Guernica* represented 'brutality and darkness'. [55] Picasso did not depict the bull with its throat slit; nor did he symbolize the modern ritual enactment of the ancient Mithraic cult with a matador's sword in the bull's massive neck muscle. Here, it is not an image of the sun; it is not, symbolically, life-giving. However, the bird next to the bull is in the position of a scream, a solar cry, which for Bataille 'approximates the screams of a slaughter.' And below, at the base of *Guernica*, a figure identifiable as a soldier in earlier studies is, through the absence of a body, *'deprived of a head'*. The head and arm with the broken sword are no longer useful for the act of life-giving sacrifice.

Above the depiction of Picasso's impaled horse an elliptical shape, with schematized rays and a central lamp, provides part of the illusion of light. In the second of Dora Maar's photographs of *Guernica* this lamp was a sun shape behind the fist, holding wheat, of the soldier's raised arm. This image can be indexed to the symbols of contemporary Spanish Civil War posters [56] and, as importantly, to Bataille's text 'Rotten Sun'. Bataille talks of the human tendency to distinguish between two suns. One is that of a most elevated conception, as it is confused with the notion of noon. Yet it is also the more abstract in that it is impossible to look at it fixedly at that time of day. He continues: 'If on the other hand one obstinately focuses on it, a certain madness is implied, and the notion changes meaning because it is no longer production that appears in light, but refuse or combustion, adequately expressed by the horror emanating from a brilliant arc lamp.' [57] Did Picasso establish some sort of arc lamp in the final stage of *Guernica*? It certainly replaced the fist and sun, and illuminates a scene of horror.

I am not arguing that Picasso's *Guernica* is somehow a visual equivalent for Bataille's essay. For, as the author says, 'it would be *a priori* ridiculous to try to determine the precise equivalents of such movements in an activity as complex as painting'. But as Bataille continues:

It is nevertheless possible to say that academic painting more or less corresponded to an elevation – without excess – of the spirit. In contemporary painting, however, the search for that which most ruptures elevation, and for a blinding brilliance, has a share in the elaboration or decomposition of forms, though strictly speaking this is only noticeable in the paintings of Picasso.[58]

It is possible to make further close comparisons between *Guernica* and Bataille's writings. In Bataille's essay 'Mouth', which was an entry in his project the 'Critical Dictionary', published in *Documents*, 1930, in the fifth issue, he discussed how, on important occasions, 'human life is still bestially concentrated in the mouth':

> ... terror and atrocious suffering turn the mouth into the organ of rending screams. On this subject it is easy to observe that the overwhelmed individual throws back his head while frenetically stretching his neck in such a way that the mouth becomes, as much as possible, an extension of the spinal column, *in other words, in the position it normally occupies in the constitution of animals.* As if explosive impulses were to spurt directly out of the body through the mouth, in the form of screams.[59]

This is the case with the two women on either side of the finished painting. When originally published, Bataille's text was accompanied by Boiffard's photograph of a screaming mouth in which the tongue is prominent. In *Guernica,* in the mouth of the horse and the grief-stricken woman on the left, and in the preparatory studies, such as numbers 28–33 and 35–42, wedge-shaped tongues are prominent.

In the preparatory studies (12–16, 21, 23, 25, 30–2, 34, 36–42), Picasso so developed the image of the screaming woman that Bataille's text seems inescapable as a source.[60] If we think of today's atrocities in the former Yugoslavia, Rwanda and Chechnya and of the recent fiftieth anniversaries of the Allies' discovery of Nazi extermination camps,[61] ways to represent physical suffering can be problematically urgent, particularly for those directly involved. Bataille writes that humans can liberate profound physical impulses in 'at least two different ways, in the brain or in the mouth, but as soon as these impulses become violent ... [they are] obliged to resort to the bestial way of liberating them'.[62]

As has been observed in the *Guernica* literature, a likely source for the head of the soldier on the ground is a corpse figure from the image of 'After the Flood' from 'L'Apocalypse de Saint-Sever' by an unknown artist. Bataille's article of the same name, with five illustrations from the French manuscript of the eleventh century, appeared in *Documents* in 1929.[63] The

French version is close to the Spanish original by Beatus of Liébana.[64] The image represents the moment from Genesis (8: 13) when Noah again removed the hatch and looked out of the ark to see a panorama of desolation, with corpses, one with a raven hacking at it, dead animals and a dove picking the branch from the olive tree.[65]

The sources for Bataille's belief in contemporary examples of ancient and suppressed needs for sacrifice and self-sacrifice ranged from savage and brutal scenes from religious documents to photographs of contemporary abattoirs. As another part of his 'Critical Dictionary', he included an entry, 'Abattoir', in a 1929 issue of *Documents*.[66] This was accompanied by three extraordinary photographs by Eli Lotar of Paris slaughterhouses at La Villette. Concerned with the overlap between human and animal, noble and base, Bataille considered the significance of abattoirs, especially where bulls and cows are slaughtered. He felt that the abattoir was linked to religion in the sense that ancient temples had a double usage, serving at the same time as sites of prayer and of ritual slaughter – blood and carnage.

The town of Guernica was itself an anciently venerated site in Basque culture. Celebrated since before official records began as the home of Basque liberties, the 'parliament of Basque senators' was traditionally held under Guernica's famous oak tree to elect an executive council, and, in the church of Santa Maria, Spanish monarchs or their representatives used to swear to observe local rights. The oak tree and the town were the centre of Basque sanctity, representing a transference of an ancient worship of the oak to political life.

Guernica: A 'Headless Allegory'?

The size, scale and format of Picasso's *Guernica* evokes ancient history painting on religious, mythological, and contemporaneous events. As in such traditions, it relies on codes, symbols and an allegorical relationship to the event represented by its title. It is not a 'real allegory' as in Courbet's *L'Atelier du peintre* of 1855. Yet Picasso expected it to have a propaganda function.

It is well known from the *Guernica* literature that there have been contradictory readings of the symbols: the bull as either a symbol of Fascism or as a symbol of the Spanish people; the horse as either white innocence or as ignoble representative of Nationalist Spain. Picasso's painting includes elements, each of which, as with Bataille's entries in his 'Critical Dictionary', offers an initial reference, only for this reference to be plunged either into an ancient connotation or a contemporary sociological or psychological context. This effect may be regarded as an encouragement to

play within a system of meanings outside of specific usage. On the other hand, *Guernica* may be the product of a contemporary conversation about the fall of the elevated paradigm of allegorical history painting as revealing a desirable threat to conventional coherence demanded by allegorical systems of the Right and the Left.

In *Acéphale*, Bataille argued that the head, rationalism and order lead to repression and totalitarianism, as with Fascism and Stalinism. In 'Propositions', published in *Acéphale* in January 1937, Bataille ended his first section, 'Propositions on Fascism', thus:

> The head, conscious authority or God, represents one of the servile functions that gives itself as, and takes itself to be, an end; consequently, it must be the object of the most inveterate aversion. One limits the extent of this aversion, however, by giving it as the principal of the struggle against unitary political systems: but it is a question of a principle outside of which such a struggle is only a contradiction in terms. [67]

Allan Stoekl has argued that, from Bataille's texts in *Documents* through to those in *Acéphale,* we can observe a continuing dialogue with the theoretical implications of allegory. For Bataille, subversion was achievable by means of a 'headless allegory' in which, Stoekl argues, 'the process of signification and reference associated with conventional allegory continues but leads to a terminal subversion of the pseudostable references that made allegory and its hierarchies seem possible'. [68] The fall of one system of allegory does not mean the elevation or stabilization of another. To be subversive, the fall of allegory has to be an incessant and repetitious process combined with a labyrinth of mythological, sexual and primitive possibilities. Bataille was thus arguing for subversion from a base materialism, from a recognition of elements of human nature and activity conventionally condemned by abstract laws, theories and idealist politics. The latter includes authoritarian imperialism (as in Fascism), utopian socialism, the Nietzschean *super*man, and 'spiritual' *sur*realism. Stoekl concludes:

> In Bataille's view, the bourgeois individuals – like Nietzsche or Breton – who foster a revolt by soaring 'above' are destined for a fall, and in a way *want* to fall; thus the 'Icarian complex', an 'unconscious' and pathological desire to fall. Icarian revolt (as opposed to base subversion) is the only pathology Bataille will condemn; it is the pathological refusal to embrace stinking decomposition – an embrace that, from the point of view of any dialectic of the cure, must itself be pathological. [69]

Picasso's numerous and detailed preparatory sketches for *Guernica* demonstrate a close engagement with the 'base materialism' of his practice and

with representations of death, pain, grief and horror. He was confronted in May 1937 with rapid and contradictory events and information about the Civil War. One source was Bataille, who Picasso met often at this time, not least because Bataille had his own contacts for information from Spain.[70]

Dora Maar's photographs of the successive stages of *Guernica* reveal changes in Picasso's struggle with the final theme and symbolic relationships inside and outside his work. Her third photograph shows that Picasso had removed the emphatic political symbol of the clenched fist and raised arm. By Maar's fourth photograph, the horse's head, which began as turned down, is turned up to fill the space left by the removed arm and fist. Picasso claimed that the horse in *Guernica* was the symbol 'of the people'.[71] The shift from explicit Communist salute to the head of a horse with a spear through its body was a decisive act.

Picasso's act could have been made because to have retained the arm and fist would have been to fix the allegory, to have made a direct association with the Popular Front, at least, and specifically with the Communist Party. Such an association would have been complicated by the Popular Front's refusal to support intervention in the face of evidence of Hitler's and Mussolini's military support for Franco, the most recent example being the bombing of Guernica. Association with the Communist Party was also problematized in May and June 1937 because of events in Spain.

In early May, POUM (Partido Obrero de Unificación Marxista), a revolutionary anti-Stalinist Party founded in September 1935, and CNT (Confederación Nacional de Trabajo), an anarcho-syndicalist trade union founded in 1910, were being crushed by PSUC/UGT forces (Partido Socialista Unificado de Cataluña, formed in 1936; and Union General de Trabajadores). The PSUC was affiliated to the Comintern and the major struggle during these 'May days' in Barcelona was between the official Communists, and the Anarchists and revolutionary Marxists. Stalin's secret police were active executioners in Spain at this time. Anarchist newspapers were banned, POUM's at the end of April, and the party was outlawed by the Republic on 16 June and its imprisoned leader Andrés Nin was murdered on 21 June by Soviet agents. As Hugh Thomas summarizes: 'May [1937] in Barcelona marked the end of the revolution. Henceforward, it was the republican state which was at war with the nationalist state, rather than revolution against fascism.'[72]

In Picasso's *Guernica* the figure on the ground has a severed arm still holding a broken sword, which, as a weapon of the soldier, has many narrative themes. The sword is also a traditional symbol of authority and administration of justice and is a conventional attribute of the Christian martyr. It is not surprising, therefore, that different social and political groups used the symbol as their own. For example, on 14 July 1936 at

l'Arc de Triomphe a ceremonial sword was held by Colonel de la Rocque, head of the Fascist Croix-de-Feu, which had recently been banned by the Popular Front government, and founder of its immediate replacement, PSF (Parti Social Français).[73] This was just before Franco launched his attack on the republican government in Spain. Popular Front demonstrations in Paris against the war soon after included large posters with the symbol of the 'fist and the sword' supporting the Left's strength of resistance.[74] This became a repeated symbol – as with the Communist fist salute – on Spanish Civil War posters throughout the coming year.[75] Significantly, though, posters supported by anarchist organizations such as CNT and FAI (Federacíon Anarquista Ibérica, founded 1927) also used the 'fist and the sword'.[76] Similarly, the revolutionary agenda of Catalan anarchists and POUM included social change with the formation of agrarian communes; hence, the symbol in many posters of the fist with wheat and agrarian implements such as the scythe.

To consider the broken sword in *Guernica* is thus to speculate on contemporary social and political struggle. For many historians the Popular Front in France was undermined from without by the withdrawal of international capital, and undermined from within by the government's failure to take positive action to support the revolution in Spain. The latter certainly divided intellectuals from the autumn of 1936 onwards. In the first of Maar's photographs the broken sword was held by a figure making the Communist salute. In the second photograph the salute becomes a fist clenching wheat depicted in front of a schematic sun. Picasso's removal of these images can be read as signifying 'loss' – of those revolutionary political groups betrayed in Spain in May 1937; of the moral authority of Communists aligned to the Comintern; of the possibility of organizations whose existence, paradoxically, played into the hands of the Falangist military which relied on fixed political targets to mobilize their rhetoric and forces. But such a reading is rendered problematic in the final painting where potential identifications are dislocated, fragmented and buried in references.

These transformations were in a political context characterized by Eluard's 'I do not know what to do [about Guernica]', in his letter dated 1 May 1937.[77] They were produced by and within a series of conversations in which Picasso, Eluard and Maar struggled, through representation, with the paradoxes of doctrine and tactics in May and June 1937.

Notes

1. Robert Short, 'The Politics of Surrealism, 1920–36', *Journal of Contemporary History* 1, 2 (1966), pp. 3–25; 'Contre-attaque', conference paper delivered on 12 July 1966, and published in Ferdinand Alquié, ed., *Entretiens sur le Surréalisme* (Paris: 1968), pp. 144–65. See, too, Robert Short, 'Surrealism and the Popular Front', in Francis Barker *et al.,* eds, *1936: The Sociology of Literature Vol I – The Politics of Modernism* (Colchester: 1979), pp. 89–104. These essays stimulated ideas first expressed in my 'Picasso's *Guernica*: A Headless Allegory', Smyth Memorial Lecture, University of Ulster, Derry, 23 October 1986.

2. Most clearly stated in 'Second Manifesto of Surrealism', *La Révolution surréaliste*, 1929, reprinted in André Breton, *Manifestos of Surrealism,* translated by Richard Seaver and Helen R. Lane (Michigan: 1972).

3. Said in an interview with *Radical Philosophy* 63, p. 26.

4. Breton, 'Second Manifesto of Surrealism', p. 183.

5. Ibid., p. 181.

6. Joseph Kosuth, 'Vico's Appliance: the Historian as Artist and the Crisis of Certainty', paper given at the CAA, 1995, in the session: *The Artist as Historian: The Boundaries between Evocation and Misinformation.*

7. The literature on the painting is vast. Recent studies, including useful discussion, documentation and bibliographies are: *Guernica – Legado Picasso* (Madrid: 1981); Ellen C. Oppler, ed., *Picasso's Guernica* (New York and London: 1988); Herschel B. Chipp, *Picasso's Guernica: History, Transformations, Meanings* (Berkeley and Los Angeles: 1988).

8. Sidra Stich, 'Picasso's Art and Politics in 1936', *Arts Magazine* 58 (October 1983), pp. 113–18.

9. Jutta Held, 'How do the Political Effects of Pictures Come About? The Case of Picasso's *Guernica*', *The Oxford Art Journal* 11, 1 (1988), pp. 38–9.

10. *Angry Arts: Against the War in Vietnam*, offset lithograph, 1967, PADD Archive MOMA, and collection of the artist.

11. On this see my 'Meyer Schapiro's Choice: My Lai, *Guernica*, MOMA and the Art Left 1969–70', Part 1, *Journal of Contemporary History* 30 (July 1995), pp. 481–511; Part 2, *Journal of Contemporary History* 30 (October 1995), pp. 705–28.

12. The Rockefeller family, major trustees of MOMA, own Standard Oil of New Jersey, which was not only connected to US involvement in Vietnam but also, during the Spanish Civil War, provided Franco with extended credit for the purchase of oil.

13. Specifically, see: 'Guerilla Art Action in Front of *Guernica* on January 3rd 1970', in Hendricks and Toche, *GAAG, The Guerilla Art Action Group 1969– 1976 A Selection,* Number 6, unpaginated (New York: 1978). Generally, see my 'Meyer Schapiro's Choice', Parts 1 and 2.

14. Clearly, too, the issue of US attitudes to Communism during the Cold War are central.

15. *Heraldo Español* (20 November 1981), four-page insert between pp. 34 and 35.

16. The number was nearer to 1,000. See Hugh Thomas, *The Spanish Civil War* (Harmondsworth: 1982 [1961]), p. 477.

17. All quotes translated from the cited text.

18. It then appeared in Breton's 'Exposition surréaliste d'objets', Gallerie Charles Ratton, Paris (May 22–9, 1936).

19. *Eluard et ses amis peintres* (Centre Georges Pompidou, Paris: 1982), p. 139.

20. There are various sources for this, including Georges Bataille, 'Autobiographical Note', *October* 36 (Spring 1936), p. 109.

21. Maar's photographs record ten stages and some details. Eight of the series and one detail were immediately published by Zervos in a double issue of *Cahiers d'Art* 12, 4–5 (1937). Eluard's poem was posted on a wall next to a photograph of a ruin of the town of Guernica in the Spanish Pavilion. An indication of Eluard's view can be gleaned from a letter dated 1 May 1937: 'I am full of incommensurable rage at the massacres in Guernica. But I do not know what to do'; in Paul Eluard, *Lettres à Gala 1924–1948*, edited and annotated by Pierre Dreyfus (Paris: 1984), p. 281.

22. See Pierre Daix, *La Vie de peintre de Pablo Picasso* (Paris: 1977), chapters 31 and 32; and Pierre Daix, *Picasso: Life and Art*, translated by Olivia Emmet, (London: 1993), chapters 24 and 25.

23. Maar exhibited two works in the 'Exposition surréaliste d'objets', Gallerie Charles Ratton, Paris (May 22–29, 1936) and signed the tracts *Appel à la lutte, L'Enquête sur l'unité d'action*, and *Du temps que les surréalistes avaient raison*. She and Bataille were both members of *Le Cercle*, led by Boris Souvarine, which was pro-Marxist but anti-Stalinist, and published their revolutionary theories in *La Critique sociale* (11 issues between 1931 and 1935). See Stitch, 'Picasso's Art and Politics', footnotes 25 and 26, and Short, 'Contre-attaque', p. 148.

24. See *'Contre-Attaque': Union de lutte des intellectuels révolutionnaires*, in Georges Bataille, *Œuvres complètes* I, *premiers écrits 1922–1940* (Paris: 1970), pp. 379–83 and notes pp. 670–1; on the history see Short, 'Contre-attaque', and Henri Dubief, 'Témoignage sur Contre-attaque (1935–36)', *Textures* (Belgium) 9 (January 1970), pp. 52–60.

25. Quoted in Short, 'Surrealism and the Popular Front', p. 94.

26. Ibid., p. 95.

27. 'Chez les surréalistes', *L'Œuvre* (24 May 1935), quoted in Short, 'Surrealism and the Popular Front', p. 101.

28. Bataille, 'Autobiographical Note', p. 109.

29. By Short's three already cited articles; Dubief, 'Témoignage sur Contre-attaque'; and John Hoyles, 'Georges Bataille (1897–1962): "Jouissance" and Revolution', in Barker *et al.*, eds., *1936: The Sociology of Literature*, pp. 105–32 and especially pp. 113ff.

30. Georges Bataille, 'Front populaire dans la rue', *Les Cahiers de Contre-Attaque* 1 (May 1936), in *Œuvres complètes* I, p. 405; Allan Stoekl, ed., *Visions of Excess: Selected Writings 1927–1939* (Manchester: 1985), p. 163. See interesting arguments in Susan Rubin Suleiman, 'Bataille in the street: the search for virility in the 1930s', in Carolyn Bailey Gill, ed., *Bataille Writing the Sacred* (London: 1995), pp. 26–45.

31. Bataille, *Œuvres complètes* I, p. 411; Stoekl, ed., *Visions of Excess*, p. 167.

32. The eighth point of the *Contre-Attaque* manifesto states: 'Nous affirmons que l'étude des superstructures sociales doit devenir aujourd'hui la base de toute action révolutionaire', Bataille, *Œuvres complètes* I, pp. 381.

33. 'L'Apprenti sorcier', first published in the *Nouvelle Revue française* 298 (July 1938), pp. 5–54, in Bataille, *Œuvres complètes* I, p. 532, and Stoekl, ed., *Visions of Excess*, p. 229.

34. Ibid.

35. *La Barre d'appui*, Paris, Cahiers d'Art; *Les Yeux fertiles* (Paris: 1936), containing a drawn portrait of the author, the three etchings from *La Barre d'appui* and the collaborative etching 'Grand Air' (3–4 June 1936).

36. Stich, 'Picasso's Art and Politics'. On evidence of Picasso's earlier political consciousness see Patricia Leighten, *Re-Ordering the Universe: Picasso and Anarchism 1897–1914* (Princeton: 1989); Francis Frascina, *Cubism: Picasso and Braque* (Milton Keynes: 1983) and Francis Frascina, 'Realism and Ideology: An Introduction to Semiotics and Cubism', in Harrison, Frascina and Perry, *Primitivism, Cubism, Abstraction* (New Haven and London: 1993), pp. 86–183.

37. Letter dated April 1936 in Eluard, *Lettres à Gala*, p. 263. A month later, in May, appeared Eluard's and Breton's collaborative *Notes sur la poésie* (Paris: 1936), which had already appeared in *La Révolution surréaliste* in 1929.

38. See Dubief, 'Témoignage sur Contre-Attaque', and Short, 'Surrealism and the Popular Front', on Eluard's participation and on the difficult relationship between Bataille and Breton at this time.

39. For Eluard's wish to place himself at the service of the Spanish and his view of the equivocation of 'les organisations intellectuals révolutionnaires' in France, see his letter to Louis Parrot, whom he met in Madrid earlier in the year, dated 11 August in *Eluard et ses amis peintres*, p. 231. On Breton's restatement of the political dilemma faced by Surrealists, see his Prague lecture 'Position politique de l'art d'aujourd'hui', 1 April 1935: 'either they must give up interpreting and expressing the world in the ways that each of them finds the secret of within himself and himself alone – it is his very chance of enduring that is at stake – or they must give up collaborating on the practical plan of action for changing this world ... it would appear that for a long time they had nothing but a choice between these two abdications', in Breton, *Manifestos of Surrealism*, p. 214.

40. In Eluard, *Lettres à Gala*, p. 271.

41. Ibid., p. 275.

42. Ronald Tiersky, *French Communism: 1920–1972* (New York and London: 1974), p. 94.

43. Eluard joined the PCF in 1927, but resigned over the Aragon affair in 1932. He rejoined again during the Second World War, in 1944. Picasso also joined in 1944.

44. Statement reprinted by Elizabeth McCausland in *Springfield Republican* (18 July 1937), see Alfred H. Barr Jnr., *Picasso: Fifty Years of his Art* (New York: 1946), p. 202 and p. 264.

45. Picasso in Jerome Seckler, 'Picasso Explains', *New Masses* (New York, 13

March 1945), pp. 4–7, as reprinted in Dore Ashton, ed., *Picasso on Art: a Selection of Views* (London: 1972), p. 137.

46. See posters in John Tisa, ed., *The Palette and the Flame: Posters of the Spanish Civil War* (London and Wellingborough: 1980).

47. Stich, 'Picasso's Art and Politics', pp. 114–17. Jacques Fauvet, historian of the PCF, called Jacques Duclos and Maurice Thorez, party leaders in the early 1930s, 'the Hammer and the Sickle'.

48. Chipp, *Picasso's Guernica*, pp. 66–7.

49. See Stich, 'Picasso's Art and Politics', pp. 116–17, and Chipp, *Picasso's Guernica*, pp. 68–9.

50. All references to studies are to the numbers as in *Guernica – Legado Picasso*.

51. Though most prominent bullfighters were with the Nationalists. Corridas were held in the republic, mostly as benefits for hospitals and schools. Anarchists opposed them.

52. Letter from Masson, *View*, 2nd series, 2 (May 1942) quoted in Dawn Ades, *Dada and Surrealism Reviewed* (London: 1978), p. 279.

53. Roland Penrose, *Picasso: His Life and Work* (Harmondsworth: 1971 edition), pp. 312–13, draws attention to this source, but as a footnote aside without exploring its full significance. See, too, Ruth Kaufmann, 'Picasso's Crucifixion of 1930', *Burlington Magazine* (September 1969), pp. 553–61.

54. Georges Bataille, 'Soleil pourri', *Documents* 3 (1930), in his *Œuvres complètes* I, pp. 231–2. Translation used: Stoekl, ed., *Visions of Excess*, pp. 57–8.

55. Picasso, in Seckler, 'Picasso Explains', p. 137.

56. See Tisa, *The Palette and the Flame*.

57. Bataille, 'Soleil pourri', Stoekl, ed., p. 231; and *Visions of Excess*, p. 57.

58. Bataille, *Œuvres complètes* I, p. 232; and Stoekl, ed., *Visions of Excess*, p. 58.

59. Bataille, 'Bouche', *Documents* 5 (1930), p. 299; *Œuvres complètes* I, p. 237; and Stoekl, ed., *Visions of Excess*, p. 59.

60. See also the works after completing *Guernica* from 8 June onwards in *Guernica-Legado Picasso*, numbers 47–61.

61. See, as one example, *The Guardian 2*, 13 April 1995, on the liberation of Belsen and the harrowing testimony of Tom Stretch who, as a British Army Chaplain, was one of the first eye witnesses, pp. 1–3.

62. Bataille, 'Bouche', p. 299; *Œuvres complètes* I, p. 237; and Stoekl, ed., *Visions of Excess*, p. 59.

63. *Documents* 2 (1929), pp. 74–84.

64. On this see O. K. Werkmeister, 'Pain and death in the Beatus of Saint-Sever', *Studi Medievali* 13, 2 (1973), pp. 565–626 and plates I–XXVII.

65. *L'Art catalan du Xe au XVe siècle* was held at the Jeu de Paume des Tuilieries, March–April 1937, with related works; Picasso was a member of the French committee of the joint Catalan–French project to exhibit Catalan art as part of the Paris World Fair that year. See Chipp, *Picasso's Guernica*, p. 87 and footnote 14.

66. *Documents* 6 (November 1929), p. 329; Bataille, *Œuvres complètes*, I, p. 205.

67. *Acéphale*, 2 (January 1937), in Bataille, *Œuvres complètes*, I, p. 470; and Stoekl, ed., *Visions of Excess*, p. 199.

68. In his 'Introduction' to *Visions of Excess*, p. xiv.

69. Ibid., p. xv.

70. Information from Toni del Renzio, who was in Barcelona during May 1937, and later in Paris, where he met Picasso, who wanted to know as much as possible about events in Spain. Del Renzio recalls Picasso's passionate anger at Franco's military intervention.

71. Picasso, in Seckler, 'Picasso Explains', p. 137.

72. Thomas, *The Spanish Civil War*, p. 661.

73. See Louis Bodin and Jean Touchard, *Front Populaire 1936* (Paris: 1985), p. 27. The Croix de Feu claimed 50,000 members in 1934 and the PSF grew enormously as the Popular Front government collapsed under outside financial and other pressures. See Jacques Danos and Marcel Gibelin, *June '36: Class Struggle and the Popular Front in France*, translated by Peter Fysh and Christine Bourry (Chicago and London: 1986).

74. See David Seymour's photograph in *No Pasaran! Photographs and Posters of the Spanish Civil War* (Bristol: 1986), p. 41.

75. See Tisa, *The Palette and the Flame*.

76. Ibid., for example p. 30.

77. Eluard, *Lettres à Gala*.

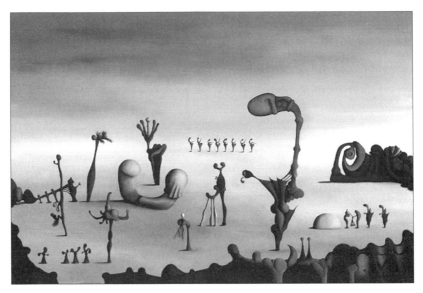

Desmond Morris, *The Arena*,1976

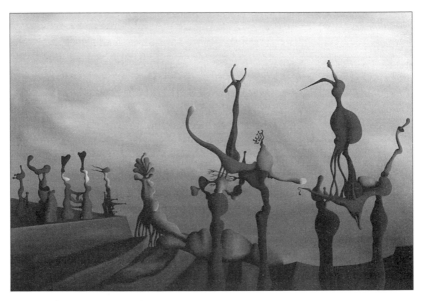

Desmond Morris, *Ascending Figure*,1976

Un Faucon et un Vrai

Toni del Renzio

There seem to have been two fallacies that have beset much critical, theo-
retical and even historical discussion of the Surrealist enterprise in the
plastic arts, twin snares set by the principles of Surrealism for the hasty,
the unwary and the presumptuous: *petitio principii* and *ignoratio elenchi*,
question-begging and irrelevant conclusion.

You will, then, appreciate – however much you may question – the
strategy of borrowing a title for my contribution from Marcel Duchamp's
explanation (and leaving it in the original French) of a 1968 drawing,
Extract, after Courbet, showing a raptor alongside a woman with her skirts
hoisted to display the pudenda. In the introduction to the *International Sur-
realist Exhibition* (Paris, 1959) Breton wrote:

> Anyone undertaking to unravel the secret of the elective fascination
> which the entirely dissimilar works of Duchamp and de Chirico have
> been able to exercise with unabated power upon Surrealism since its
> origin is likely to get lost in sterile conjectures by failing to realize that
> their highest common factor is *eroticism* … a 'veiled' eroticism (the
> first perfectly deliberate, the second almost certainly involuntary) having
> recourse to two different emblematic structures. One might add that,
> over and above their extreme disparity of means and appearance, what
> in general characterizes and qualifies works of art as Surrealist is, first
> and foremost, their erotic implications. [1]

In a subsequent remark in the same introduction, and citing with a cer-
tain approval the preface to an 1885 Latin–French erotic dictionary, Breton
wrote of an 'aversion to those words which we are told are the language
of love, but which smell bad and make dirty stains on the paper on which
they are written'. Only by that aversion could eroticism be free from shame
and take its due high place. 'Our deepest concern', Breton finally declared,
'has been to banish such words – the representations they entail – from this
exhibition.'

This was an attempt at a distinction which Marcuse,[2] not yet the guru
of the Quartier Latin, was also making in *Eros and Civilisation*, between a

vulgar, exploitative and oppressing pornography and a liberating ideal, first articulated in the *Prolegomena to a Third Manifesto of Surrealism or Else*,[3] of an entirely new role for women in our society (and implicitly, therefore, also for men), opposing such banalization of the erotic and its reduction to the representation of scabrous scenes. On the contrary, for Surrealism, eroticism resides in the ambiguity arising within a complex of symbolic transpositions wherein the latent content manipulates the manifest. It is, perhaps, a contentious argument. It characterizes the mental attitude of the artist rather than the manifest content of the work. Breton must have been well aware of Duchamp's more recent work since the *Prière de toucher* cover for the catalogue of the 1947 *International Surrealist Exhibition*, or Hans Bellmer's extraordinary works, as well as those of many others such as Leonora Carrington and Clovis Trouille. No one need doubt the erotic implication of Duchamp's *Large Glass*. If that affectionate sobriquet is insufficient, there is, then, its proper title and, beyond that, the documentation so lovingly and painstakingly assembled in *The Green Box*. It is not so much to this aspect, however, that I now wish to refer, not to that marvellous essay, 'La Phare de la mariée', but to *Genesis and Perspective of Surrealism in the Plastic Arts*. With the *Large Glass*, Breton wrote, Duchamp had transcended the practical and theoretical considerations that had guided his and Picabia's deliberate confusion of man and machine:

> The emancipation from the exterior object was taken a stage further. Once the artist had achieved the desired reconciliation between man and machine, and in so doing had demonstrated that the great difference between the two was that the latter could neither construct nor repair itself, neither perfect itself nor even destroy itself, unaided, *he was then quite naturally led to Surrealism*' (my emphasis).

It is not now at all inapt, therefore, to digress somewhat with a little historical interlude. First, let me remind you, Duchamp never formally submitted to the discipline of any Surrealist group, neither in interbellum nor postbellum Paris, nor yet during his wartime stay in New York. It was Duchamp, however, who had rallied support for Breton in the 1938 Paris *International Surrealist Exhibition* and who had covered the ceiling of the gallery with coal sacks and lit it with braziers of glowing coals – Breton was also the name of the largest coal merchants in Paris. It was Duchamp, too, who had installed the wartime New York show, *First Papers of Surrealism* (which included Mondrian), in a tangle of seven miles of string, wherein no picture was hung upright or square (thereby cocking a snook at Mondrian perhaps). I do not, incidentally, think that the best-known seller of string in New York was also called Breton, so the tangle may suggest itself as symbol of something else. It was Duchamp who finally broke with Breton

over the inclusion of a Dalí Madonna in the 1960 *International Surrealist Exhibition* in New York without consulting Breton and the other two organizers in Paris. He was tired, he once told me, of the role of Breton's *alter ego*. It was Duchamp as well who, as it were, took the opposite road to Calder and Man Ray, spending most of his time in New York, and dying the possessor (proud or not I don't know) of a US passport. This all points to the extraordinary ambiguity of the man and his works, of his constructed history and cunningly curated myth. Breton had written of him as 'the most singular, the most elusive, the most deceptive'.

Breton's 1959 'Introduction' consisted of two parts printed side by side, the one addressed to the exhibitors and spaced so that its topics aligned with those of the other, addressed to the visitors. It is from the latter that I have so far quoted, but I now wish to draw your attention to some very important statements in the former:

> In view of the present situation in the plastic arts, which must make one consider any distinction between the various tendencies (the most striking of which derive from Surrealist automatism) to be rather vain, Surrealism proper owes to itself to reassert its rights in a domain, specifically its own, which runs no risk of becoming fragmented between increasingly modest and numerous exploiters and then being resolved in the vapours of technical problems.

That 'domain' is, of course, where erotic implications are determinant; the 'various tendencies' and their 'exploiters' constituted the ranks of Tachisme, Abstract Expressionism, neo-Dadaism, 'nouveau réalisme', and whatever, though Rauschenberg was included in the show; and, finally, 'modest' refers to the talents on display, not to their pretensions.

The adoption, in total or in part, of Surrealist techniques and practices by no means assures a Surrealist outcome and so can in no way contribute to Surrealist visuality. On the other hand, however, Max Ernst's works continued to be regarded as Surrealist, though, after his exclusion from the group, he was not.

Because of its longevity as a movement – Surrealism was, even some 25 years ago, the longest established current still affecting the arts – there were then, as there are now, many who had arrived and departed, but whose presence remains in those works accomplished within the Surrealist context. There were also, then as now, some non-Surrealist artists whose works could be fitted into a Surrealist theme, as could, too, a considerable number of works from the past – recent and remote – along with 'ethnic' artefacts, fetishes, objects from tribal Africa, New Guinea, Polynesia and Aboriginal Australia, from the native peoples of the Americas, past and present, the naïve and autodidactic works within our own societies,

the art of the insane, and, of course, some 'folk art', all of which, indeed, had always found a presence, not at all marginal or subsidiary or patronized, in Surrealist exhibitions, publications and theoretical discussions. One should note the support given to Jean Dubuffet and *l'art brut*. What Surrealism claims as its own is not, therefore, limited to the production of the members of its groups, while any selection from that production cannot alone guarantee an enterprise to be Surrealist. An exhibition of Surrealist works does not necessarily constitute a Surrealist exhibition. This is, perhaps, confirmed by the numbering of the international exhibitions adopted at the 1959 *Eros* exhibition in Paris and applied retrospectively. The MOMA New York show of 1938, *Fantastic Art, Dada, Surrealism* was not given a number because, I suspect, it was a misleading popularization which was as confused and confounded as it confused and confounded. Probably the two installations by Duchamp (Paris 1938 and New York 1942), numbers three and five respectively, more than any other, exemplify what a Surrealist exhibition can be.

As well as Duchamp, notably Picabia, Arp and Klee were outside the group but were acclaimed and frequently took part in Surrealist activities, while Picasso, offered every latitude and leeway, nonetheless chose to submit to the discipline of the group. Calder and Kandinsky, Tamayo and Riopelle, Rauschenberg and Baj, all received the Surrealist accolade in one form or another, and the members of the Cobra group were more or less accepted. There was also the brief dalliance in the 1930s with Balthus, which was not renewed after the war. If Giacometti went his own way, it was with no hostility towards or from the Surrealists. So much, then, for the cantankerous sectarian exclusivity with which Surrealism has so often been damned.

In *Genesis and Perspective*[4] Breton also admitted having given Chagall insufficient recognition, being repelled by his mysticism, though no longer holding this against him: 'His complete lyrical outburst dates from 1911, when, for the first time, the metaphor made its triumphal entry into modern painting.' What had happened to art, particularly since photography, Breton suggested – remarkably in parallel with Walter Benjamin – with regard to such pioneers, had been a crisis of the model: that, taken from the external world, no longer existed nor could exit, while that, taken from the internal world, which would replace it, awaited its discovery by Surrealism. The instrument of discovery was, and still is, automatism, although widely misunderstood and, sadly, in more or less bad faith, just as widely misrepresented. According to Breton:

> The Surrealism in a work is in direct proportion to the efforts which the artist has made to embrace the whole psycho-physical field of which consciousness is only a small fraction. In these unfathomable depths

there prevails, according to Freud, a total absence of contradiction, a release from the fetters caused by repression, a lack of temporality and the substitution of external reality by psychic reality obedient to the pleasure principle and none other. Automatism leads us straight to these regions.

This is not at all, however, a recipe, a prescription of a *modus operandi* nor any guarantee of Surrealist outcome. Indeed, a premeditation need not necessarily preclude any intervention of automatism and can often invite it. As Heraclitus put it: 'If you do not seek the unexpected you will not find it, for it is painful and hard to find.' Though the setting up of dream images, more or less in a manner of *trompe-l'œil*, is vulnerable and its achievements fragile, the utmost vigilance can protect it from the risks and ensure that discoveries of automatism are not suborned. One thinks of those marvellous works of de Chirico, for the most part executed prior to 1919, when the magic wings attached to his hand swept it over canvas after canvas, releasing it from obedience to his eye, while automatism, in one of its forms, relieved his conscious brain from the tedium of inventing or locating a subject.

Writing a preface to what, I believe, was Max Ernst's first Paris show, Breton observed:

A landscape into which nothing earthly enters is beyond reach of our imagination. And it seems likely that, denying *a priori* any effective value in such a landscape, we should refuse to evoke it. It would be equally sterile for us to reconsider the ready-made images of objects (as in catalogue figures) and the meanings of works, as though it were our mission to rejuvenate them. We must accept these conventions, and then we can distribute and group them according to whatever plan we please.

Some 20 years on, Breton recalled the effect upon him of the first Max Ernst collages he saw:

The external object had broken away from its habitual environment. Its component parts had liberated themselves from the object in such a way that they could set up entirely new relationships with other elements, escaping from the reality principle and yet gaining a certain importance on the real plane (disruption of the notion of relation).

In a certain sense, then, the collage embodies the very essence of Surreality, the precise visual realization technically of Lautréamont's disquieting similes from *Les Chants de Maldoror*, starting with the exemplary 'chance meeting of an umbrella and a sewing machine upon a dissecting table'.

Automatism is the means whereby chance might take its due role in the creative process precisely in those works which, at first encounter, seem to have rejected it, just as the free play of chance opens to automatism the expressive means apparently otherwise denied to it, the one or the other determining the Markov chain in the creative operation of the other, a dialectic that dominates all Surrealist undertakings. Much as Benjamin pointed out that, with the coming of sound, an actor could now be filmed at the speed of speech, so automatism proceeds at the appropriate pace of the nature of the imagery.[5]

The point at issue, however, is not a lack of consciousness, but, on the contrary, ever more consciousness, even though this reveals it to be only a partial factor in the creative process.

The three paths that Breton set out in the New York interview of 1941 – alienation of sensation, objective chance and black humour – are not to be viewed as alternatives, but as complementaries, the mix varying from artist to artist and from work to work. Whatever the chosen route, the two others do not diverge but intertwine and converge with it. This effectively rejects any sterile academic and reductive taxonomy. Who is there who can tell me the precise psychic origins of, say, Duchamp's *Not a Shoe?* – or even the physical origins, however obvious they may be thought to be? Where the part of humour? Where that of chance? What and where the degree of alienation? But we do not need to know the French expression, 'trouver chaussure à son pied', to recognize the erotic by-play.

Surrealism, of course, does not constitute a style, nor does it privilege any one style above another and has ever accommodated what was appropriate to any one purpose, authenticity overruling any other considerations. Nonetheless, from time to time, Breton did address the problematics of styles within Surrealism. In his preface to Enrico Donati's show in New York, 1944, he wrote of the two attitudes in Surrealist painting that had happily co-existed for twenty years without excessive friction but which now threatened schism, having become 'rival' systems of figuration. He was referring, though in a veiled manner, to the simple-mindedness of the Pollock generation in New York: 'The accusations of academicism and abstractionism which the adversaries hurl at each other at regular intervals do, despite everything, reveal something more than a sterile polemical violence; they indicate, in fact, the two reefs between which art must be carefully steered by an expert helmsman.' Breton saw little point in choosing between them. One should note, in passing, that none of the young men and women in New York, such as Lionel Abel, Harold Rosenberg, Robert Motherwell, Robert Allerton Parker, David and Susan Hare, who gathered around Breton and the Europeans and collaborated in *VVV*, appreciated the discipline demanded of them to form a Surrealist group, nor possessed the commitment to continue any Surrealist

research after the Europeans' departure.[6] The issue had been undermined to a certain extent by Breton's stance from his earliest writings on art. May I recall to mind that first Max Ernst preface: 'A landscape into which nothing earthly enters is beyond reach of our imagination.'

Some forty years after that preface, writing of René Magritte, Breton signalled the inadequacy of the traditionally accepted distinction of the two modes of cognition which, I suggest, correspond very roughly and somewhat loosely to the two systems of figuration. He referred to the Spinozan philosopher, Constantin Brunner, and his notion of a third mode called 'analogon'. Defined as 'superstitions thought', the conversion of relativity into an absolute, a 'fictious' absolute. It may combine with either sensory perception or abstract thought, but never with both. Breton then called upon Dore Ashton: 'The artist who believes he can maintain the "original status" of an object deludes himself.' Each object lies in wait for the imagination to launch it on a career of metaphor and to take off into the symbolic structure of the dream or myth.

In another piece on Magritte, some three years earlier, Breton had noted Magritte's concern to bring into consciousness the latent life of these objects, to construct the semantic bridge springing from the proper meaning to the figurative, transposing them into the drama of the enigma. Breton wrote of 'object lessons'. What better description could there be of that masterpiece of 1929, *La Trahison des images*, with its provoking inscription in childish copperplate, 'Ceci n'est pas une pipe', that had inspired even Duchamp in the title, *Not a Shoe?* What erotic depths does the encounter of these two disparate works reveal, these two quite different displaced signifiers with but a single universe of discourse?

It is evident, I firmly believe, that the visuality of Surrealism, among the many other things that it achieves, comments upon language, often aided by the 'poetic' titles or by inscriptions within the work; but this neither renders it literary nor denies its autonomy. There is, inevitably, cross-channel redundancy, much more complex when words are incorporated within the fabric of the work. It is, of course, a supreme irony of the situation that Surrealism began as a literary movement, albeit one that literature has ever found hard to accommodate – I really mean do 'literature', rather than the literary establishment for which Surrealism has always voiced its disdain and mistrust. Also, Breton has related something of the debates that arose from the first proposals to bring the plastic arts within the Surrealist imperatives. Yet, today it is the visual manifestation that first occurs to most people and, in the anglophone regions at least, the existence of the poetry is hardly suspected. But this underscores the situation of a Surrealist image, constituted in a way by no means clear-cut and unproblematical, identifiable readily, perhaps, but not quite so readily definable, if at all.

Look at Masson, for example, or the so-called automatic techniques (frottage, fumage, decalcomania), including those of Matta and Esteban Francés. Look at Miró or Tanguy, both of whom made quite distinctive contributions to the range of Surrealist visuality, and at Delvaux, Brauner and Paalen. Above all, however, look at the role of the object in all its many mythopoetic and fetishistic manifestations: Duchamp's ready-mades and constructed pieces, the sculptures of Arp and Giacometti, which they called objects; found objects; found objects interpreted; the vast array of assemblages, including Cornell's boxes; objects functioning symbolically, including many by Man Ray, whose photographs marvellously exemplify Surrealist visuality; Breton's poem-objects; objects so treated by the elements or by humans accidentally or by artists wilfully as to be unrecognizable or otherwise enigmatic; objects whose past or present function eludes us; objects that in one way or another all serve as springboards into metaphor's vertiginous spiral, discovering more to the reality within than to the data surrounding them in their quotidian familiarity.

I have here limited myself to seeking what directions I could discover in Breton's writings on the plastic arts, a corpus of critical, theoretical, appreciative and innovatory texts, often intensely poetic, more extensive and wider-ranging than those of any other Surrealist in the French language of which he was the greatest master since Chateaubriand, and the most persuasive.

Notes

1. All the texts of Breton cited may be found in either *Surrealism and Painting* (New York: 1972), or *What is Surrealism?* (London: 1978). Breton has never been well served in English translation. I have, therefore, frequently modified passages where I felt his meaning to be obscured or misrepresented, or where the English version appeared infelicitous, if not clumsy.
2. Herbert Marcuse, *Eros and Civilisation* (Paris: 1963).
3. André Breton, *Les Manifestes du Surréalisme suivis de Prolégomènes à un troisième manifeste du Surréalisme ou non* (Paris: 1947).
4. André Breton, *Le Surréalisme et la peinture suivis de Cenèse et perspective artistiques du Surréalisme et de fragments inédits* (New York: 1945).
5. Walter Benjamin, *Illuminations* (London: 1973), p. 221.
6. The journal *VVV* was published in New York between June 1942 and February 1944.

The Visual Poetics of British Surrealism

Michel Remy

The visual poetics of British Surrealism is inseparable from the aesthetic historical context. Indeed, it is hard to understand why the Surrealist proposition took so much time to develop in England if one does not bear in mind the overwhelming importance of Bloomsbury theories, the domination exerted in artistic matters by the 'Bloomsbury spirit'. This will not be the place to analyse and trace the history of Bloomsburyism. Suffice it to say that its main tenets, held up and defended by Roger Fry and Clive Bell – followed on closely by artists such as Duncan Grant, Winifred Nicholson and Ben Nicholson – are all dependent on the concepts of order, structure and visual centrality. The eye is required by them to integrate and eventually to unify. Visuality has here a teleological nature, since it posits an end and assigns to itself the task to reach it.

In order to reach such pure unity of the work, the main principle defended by Bloomsbury artists and critics was the eventual exclusion of representation, 'a sign of weakness in an artist';[1] representation as such is declared to be parasitical, extraneous and obtrusive. Internal arrangement of forms is privileged and any mimetic or moral function in the work is rejected. Art is above and beyond reality, above and beyond any kind of moral, ethical engagement: 'Every sacrifice made to representation is something stolen from art'.[2] Such formalism blatantly appears in this statement about Cézanne and Renoir by Roger Fry in 1920: 'Whatever Cézanne may have meant by his celebrated saying about cones and cylinders, Renoir seems to have thought the sphere and cylinder sufficient for his purpose. The figure presents itself to his eye as an arrangement of more or less hemispherical bosses and cylinders …'[3] To the concept of representation, Bell will oppose the concept of 'pure art', an art conceived as an assemblage of forms contributing to create a purely abstract language – a visual music. So much so that Fry ends up advocating a purely spiritual conception of art, setting free, as he wrote, 'a pure and as it were disembodied functioning of the spirit'.[4] It is this disembodiment which introduces a fracture in the history of twentieth century art.

The positing of an ultimate essence, of a fundamental unity in all constructions, of the significance of the arrangement – the direct heirs to

Platonism and Aristotelianism – induces a centripetal movement of the eye. The subordination of emotion, this kind of aesthetic Quakerism central to the dominant aesthetics of the 1920s in England, installs the supremacy of the eye as the one and only origin, as the one and only ruler of what it sees on the canvas, in a kind of optical totalitarianism – think of Ben Nicholson.

We have by now understood that exactly the reverse takes place with Surrealism's visual poetics. The task of Surrealism is to establish a new eye, an eye no longer dictated to by the self-centeredness and absolutism of the artist, an eye opening itself to relativity and to otherness. That it was a much needed reaction is evidenced by the writings of a critic and theoretician whom one might oppose to Fry and Bell, and who deserves to be reassessed – R. H. Wilenski, whose *The Modern Movement in Art* seems to me decisive.[5] Not only does he stress the work's contact with the spectator arriving on the scene, but, criticizing Bell's egotistical method of approaching art, he insists that there is no intrinsic value in a work of art; for him, its value depends on how the spectator's eye takes it in.

Almost in answer to these statements, British Surrealism will develop visual strategies whose aim is to dislocate and de-centre the visual process, not only by disseminating the focus of the image, but also by actually staging and identifying, within the frame of the canvas, the visual operation itself. The spectator is made part of the visual process and led to assess his own participation in the very process. To illustrate this as sharply as possible, it is particularly relevant to concentrate on the confrontation of the spectator with the representation of eyes and see how this ensures the provocation of visual habits.

In that respect, it is probably S. T. Haile who most accurately involves and reinstates the spectator's eye as both the beginning and the end, indistinctly, of the actual making of the image. In his paintings, eyes are both active and passive, objects and subjects, made to act as the delegates, the deputies, so to speak, of the 'external' eye of the spectator. Because the eye is represented on its own, detached from any constituted body, it, in its turn, detaches the spectator's eye from its own body and its inherited certainties. The poetics of the Surrealist eye is the poetics of suspension. Haile's *Brain Operation* (1939), is centred on the act of cutting and dovetails a whole series of tensions: bright/dark areas, upper/lower levels, straight/curved lines, angular/round shapes, figurative/non-figurative forms. It is a space of intensity, filled with the tension initially created by the half-open scissors. An operation is under way – one thread has already been cut. The eye is being cut off and forms are about to fall, but hands, engaged in the process of cutting, have also been cut, as is shown by their section with arteries and nerves. Vision is thus a process by which the eye is divided, cut from itself in the same way as it cuts and divides.

11.1 Samuel Haile, *Brain Operation*, 1939 (Photo: Austin/Desmond Fine Art)

To cut is to be cut. And the bi-dimensionality of the painting, the liberation of the lines from the objects, reveal how forms are no longer held up by their contours, how a lateral movement of separation takes place, a movement of re-vision.

Haile's obsession with eyes is linked to the act of cutting. *Surgical Ward* (1939) shows the same framing of space by eyes detached from bodies. Here, everything is seen as having already been cut off, dissected – skin tissues, nerves, eyes, hands, profiles. Eyes have definitely cast off the bodies they belonged to and re-originate their gaze through an autopsy (etym.: 'seen with one's own eyes') – or could we say, *optopsy*? Eyes are the surgeons of accepted reality. In *Clinical Examination* (1939) the coldness of the colours echoes the coldness of the gaze, which reduces the body on the table to a mere spread-out succession of organs – an experience of the irreducible ruthlessness of the gaze.

This links up with the fundamental principle of Surrealism, i.e. the freeing of the eye from any kind of authority. In *Mandated Territories* (1938) this radical struggle with authority is given another dimension when one refers to Haile's profound commitment to left-wing and anti-colonialist ideas. The proliferation of eyes, growing from the ground in revolt against the invading monster, the renewed dynamism of the lines – now vegetable

11.2 Samuel Haile, *Mandated Territories*, 1938

stems – all point to the primordial energy which the eye must retrieve. The same can be said about *The Woodman* (1939), where the eyes have vanquished the aggressor of the woods.

There is more: in all those works, the spectator's eye is asked to participate in the process of dis-organization. The line is drawn in such a way as to make eyes suspend the forms and the links between the forms. In that way, vision becomes part of a general, universal process of growth, a telluric raising up of forms. *Earth Processes* (1939) is such a place, where the eye sees, beyond surfaces, the deep innervation of organs and participates in the process of growth which makes forms tremble at their limits.

Indeed, during that slow movement of intensification, the eyes drift away from themselves, so to speak, as the originators of forms. So is the case with Edith Rimmington's work, where a centrifugal movement de-multiplies and disseminates the organs of sight, just as bodies are deprived of any identifiable totality. *Museum* (1951) shows a glass globe in which there is the head of a Greek statue, and on which several eyes are seen floating. Behind and beside, animal and vegetable organs – recalling larvae, insects and sexual organs – also float in suspension. The fragmentation of the bodies, the multiplication of the eyes, the splintering of our gaze, all this bars the spectator from reaching any totality. The head itself has

blind eyes, which contrasts with the floating eyes, freed from any head and body. Moreover, our vision stumbles on an impossibility: the head cannot have been reconstituted in the globe as one would a bottled ship. Our eyes are thus confronted with the impossible, and their multiplication appears to be useless. The eye will always be incomplete and Surrealist visuality constitutes itself in and from this incompleteness, caught between its desire to encompass everything and its fulfilment. Hence, the ironical title which refers to a museum, a place of fixed, classified objects, pinned to walls as butterflies in boxes. Eyes cannot but wander, away from the law.

Rimmington's *The Onlooker* (*c.* 1944) – he who stares at us as we stare at him – is full of the tension between the organic softness of the eyeball coming out of, or entering, the seashell and the phallic aggressivity of the murex shell. This tension reinvests the eye with a singular power, created by the contrast and the dislocation, linking it with our own eyes in a kind of subversive complicity. The reality principle is superseded by the pleasure principle. The same takes place in *Sisters of Anarchy* (*c.* 1949), where the two eyes of the owl are the nipples of one of the sisters, splitting her into two beings; or in *Life and Death Traps* (1950), in which eyes, in the

11.3 Edith Rimmington, *Museum*, 1951

total freedom they have gained, join in the dance of organic vegetable forms, playing with life and death, with being swallowed or not by the hazards of animal or vegetable predation.

Further reading into the function of the eye in British Surrealist painting is provided by Emmy Bridgwater. In two works which summarize her approach to the act of creation, the eye appears to be inseparable from the bird and the egg. The eye is obviously here a place of origination, not an origin but a *locus* of various forces from which forms emerge. *Budding Day* (1948) shows the inchoative quality of the eye, seen between opening and closure, the two birds stressing the two eyes' potentialities just as the latter contain in themselves the capacity for flying away. *Bursting Song* (1948) in a forceful way, shows how the bird and the eye share the same function: they are both at the origin of life, of the becoming of the world. Why do we not allow ourselves to be tempted by some poetical etymology: eye/*Eier* ('egg' in German), egg/*Augen* ('eye' in German)? Somewhere, deep down, the origin must be the same.

11.4 Emmy Bridgwater, *Bursting Song*, 1948

Active expectancy is what founds Surrealist visuality, and this is blatantly exemplified by F. E. McWilliam's sculptures, based as they are on the refusal of the given conventions of organicity and unicity. His Surrealist works confront the eye with what is lacking: be it in *Profile* (1939/40) or *Two Forms* (1938), the eye is literally fascinated by what it is obliged to see as an absence, that of what would make the form complete. We are forced to see a form which includes emptiness, and this is stressed in the first case by the presence of one staring eye. Visuality here rests upon a radical split between what we are asked to see and what our mental habits push us to reconstruct – but to no avail. McWilliam reveals the extent to which forms are fundamentally articulated on sheer vacancy, how the fullness of our vision cannot but be articulated on a blank, which we could almost name the desirable, never to be reached and exhausted. His sculptures, by dovetailing presence and absence, law and desire, are places which tell a new kind of fiction, an optical fiction; they are the moments of Lewis Carroll's Cheshire cat, celebrating a vision which asserts the eventually ungraspable quality of its own elaboration.

So, how can one properly see with the split eyes, the splitting eyes of Surrealist works? Through the experience of this radical impossibility of exhausting the act of seeing, we are asked to re-found, re-originate the work we see, in the gap between us and that very work. Evidence of this is clearly given by Surrealist objects, such as those exhibited in London at midnight on 27 November 1937. Those objects are all emblems of the problematics of Surrealist visuality.

Geoffrey Graham's *Virgin Washerwoman* (1937) is a case in point. Instead of the burning coals which will make the iron useful, one sees a pair of eyes, burning with all the difference and tension that they introduce into the object, a tension between the organic and the inorganic which excludes the object from its identity. Or rather, being now part of the iron, the eyes, foreign to it as they are, reinforce its identity and simultaneously alter its identity by disrupting it. Both the object and our eyes are thrown into a liminal space, open to various visual connotations and correspondences, as the title itself implies: the heavy masculinity of the iron, the phallic quality of the washerwoman's gestures when ironing, telescope with the latent femininity in the title as well as in the opening of the iron, heralding a kind of visual rape.

Charles Howard's object, *Inscrutable Object* (1937), is properly inscrutable and, because it calls itself so, it sends us back to ourselves and our own eyes. We see an object, and yet it says it cannot be seen. This seems to us the emblem of surrealist visuality: the object of our vision will for ever remain foreign to us, since it is the ever inexhaustible object of our gaze, the repository and delegate of our desire. Howard's object is unnameable because the reign of totality is over, when a name used both to say an

object and to found the vision of that object. The Surrealist object means the subversion of the law which controls and limits our vision; in front of it, we merely see ourselves seeing it.

Indeed, in its constantly renewed attempt to blend perception and representation, the Surrealist eye is fascinated by its cutting and splitting, by its being cut and split, by the central blank between the two split parts. That intermediary space is, deeply, that of Conroy Maddox's multiplied encounters, of Roland Penrose's strategies of visual inversions and reversals, of Humphrey Jennings's minimal collages and of Desmond Morris's worlds of pure origination. The function of the eye, as we have seen it, extends to all the displaced and displacing objects of other Surrealist works and epitomizes their radical questionings.

What is eventually split, and irrevocably so, is the 'I' of the spectator – or maybe this is no consequence, but the cause of it all. The subject,

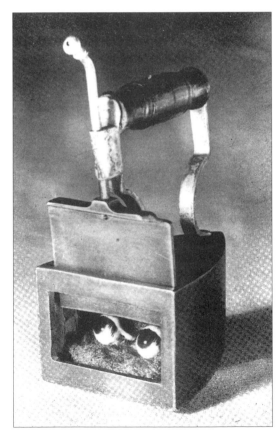

11.5 Geoffrey Graham, *The Virgin Washerwoman*, 1937

11.6 Charles Howard, *Inscrutable Object*, 1937

fascinated by what it sees, is split in its totality, in its being a subject. Or, vice-versa, it may well be this very fascination for these liminal visions which reveals its being constitutively split, almost by definition. The 'I' is subverted by its own desire, split between an 'I' which sees and an 'I' which is seen by what it sees. Both are radically different. The Surrealist operation – and it is the merit of British Surrealism not to have failed to exemplify it all the way – is the constant provocation, aesthetic and philosophical, of the so-called unity of the I/eye – spell it as you wish.

Notes

1. Clive Bell, *Art* (London: 1914), p. 44.
2. Ibid.
3. Roger Fry, 'Renoir', *Vision and Design* (Harmondsworth: 1920), p. 212.
4. Ibid., p. 192.
5. R. H. Wilenski, *The Modern Movement in Art* (London: 1927).

Desmond Morris, *Totemic Figure*, 1988

Index of Names

Bold type indicates an illustration; () indicates name at birth; [] indicates name adopted.